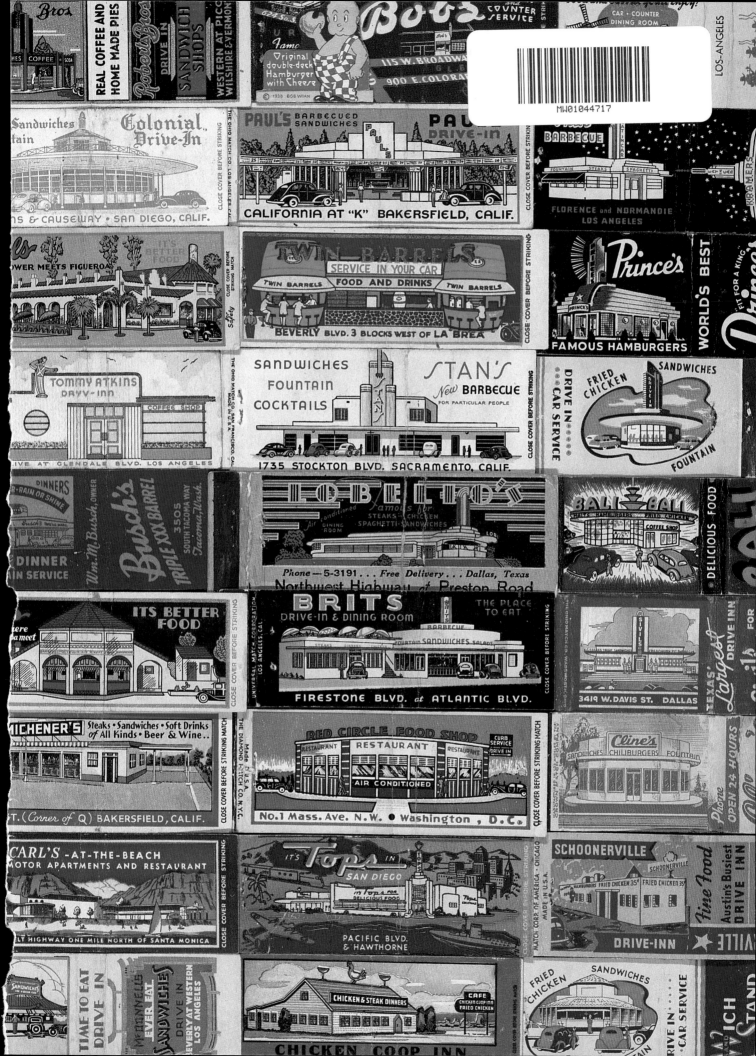

Copyright © 1996 by Jim Heimann.
All rights reserved. No part of this book
may be reproduced in any form without
written permission from the publisher.

Library of Congress
Cataloging-in-Publication Data
available.

ISBN 0-8118-1115-8

Printed in Hong Kong.

Book and cover design by
Jim Heimann.

Production by Mechanical Men, Inc.

Distributed in Canada by
Raincoast Books, 8680 Cambie St.,
Vancouver, B.C. V6P 6M9

Chronicle Books
275 Fifth Street, San Francisco
CA 94103

10 9 8 7 6 5 4 3 2 1

PHOTO CREDITS

Every effort has been made to secure permission and provide appropriate credit for photo-
graphic material and text in publications no longer active; the author deeply regrets any
omissions and pledges to correct errors called to his attention in subsequent editions.

A&W: 17 (Top), 21 (Top)
Wayne and Lillian Allison Collection: 79 (Bottom), 124 (Top left and right)
Archive Photos: 75 (Top), 123 (Middle, Bottom left), 126(Top left)
Armet, Davis and Newlove: 110
Bettman Archives: 99 (Middle)
Bishop Museum/Ray Jerome Parker: 85
Burbank Historical Society: 53 (Middle left)
California State Library, Sacramento: 6, 28 (bottom), 36, 62 (Top)
Dallas Public Library; Texas/Dallas History Archives Division: 59 (Middle left), 64 (Left)
Ekstrom Library Photographic Archives; University of Louisville: 63; Standard Oil of New Jersey Collection (Middle), 73; Standard Oil of New Jersey Collection (Left), 100; Standard Oil of New Jersey Collection (Bottom), 102; Caufield and Shook Collection (Middle and bottom), 111; Royal Studio Collection (Middle), 116; Royal Studio Collection (Middle), 122; Royal Studio Collection (Left)
Jeff Ethell: 89, 112
Florida State Archives: 111 (Bottom)
Glendale Public Library, Department of Special Collections: 94 (Top left, right and bottom), 95
Gotham Book Mart: 43 (Bottom left), 61, 64 (Right), 65 (Left and middle)
Chris Hansen: 19 (Bottom), 94 (Middle left), 95 (Top), 120 (Center)
Jim Heimann Collection: 2, 3, 4, 7, 9, 10, 11, 12, 13, 14, 16, 18, 23 (Middle left and right), 24, 26 (left), 30 (Bottom), 32, 37 (Bottom), 39, 40 (Bottom left and right), 43 (Bottom right), 46, 49, 50, 59 (Top), 70, 76 (Top and bottom left and right), 77 (Left and middle), 80, 90 (Top), 92, 94 (Center), 95 (Center and left), 97 (Top and bottom right), 99 (Right and left), 102 (Top and botton left), 103 (Bottom), 104, 107 (Top), 108, 109, 116 (Bottom), 118 (Top left and right), 120 (Top and mid-dle left), 121, 122 (middle), 124 (Top mid-dle), 126 (Bottom), 127
Bruce Henstell: 54 (Top right), 55 (Top right and bottom left), 71 (Top right), 77 (Right)
The Historic New Orleans Collection: 111 (Top)
Burton Holmes Collection: 23 (Bottom left), 29
Dell Hudson Collection: 74, 125
The Huntington Library: 27
Indiana Historical Society/Martin Collection: 100 (Top), 118; Bass Photo Company (Top middle)
The Institute of Texas Cultures: 72; Zintgraff Collection, 78; The San Antonio Light (Left), 119; Zintgraff Collection (Bottom)
Richard Kocher Collection: 76, 107 (Bottom)

Lawry's Restaurant's/ Tam 'O Shanter: 17 (Bottom)
Library of Congress: 42
Long Beach Public Library: 73 (Top right)
Los Angeles City Archives: 33, 59 (Bottom), 84
John Mariani: 120 (Middle right)
MCA/Universal Studios: 123 (Bottom right)
MGM Research: 35, 37 (Top), 63 (Left), 69, 71, 73 (Right), 75 (Bottom), 79 (Left and right), 86 (Middle), 87, 88 (Bottom right), 95 (Right), 97 (Bottom left), 113 (Bottom), 117 (Top right), 118 (Bottom), 123 (Top)
Motor Vehicle Manufacturers Association of the United States, Inc.: 53 (Middle right), 126 (Top right)
National Archives: 23 (Bottom right), 30 (Top), 98
New York Public Library: 23 (Top left)
Oregon Historical Society: 97 (Middle), 101 (Middle), 116 (Top), 119 (Top)
Pig Stand Inc.: 15, 19 (Top), 21, 22, 28 (Top), 100 (Middle)
Rosenberg Library, Galveston, Texas: 56, 65 (Right), 66, 67
Sacramento Historical Society: 115 (Middle left), 122 (Right)
San Diego Historical Society: 31 (Bottom), 48 (Middle), 86 (Bottom), 101 (Top), 117 (Middle)
Seaver Center for Western History: 26 (Right)
Security Pacific Collection/Los Angeles Public Library: 48 (Bottom), 68, 88 (Left and top right), 101 (Bottom)
Sickles Photographic Archives: 113 (Top), 120 (Bottom)
Time/Life: 81, 105
Bruce Torrence Collection: 31 (Top), 34, 41 (Top), 86 (Top), 117 (Bottom)
UCR/California Museum of Photography, Will Connel Archive/University of Calif-ornia, Riverside: 25, 44 (Bottom), 60
University of California, Los Angeles/Department of Geography: 91 (Bottom)
University of Southern California; Herald Examiner Collection: 75 (Middle), 83 (Top)
Bob Whelan: 108, 115 (Middle right)
White Castle: 78 (Top)
Whittington Collection/University of Southern California Regional History Center: 17 (Top), 31 (Middle), 40 (Bottom middle), 41 (Bottom), 43 (Top), 44 (Top and middle), 45, 53 (Top and bottom), 58, 62 (Bottom), 63 (Right), 82, 83 (Middle and bottom), 91 (Top)
Willborn and Associates: 78 (Top right), 90 (Bottom), 115 (Bottom), 119 (Middle)
Williams Collection/Cliff Wesselman Photographer: 59 (Right middle)
Tom Zimmerman Photography: 48 (Top), 57, 103, 115

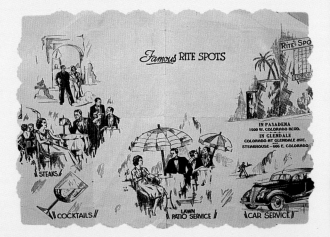

CAR HOPS AND
CURB SERVICE

A HISTORY OF AMERICAN
DRIVE-IN RESTAURANTS
1920-1960

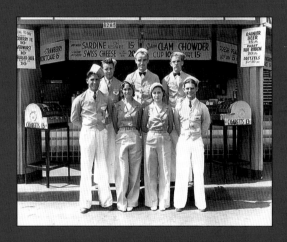

JIM HEIMANN

CHRONICLE BOOKS
SAN FRANCISCO

To Roleen and Zoë, Bon Appétit

Table of CONTENTS

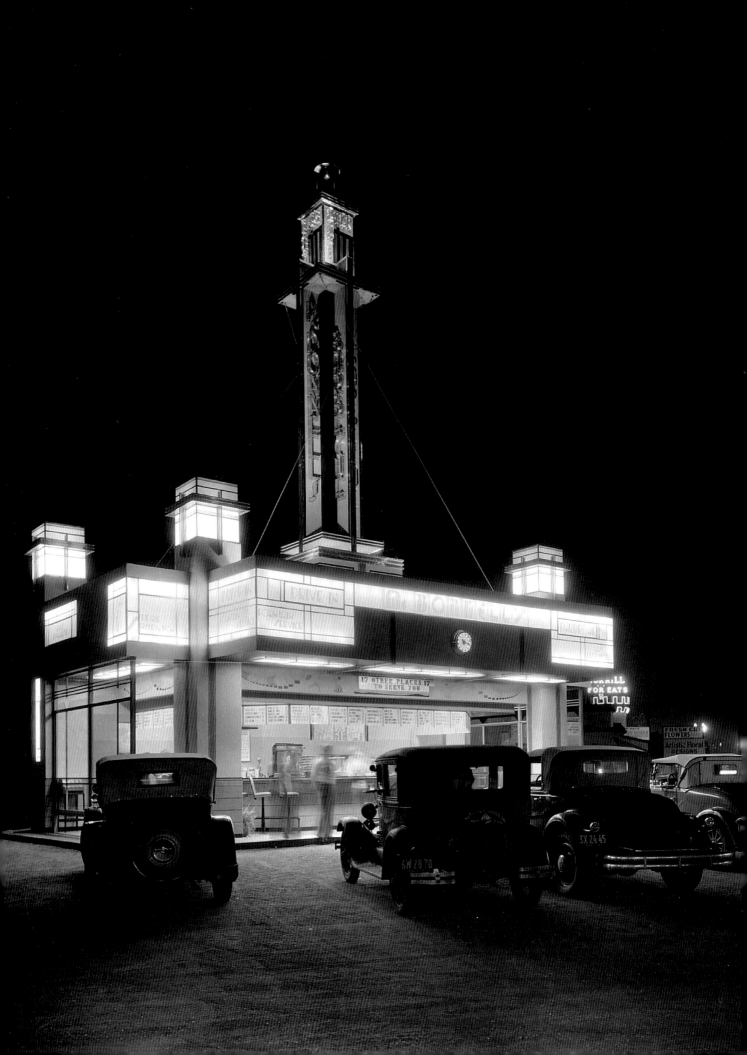

PREFACE

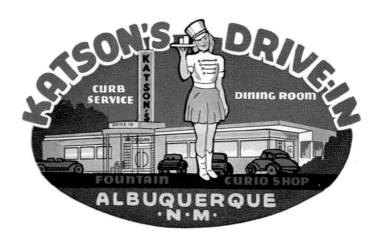

C*ar Hops and Curb Service* began in the late '70s while I was working on my first book, *California Crazy*. It was while I was researching that project on oddball roadside architecture that drive-in images also started popping up revealing yet another lost architectural world. As photos and clippings piled up, additional files were filled and the hunt was on.

However, several events that pre-date this research served as the true inspiration for compiling this book on the history of the drive-in restaurant. My parents, who met on the North American Aviation assembly line while riveting B-25 wings, told dinnertime tales of post–swing shift outings eating at wartime-era drive-ins. Patmar's, DeMays, Sally's, Simons, and Roberts were names that conjured up fanciful images in my mind, but had disappeared in one short decade before I had a chance to see them for myself. My Uncle Ray and his future wife Bobbie were two hep teenagers in the early '50s when, to my surprise, they threw me in the back of their car one day and treated me to a burger and coke at Scrivners Drive-In on Manchester Boulevard in the Morningside district of Los Angeles. There, KFWB DJ Art Laboe was doing a live broadcast in a parking lot jammed with teenagers, and to a five year old this first drive-in encounter was not easily forgotten.

My own teen years were punctuated with a few drive-in episodes, though I must admit that as many times as I drove in and out of them I don't recall ever purchasing food at one. By the mid-sixties the burgers at McDonald's and Hamburger Hand-Out were quicker and cheaper, saving my friends and myself time and money for cruising the Sunset Strip. Our local cruise spot, Hawthorne Boulevard in L.A.'s South Bay, was frequented by some local guys called The Beach Boys (Dennis Wilson's red corvette was a local landmark) and the drive down Hawthorne Boulevard from the A&W to Ships Drive-In and back served in part as the inspiration for their song "I Get Around."

Since those events, and in the almost twenty years of casual and feverish research, countless friends, individuals, and institutions have aided my efforts in completing this book. A tip of the hat to Roleen and Zoë for putting up with my obsessions and ignoring the piles of books, notebooks, files, photos, and junk around the house. Thanks to my parents for sharing their stories and guidance and to Ray and Bobbie for allowing a little kid to tag along on a date.

Special mention must be made to several individuals who unselfishly shared their photos and anecdotes. Ed Whittington, who cautiously let me into his studio some eighteen years ago, has become a valuable friend letting me forage for years through his family's amazing collection of commercial photographs. He is one of those hidden resources that are invaluable to the preservation of our recent past.

Early on in my research Bill Roberts filled me in on his family's drive-in history, enlightening me to firsthand knowledge about the restaurant business. Lillian and Wayne Allison, with their lifelong experience in all aspects of the drive-in business, provided me with invaluable car hop stories and were the source of car hop lingo. Dino, Alexa, and Greg Williams graciously opened up their photo collection to me, providing some great shots and great comraderie.

Special thanks also goes out to those friends who have helped me research, donated their time and just been there when I needed them. Chris DeNoon is by far the best researcher around and his skills have been invaluable in all my projects. On top of that he's just a great guy. Among the others who have helped me out over the years are David Boule, Henry and Freda Vizcarra, Nancy and Janet Duckworth, John Baeder, Carol Goldstein, Jay Nichols, Alan Hess, Brad Benedict, Richard Gutman, and Tom Zimmerman.

For their knowledge and the generous sharing of their collections, thanks to Richard Hailey of the Pig Stands Inc., Arthur Whizin, Jeff Ethell, John Margolies, John Mariani, Andy Brown, Ralph Bowman, Eric Rachlis of Archive Photos, Lee Brown, Bob Whelan, Chris Hansen, Bruce Henstell, Bruce Torrence, Richard Kocher, Julius Shulman, Marc Wanamaker and Gary Frederick of the South Pasadena Antique Emporium.

Thanks also goes out to all of the researchers at facilities and institutions that preserve images of twentieth-century architecture and artifacts, especially Dacey Taupe of the University of Southern California and Carolyn Kozo of the history department of the Los Angeles Central Library. Among the others are: the Kansas City Historical Society, Topeka, Kansas; The Rosenberg Library, Galveston Texas; The Texas State Library; John Anderson, Austin, Texas; The Lake County Museum, Curt Teich Collection, Lake County, Illinois; The Oregon Historical Society; Archives of the City of Los Angeles; The Florida State Archives; Blue Earth County Historical Society, Mankato, Minnesota; Ekstrom Library, Louisville, Kentucky; UCLA Department of Special Collections and the University of California/Riverside Museum of Photography.

At Chronicle Books special thanks goes to my patient and understanding editor, Bill LeBlond, whose friendship goes back to *California Crazy* days. To Pamela Geismar, Leslie Jonath, Michael Carabetta, and the rest of the crew—a hearty handshake for walking me through the final phase of this project.

I am also indebted to Tracey Lane and Fritz Koch for their generosity in providing the books initial design and layouts. And last but not least, this book would still be on my desk if it weren't for the endless hours of production time put in by Tracy and Pam Thomas (with the support Tina Glaub) of Mechanical Men.

Opposite. McDonnell's Drive-In (1930) at the northwest corner of Beverly Boulevard and La Brea Avenue in Los Angeles.

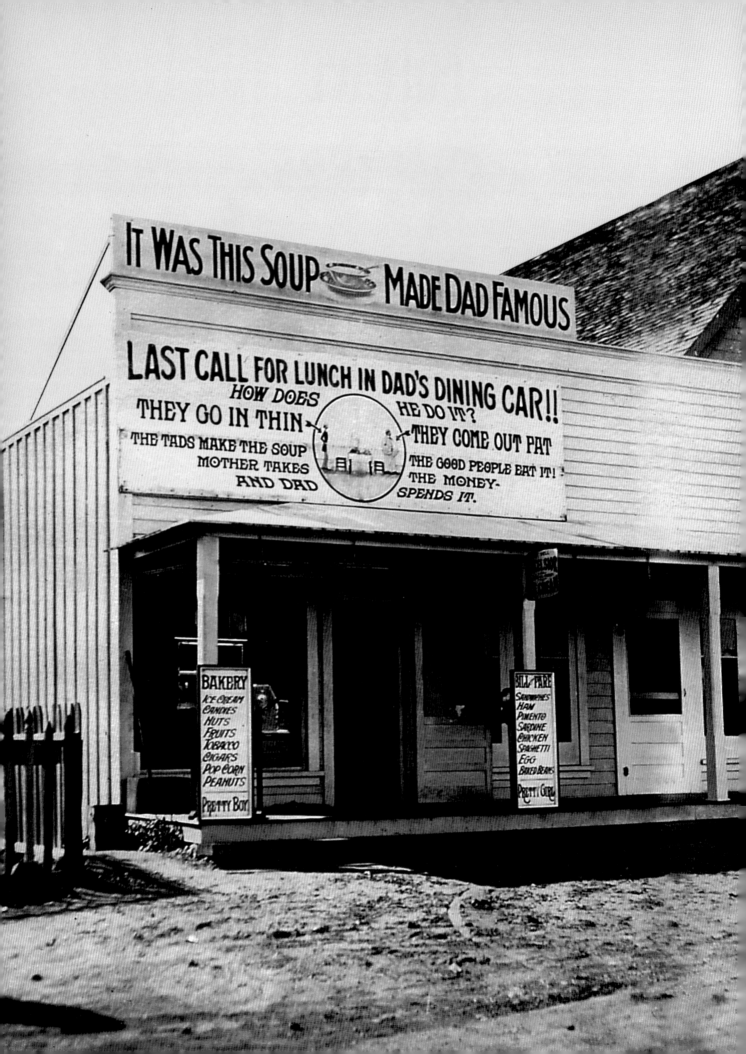

THE CULTURE OF THE CAR

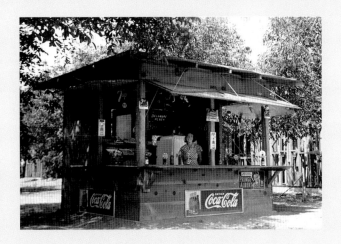

At the onset of the twentieth century, the American roadside was a simplified landscape of rural roads and crude highways connecting urban areas. Railroads dominated transportation and in 1900 consumed a total of 250,000 miles of track as compared to less than 160,000 miles of roadway. With the introduction of the automobile (especially Henry Ford's affordable, mass-produced auto), the roadside and American culture abruptly accelerated into a period of rapid development that changed the environment and habits of Americans everywhere.

As streets and highways spread out from city and town centers, the commercial Main Street began to take on diminished importance. The availability of the car for transportation to work, as well as for pleasure, made

Above. Typical of early roadside refreshment stands, this simple shed served a newly mobile American citizenry. Opposite. Located on the El Camino Real, this 1919 lunch-room in San Juan Capistrano, California, catered to a newly mobile tourist arriving by auto.

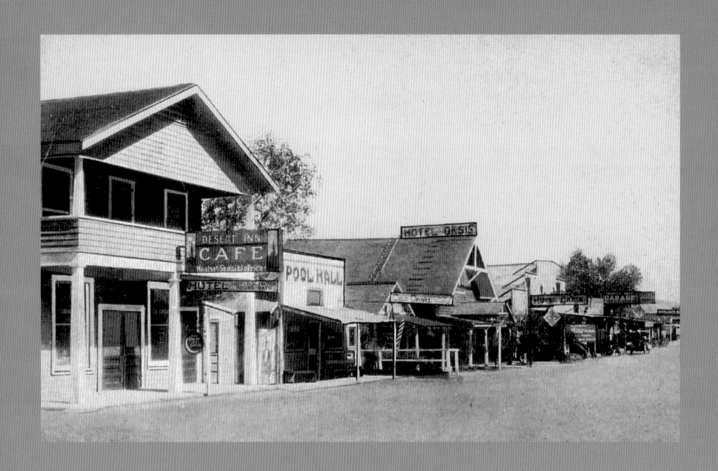

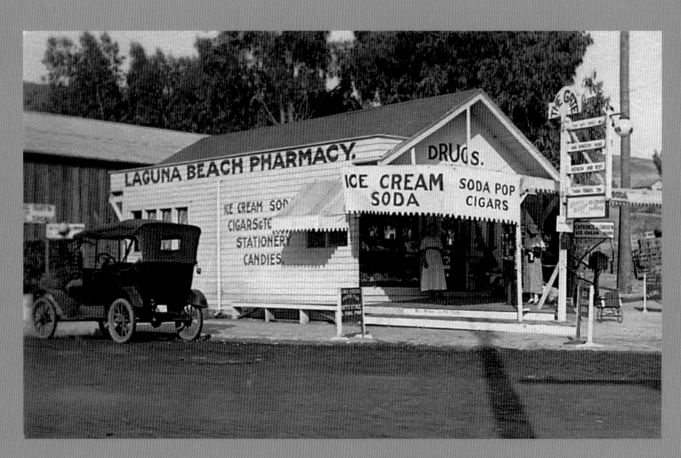

Top. *This view of Main Street in Ludlow, California, shows signage and services beginning to attract the auto trade.* Bottom. *Signs on this Laguna Beach, California, drugstore reach out to draw a new breed of customer arriving by automobile.*

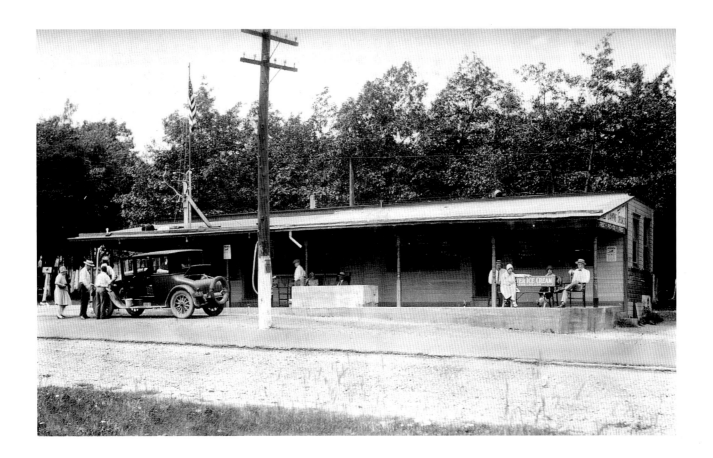

touring in vehicles a new pastime. As Americans became comfortable with the idea of travel for recreation, the roadside readily accommodated their mobile needs. Providing for the necessities of these motoring vagabonds was a whole host of services. Gas stations, auto camps, refreshment stops, and souvenir and fruit stands littered the emerging highway scene and lured the wayward traveler to come in and spend. In this evolving commercial landscape a new set of architectural standards began to develop that embraced this culture based on high speed and mobility.

This new breed of American drivers gravitated away from the cities and onto the road, making several amenities crucial. Businesses that could provide fuel, food, and a place to sleep competed for a dollar that was increasingly being spent on consumer goods. Capturing the attention of these customers driving by at 35 mph became paramount and it was along the roadside that the dining locale began to take on inventive, eye-catching characteristics.

Initially, the unsophisticated drive-ups were extensions of an established order sanctioned by Main Street merchants. Often food service along the road consisted of simple stands: a few boards nailed together providing a counter and an awning for shade, but lacking advertising and identity. As traffic increased, roadside entrepreneurs were quick to realize the importance of drawing notice to their businesses, so image became a primary focus. The false-front look of dense, commercial urban blocks was abandoned because roadside eateries had space and time to hail customers from

With an American public flocking to the highways after World War I, early refreshment stands like this one outside of Elk Park, Pennsylvania, were an increasingly familiar sight.

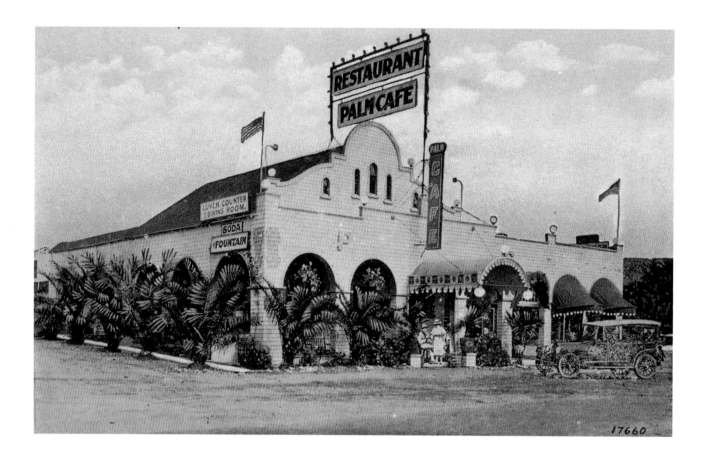

a distance. Signage was integral to ushering customers in, as was color, lighting, architectural style, and even the uniforms of the restaurant's servers. Once the basic design tenets were set, variations abounded, even as chain restaurants and franchise outlets codified their images.

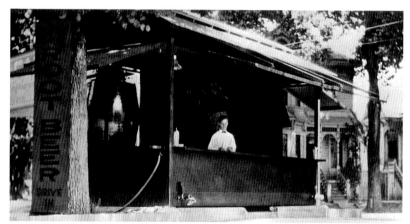

With their greater mobility, Americans gradually accepted eating outside the home. Until the 1920s, cafes and restaurants were limited eating experiences for the majority of Americans. But as workers began traveling beyond walking distance of their homes, they began to take their meals at inexpensive and quick lunch counters and lunch wagons adjacent to the workplace. This trend gained further popularity with leisure-based travel, which set the stage for dining in one's car. Two innovative Texans sensed early on that these new eating habits, coupled with the positive reception of the car, could be a profitable marriage, so they conceived what is considered to be the first curbside restaurant catering to the automobile and named it the Pig Stand. This Dallas establishment merged the auto and eating into a new American diversion.

Top. Tourists bound for San Diego were lured into the Palm Restaurant in San Juan Capistrano, California, by a roof-top sign designed to draw in the auto traveler.
Bottom. One of the earliest drive-ups, a circa 1921 A&W root beer stand in Sacramento, California, is situated curbside to serve auto patrons.

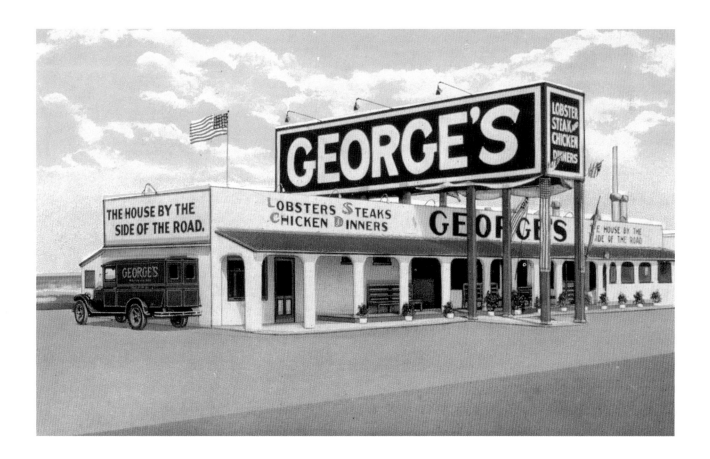

The concept of curb service, however, was not a new one. Prior to the automobile, the idea of serving customers outside a restaurant is said to have originated at a Memphis drugstore owned by Harold Fortune. The story goes that young Mr. Fortune managed the store's soda fountain and, one summer evening in 1905, was inundated with so many customers that he allowed gentlemen patrons to take their orders outside to their ladies, so they wouldn't have to wait for service inside. It proved to be a popular idea, and Fortune soon hired runners to take orders curbside and deliver their treats to waiting carriages.

The advent of the automobile only improved Fortune's business. In 1914, he moved the store to a new location where the service was continued with such popularity that cars parked up and down the block, creating traffic jams. Breaking the curb in front of the store to allow cars to park partway on the sidewalk proved futile—the police commission created an ordinance banning curb service in the business district. Moving his drugstore, in 1922, to the Memphis outskirts, Fortune added a parking lot and separated the fountain from the store while adding food to the fountain menu. But Fortune, who is credited with popularizing the first curb service, was a year late in creating what was to be the true forerunner of the drive-in restaurant.

Top. The larger the sign, the easier it was to grab motorists' attention while whizzing past George's Restaurant in Carlsbad, California.

B y 1920 there were eight million automobiles on the American road, an increase of 300 percent from 1915. The assembly line of Henry Ford produced cars available to anyone who could plunk down or put on credit the required $920 (in 1924). This transformation to mass public mobility

was fundamental in making the '20s roar and it yanked small town America, where almost 50 percent of the population lived, onto a network of improved roads and into town to sample post–World War I prosperity. Movies, nickelodeons, and the radio also brought Americans greater exposure to the world at large, signaling forever an end to pre-war values. Into this climate of innovation, mobility,

and relaxed mores came J. G. Kirby, a Dallas businessman, and Dr. R. W. Jackson, a prominent physician. In 1921, these two men joined idea and assets to create the Pig Stands Company, Incorporated. The founding of the first restaurant built specifically for the purpose of serving meals to motorists in their cars was Kirby's brainstorm—he deduced that "people with cars are so lazy that they don't want to get out of them to eat." The money was Dr. Jackson's. The company was incorporated with $10,000 in capitol, with the stock split between Kirby and Jackson. As president of the company, Dr. Jackson preferred to be the silent partner, deferring to Mr. Kirby to manage the enterprise.

Awaiting their food orders, drivers line the street adjacent to the Dallas Pig Stand #2, the first food stand to offer curb service.

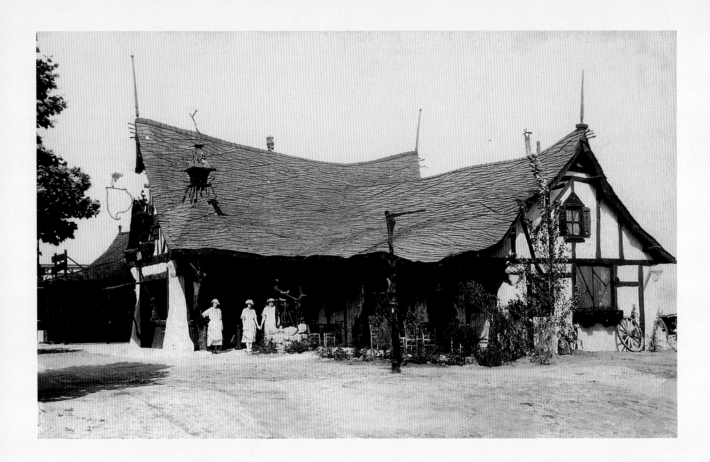

The inaugural Pig Stand opened in September 1921 on the Dallas–Fort Worth Highway, on the outskirts of Dallas. It was relocated later in the '20s to Second Avenue in Dallas, operating there until 1932, when the lot was purchased by the State Fair of Texas. A second Pig Stand opened at 1301 North Zanga Boulevard in 1924, and the expansion of the chain quickly followed.

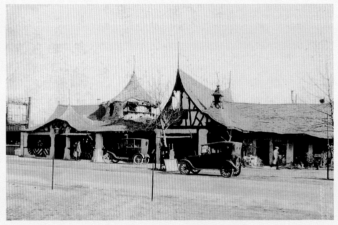

With the death of Mr. Kirby in 1926, Dr. Jackson assumed active management, which he continued until his death in 1955. The Jackson family then asked Royce Hailey, an ex–car hop and Pig Stand employee since 1930, to take the helm of the company as president. He eventually turned the business over to his son Richard Hailey, the Pig Stand's current owner.

The popularity of dining in one's car surpassed most restaurateurs' expectations but once proven successful, the idea flourished. The informality of dining à la car fit perfectly with America's new on-the-move attitude. The evolution of the roadside stand from brief food stop to a more traditional restaurant made curb service all the more appealing. Also contributing to the success of the drive-in was weather. It was no coincidence that the sun belt led the country in drive-in

In Los Angeles in 1922, the Tam O'Shanter followed the Pig Stand in offering customers service in their cars. This whimsical restaurant, designed by motion picture set designer Harry Oliver, sought to attract passing motorists to stop in and order food to be served in their cars from the counter at left.

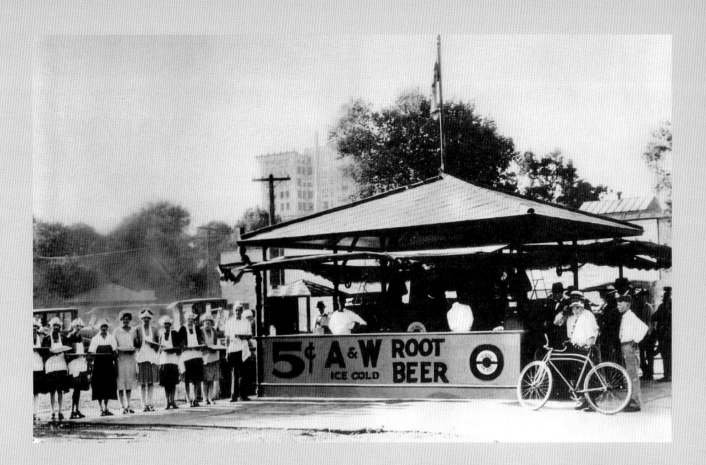

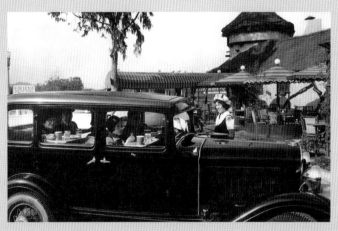

restaurants, with its mild climate contributing to year-round productivity. Texas and California laid claim to the most drive-in restaurants. After the opening of the Pig Stand in Dallas, three Californians followed suit by opening a car service eatery on the outskirts of downtown Los Angeles. Lawrence Frank, Joe Montgomery, and Walter Van de Kamp opened Montgomery's Country Inn on Tropico Avenue (later renamed Los Feliz Boulevard) near Griffith Park. Frank and Van de Kamp had a successful bakery business and Montgomery offered restaurant savvy. Having previously hired MGM studios art director Harry Oliver to design their bakeries' windmill-shaped outlets, Van de Kamp and Frank again turned to him, requesting a restaurant design "from old Normandy." The partners knew its country location needed to attract people driving by, so they admonished Oliver to "Make it fanciful. Make it stand out." The result was a fairy tale–like structure that was pure Hollywood. Walls leaned, rooflines meandered, and interior beams were charred and fatigued, giving the appearance of an antiquated building. Oliver's success in bringing set design from behind studio walls and on to the street was an early

Top. *Forerunner of the car hop, A&W tray girls line up next to a mid-'20s root beer stand.* Bottom. *At the Tam O'Shanter food was served to car patrons on a padded wooden plank that was inserted through the windows, spanning the width of the car.*

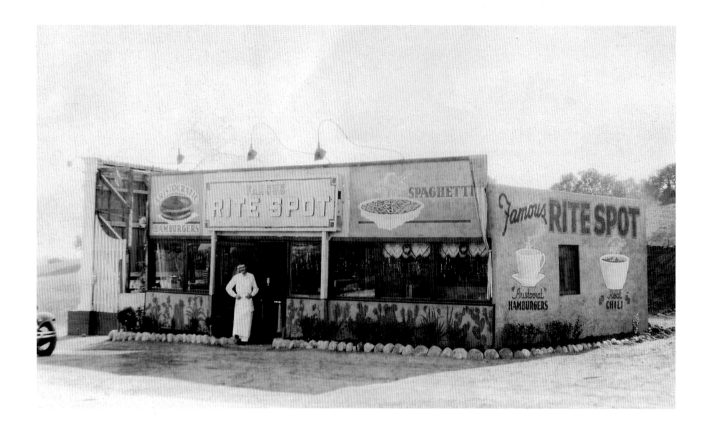

force in creating the whimsical architecture that would become synonymous with Los Angeles. And it also proved

quite successful at bringing in customers. Frank knew that a majority of his patrons arrived by automobile, so he

instituted an in-your-car service on his first menu, providing each auto that sidled up to the restaurant with a wood-

en plank that was inserted through the windows. The food was placed on the padded board and a crude, but effec-

tive, car service was born. As the restaurant evolved, a curio stand and dining rooms were added to Montgomery's.

By 1930, the parking lot was given over to full car service, with waitresses decked out in Scottish uniforms, com-

plementing the eatery's name change to the Tam O'Shanter Inn. Its location near early motion picture studios gar-

nered it a stellar clientele and in the '20s it was not unusual to see the likes of Tom Mix, Rudolph Valentino, Mary

Pickford, and Gloria Swanson there. Walt Disney, whose Hyperion Avenue studio was just a short distance away, was

fond of the outdoor dining area, a part of which had been enclosed and heated. Throughout the 1930s, the establish-

ment remained one of Disney's favored lunch spots.

Other restaurants were quick to open and lay claim to having initiated car service as trade publications touted the

wonders of selling to customers in their cars, but Fortune's Drug Store, the Pig Stand, and the Tam O'Shanter stand

out as the earliest innovators of the drive-in concept. Throughout the '20s, with the idea of eating in cars implanted

firmly in the public's mind, other eating establishments opened or were modified to accommodate the automobile.

Birthplace of the cheeseburger: Lionel Sternberger's Rite Spot, shown here on dusty Colorado Boulevard near Pasadena, California. Sternberger expanded his restaurant's business to include drive-in service after his initial success.

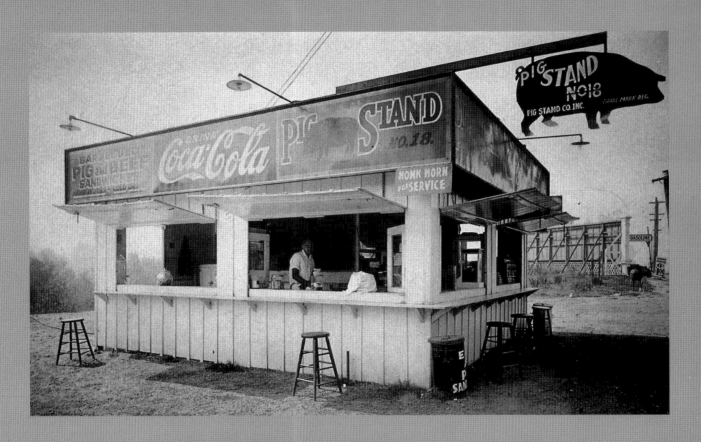

The simple roadside stand was still a presence along the bucolic byways of the United States, but urban eateries were also flourishing and thriving. Among early entries into the drive-in concept was the A&W chain, which was formed on June 20, 1919, in Lodi, California, by root beer stand owner Roy A. Allan and former employee Frank Wright. Combining the initials of their last names, they opened their first drive-in during the summer of 1923 in the Sacramento area at a location that was also used as a car lot. Soon after, they introduced their tray boys as outdoor waiters. In 1924, Frank Wright dissolved his interest in the company, but the name remained and Roy Allen proceeded to expand his A&Ws beyond the West. Out of one of these outlets on the East Coast evolved the Hot Shoppes, a storefront lunch counter that derived its name from the hot sandwiches, chile, and tamales they sold. Opened in the summer of 1927 by J. Willard Marriot, this Washington, D.C., grill-in-the-window stand rapidly extended beyond the downtown area and capital-

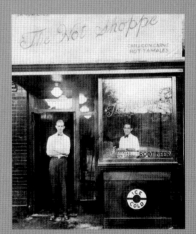

ized on recognition of the black and orange A&W logo by incorporating the orange color into the restaurant's roof for an attention-grabbing touch. These outlets soon sought the car trade, and in less than two years Marriott opened one of the first drive-ins in the East, followed by many East Coast chains, spreading the eat-in-your-car notion countrywide.

By mid-decade, many of these new restaurant chains moved toward architectural standardization. White Castle

Top. *Early Pig Stands were little more than plain wooden sheds with limited signage and a minimum of counter space. A honk of the horn summoned a car hop.*
Bottom. *The original Hot Shoppe stand in Washington, D.C., was the first outpost for a chain of East Coast drive-ins.*

White Tower, Little Tavern, and others added car service in the '30s, and their image consistency was a critical early design element that gave them recognition and success over a wide region.

Meanwhile, in California drive-in innovation blossomed. Though continuing to spread throughout the country, the number of drive-in restaurants in Southern California was unrivaled. The combination of mild weather, relatively inexpensive real estate, and a vast network of suburbs connected by miles of highways made Los Angeles ripe for a car-based industry. Hollywood served to inspire and be inspired by the drive-in, as demonstrated by designer Harry Oliver's Tam O'Shanter. Architectural experimentation was also fostered by the large number of progressive practitioners who found a client-base open to new ideas and an atmosphere unencumbered by an established architectural hierarchy.

The Texas Pig Stands soon spread to Los Angeles from Dallas. Modest by comparison to the rambling Tam O'Shanter, most of the Pig Stand structures were simple, modified roadside stands, but modesty did not hinder their proliferation on the West Coast. While most Los Angeles drive-ins consisted of a single unit, the Pig Stands had fifteen restaurants in California by 1930. Number Eighteen called itself the first drive-in, a distinction it shared with a handful of others claiming "first rights." Number Twenty-one capitalized on its drive-thru service, another first that is difficult to verify. Pig Stand Number Forty-nine stood at the very visible and popular corner of Sunset and Vine, becoming another great magnet for movie stars from local studios.

It was also in the Los Angeles area that the Pig Stands experimented with a variety of building designs, including a hexagonal stand at the northwest corner of Pico Boulevard and Western Avenue. Marking a departure from the simple batten board rectangular stands, it took full advantage of its corner location. This forerunner of the circular drive-in of the '30s made practical use of a centralized food service and allowed for maximum usage of the frontage for parking. Remodeling of the building a few years later included a handsome tile front beneath an extended canvas awning which, in turn, was crowned with advertising panels. Pole signage, positioned at the corners of the main intersection, gave plenty of advance notice to potential customers of culinary delights nearby. Variations of this design popped up all over Los Angeles, confirming its success as a commercial building style.

The quest for greater visibility along the highway was never-ending, as more and more businesses vied for the car trade. One response by roadside business owners was to advertise on a grand scale. The practice of using over-scaled, outlandish forms as attention-getters on the roadside wasn't new, nor were buildings in the shapes of giant objects, but the anything-goes climate of the '20s, wedded with the naive boosterism of individual owners, produced more and more exotic and oddball structures in cities and along the wayside. Neon, introduced in 1923, was immediately incorporated

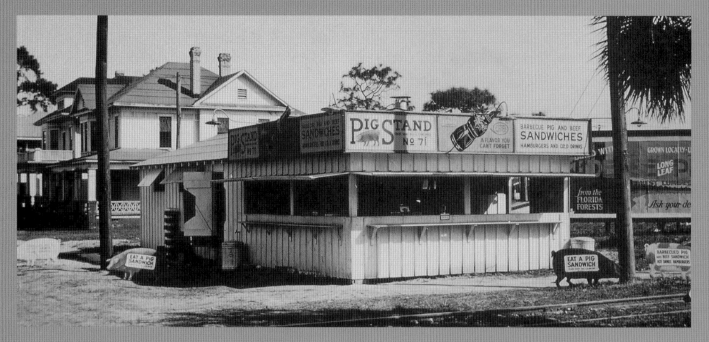

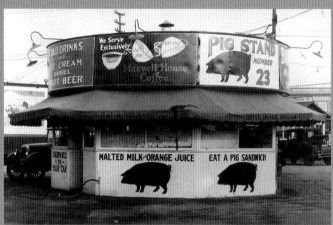

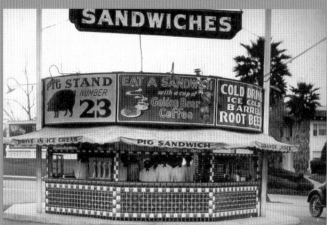

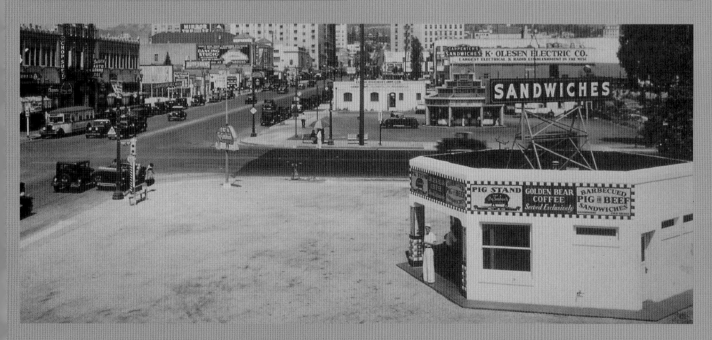

Top. A Jacksonville, Florida, Pig Stand retains the simplicity of a roadside stand. Middle. As one of the first octagonal drive-ins, the first Los Angeles Pig Stand (located on the northwest corner of Pico Boulevard and Western Avenue) took full advantage of its site. This much copied shape catered to automobiles by offering service in the round. Later improvements to this Pig Stand included neon signage and decorative tile work. Rooftop panels provided space for further advertising. Bottom. The Hollywood Pig Stand at Sunset and Vine competed for the drive-in trade with a Carpenter's outlet across the street.

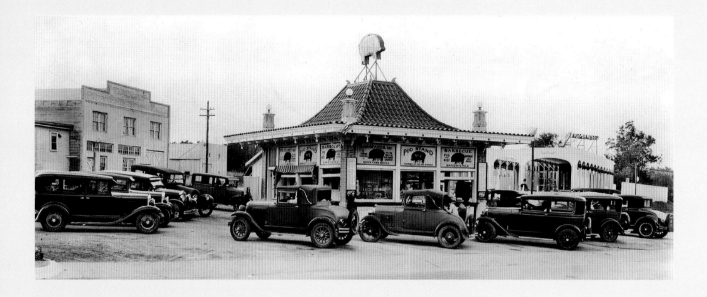

into American drive-in buildings and signage, becoming a standard element of drive-in design for decades to come. This rapid adaptation of building styles and new materials was indicative of the restaurant industry's image-consciousness and emphasis on being up-to-date. Selling the public on sparkling cleanliness, speed, and good food spelled success, and the drive-in was unsurpassed in this area.

Menus in the early days of drive-up service were simple and limited to food that was quick to prepare and serve. The Pig Stand built its business on barbecued pork and ham sandwiches washed down with Coca-Cola. Originally the Tam O'Shanter sold frankfurters, waffles, and ham dinners, but it was the ubiquitous hamburger that proved to be the most popular drive-in item. Simple to prepare in high volume, it was the staple of chain restaurants such as White Castle, where great pains were taken to convince customers that their product was not the burger of greasy spoon counters. The hamburger rose to perfection when served at drive-ups such as the Tam O'Shanter, where the better part of 1925 went into experimenting with a recipe for their 20 percent fat, 80 percent lean, ground beef shoulder, grilled-to-order burger. Also popular on the menu were hot dogs, toasted sandwiches, pie, ice cream, assorted fountain items, and regional specialties. In the West, chile, tamales, and spaghetti made most menus. Oysters and seafood were popular in the East, and fried chicken could be found in the South. As drive-ins grew in size and number, many of these local favorites were incorporated into kitchens across the country and, save for a few unique local items, customers knew pretty much what to expect when they pulled up for a meal. Even as menus expanded and were embellished with full-course dinners, the basic items of the '20s quick cuisine remained the staples during the drive-in's later heyday.

Above. Echoing the 1920s trend of exotic commercial architecture, this San Antonio Pig Stand combined a pagoda-like roof with neoclassical detail. Opposite. The bizarre architectural anomalies that flourished during the '20s were an imagery used by drive-ins to draw in customers driving by at 35 mph. Top. The Tee-Pee Drive-In in the Belmost Shores section of Long Beach, California. Middle Right. A Washington Boulevard roadside stand on the outskirts of Culver City, California. Bottom Right. The Toed-In Drive-In in Santa Monica, California. Bottom Left. A giant Indian head dispenses A&W root beer to roadside customers. Middle Left. The Twin Barrels Drive-In on Beverly Boulevard near Hollywood, California.

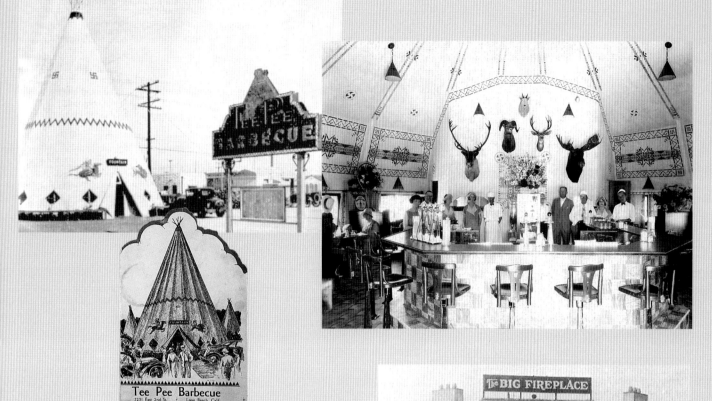

Tee Pee Barbecue
5251 East 2nd St. Long Beach, Calif.
R. R. MACPHERSON R. C. MACPHERSON

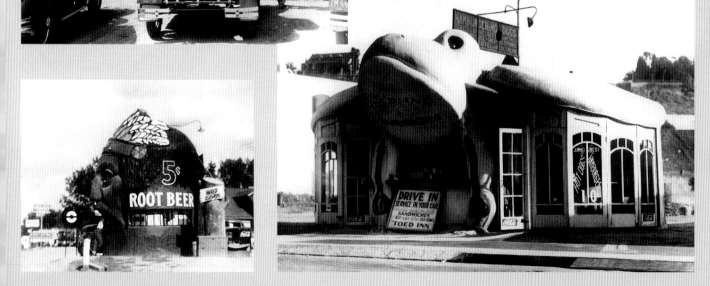

One would hardly suspect that the decade that ushered in the Great Depression would also witness the rapid rise of a simple eating concept to an institution that would reach its apex in a mere ten years. Yet the drive-in restaurant, which had been quickly accepted by the public in

the '20s, retained that popularity, creating an inexpensive diversion and new meeting place for a population who craved affordable food in an informal dining environment. Eating patterns were evolving and the trend for fast meals suited pinched pocketbooks perfectly. Drive-ins were also convenient substitutes for the taverns and bars that had vanished with Prohibition. The popularity of the soda fountain coincided with the disappearance of alcohol from public view, and soft drinks and malts became a sweet staple of drive-ins, snack shops, diners, and drugstores. In 1933, when beer was reintroduced after the repeal of Prohibition, hard liquor soon followed. Restaurants happily added alcohol to their menus as quickly as it had disappeared fourteen years earlier. The restaurant industry lobbied to restrict alcohol consumption to places serving food, in an attempt to eliminate the saloon culture of a "wet" United States, but, ultimately, it was unsuccessful. The drive-in restaurant industry included beer after the repeal and, within a few years, added cocktail lounges to the expanding services of drive-ins.

Opposite page. A '30s classic, this Los Angeles Carpenter's Drive-In epitomized the clean lines of circular drive-ins, a style that would flourish throughout the United States during this decade.

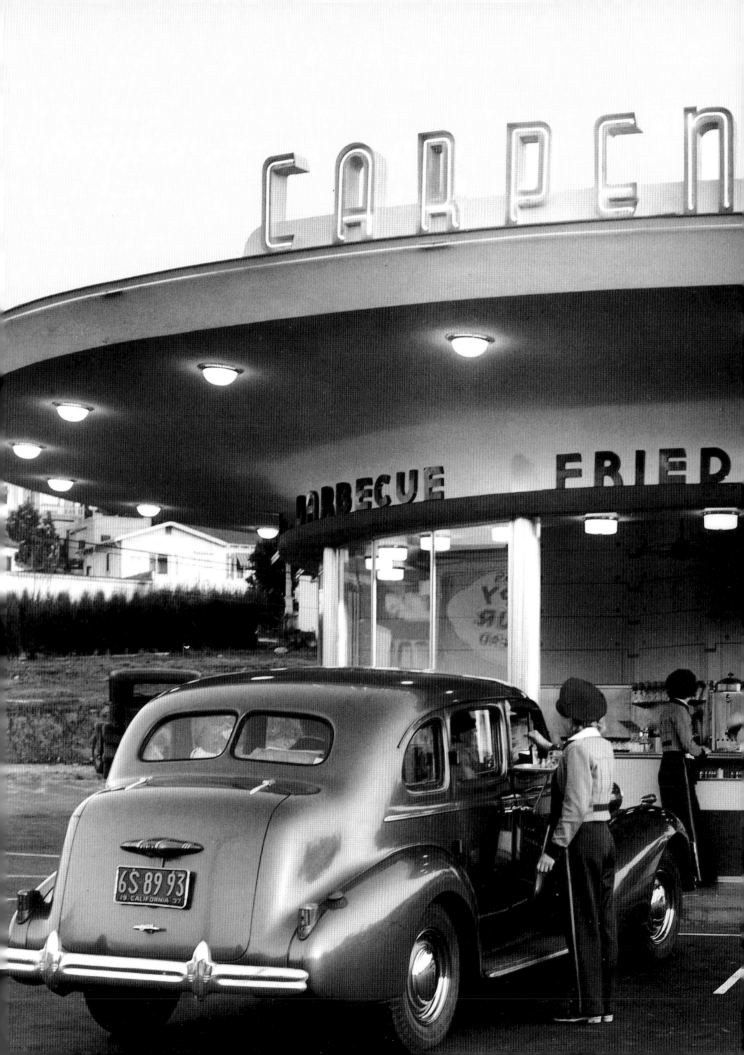

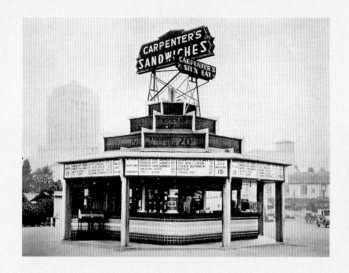 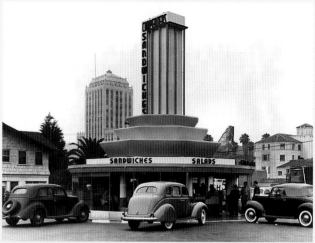

Specialization and standardization were trends that continued from the previous decade. A restaurant was now a diner, tearoom, sandwich shop, coffee shop, or drive-in. Owners of multiple units attempted to unify their chains with similar buildings, consistent signage, and uniforms.

Harry Carpenter, a restaurateur whose chain of Los Angeles restaurants bore his name, typified the '30s dining entrepreneur. The son of a lunch counter owner, Carpenter grew up behind the grill and was well acquainted with these small, quick–service eating places that made considerable money with low overhead. His father's success in Omaha preceded a move to Kansas City, where before Carpenter was 20 his father had turned over the business to his sons. Carpenter's brother sold his lucrative share to Harry for next to nothing and moved to a ranch in Kernville, California.

In 1916, Harry was lured to Los Angeles by his brother's glowing descriptions of the city. He opened his first restaurant there in the Sun Building on Seventh Street near Hill Street. Five successful years later, Harry accepted an offer to sell the place, netting a hefty profit. He took his earnings and moved farther west to 2024 West Seventh Street, a busy location adjacent to Westlake Park. For ten years this small counter restaurant thrived, and though Carpenter invested in a chain of San Francisco donut shops and a failed joint venture with fellow restaurant man M. A. McDonnell, he never lost interest in roadside stands and pie counters.

In 1931, Carpenter opened his first drive-in at the southwest corner of Wilshire Boulevard and Western Avenue, which was an instant hit. Having carefully observed other similar restaurants, Carpenter constructed his in the increasingly familiar modified octagon and added all the components that were marking Los Angeles drive-ins as innovators: gleaming tile, "sanitized" counters, open front service areas for speedy access, a brilliant light display, and signs, signs, signs. Open twenty-four hours a day and serviced by thirty uniformed attendants, Carpenter's drive-ins were quickly

Left. One of the first Carpenter's Drive-Ins was located at the heavily traveled Los Angeles intersection of Wilshire Boulevard and Western Avenue. Adopting the octagonal shape of a nearby Pig Stand, other Carpenter units were constructed using the same design. Right. Remodeling its earlier building, a streamlined Wilshire Boulevard Carpenter's was an up-to-date restaurant reflecting mid-'30s architectural trends.

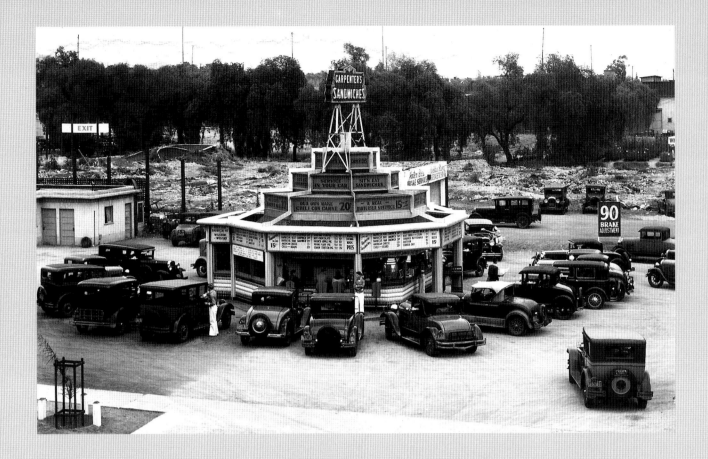

opened at two more locations, one at Sunset and Vine and another at Wilshire and La Cienega Boulevards. Rain or shine his customers came, Carpenter claimed, for the moderately priced, high-quality food that resembled the fare at almost every other drive-in. Hamburgers, hot dogs, melted cheese sandwiches, corned beef on rye, and chicken à la king on toast were the main entrées, though Carpenter touted his made-on-the-premises pies as the area's very best. While his food stands represented the popularity of drive-ins in general, his Sunset and Vine location became the focus of much attention for its proximity to Hollywood and the nearby CBS, NBC, Paramount, and Goldwyn studios.

It didn't hurt the publicity-minded Carpenter that some of Hollywood's best-known stars munched on sandwiches while in the area, or that journalists made mention of the fact that the parking lot was difficult to navigate because it was packed with Packards, Lincolns, and Cadillacs. This image, projected from coast to coast, elevated the status of the drive-in from roadside stand to a respectable and even glamorous dining option. Carpenter's success continued throughout the '30s as more outlets were opened, each one more modern than the last. Stories like Carpenter's were becoming an oft repeated tale throughout the United States, as small-time hamburger stands made the jump to fully staffed drive-in service. From Yaw's in Portland, to the Varsity in Atlanta, the Teepee in Indianapolis, and the White Towers across the nation, the drive-in restaurant had passed the novelty phase and was embedding itself into popular culture.

An instant Hollywood hangout, Carpenter's Drive-In at Sunset and Vine garnered much media attention because of its proximity to nearby motion picture studios. The familiar octagon shape with its stepped advertising tower remained a standard drive-in form until the mid-'30s.

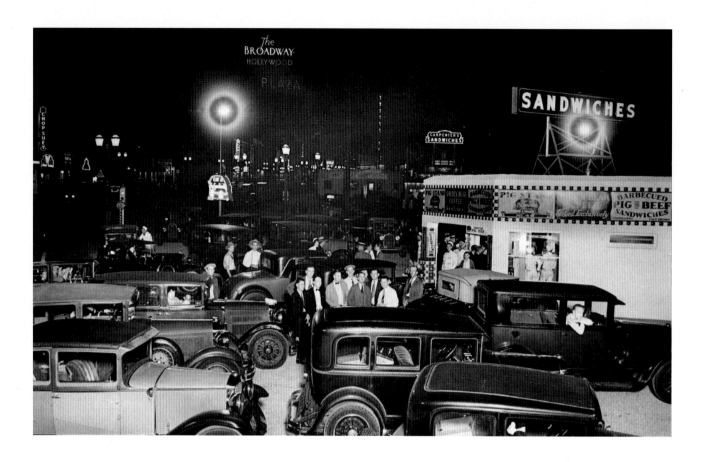

Architecturally the drive-in was inventing itself as it went along. Drive-ins of the '20s closely resembled established roadside stands: simple structures, rectangular in shape, usually made of wood or stucco, and built by a local contractor or the owner himself. Success demanded more creative ways to serve customers and by the mid-20s the Pig Stands had several styles. An octagonal shape was introduced for greater efficiency, visibility, and economy of site. The precursors to this shape were found in exposition architecture, which was a richly mined source for commercial buildings.

The 1925 International Exposition of Decorative and Modern Industrial Arts in Paris, considered the birth of the Art Deco movement, provided inspiration for a generation's worth of building designs. It is doubtful that the style of a roadside stand could be the direct result of such sophisticated principles; nonetheless, this and other expositions had far-reaching effects on the design of even the simplest of commercial structures. The Pig Stand's octagon, however, was more practical in nature. Another style of the Pig Stand built later in Texas was more in keeping with the whimsical, programmatic tradition that was flourishing as the '30s began. Reminiscent of an oriental pagoda with a tiled roof, this later design sent a mixed visual message by the addition of neoclassical corner columns mounted with glass globes,

Top. The opening of the Hollywood Pig Stand at the popular corner of Sunset and Vine was heralded with premiere-like fanfare in August 1931. Bottom. The interior of a Sanders System giant coffee pot illustrates the simplicity of early drive-ins. Opposite page. Enticing motorists to drive in and sample its wares, this giant coffee pot, located on the northeast corner of Beverly Boulevard and Poinsettia Street, was one of several Sanders System Drive-Ins found in Los Angeles.

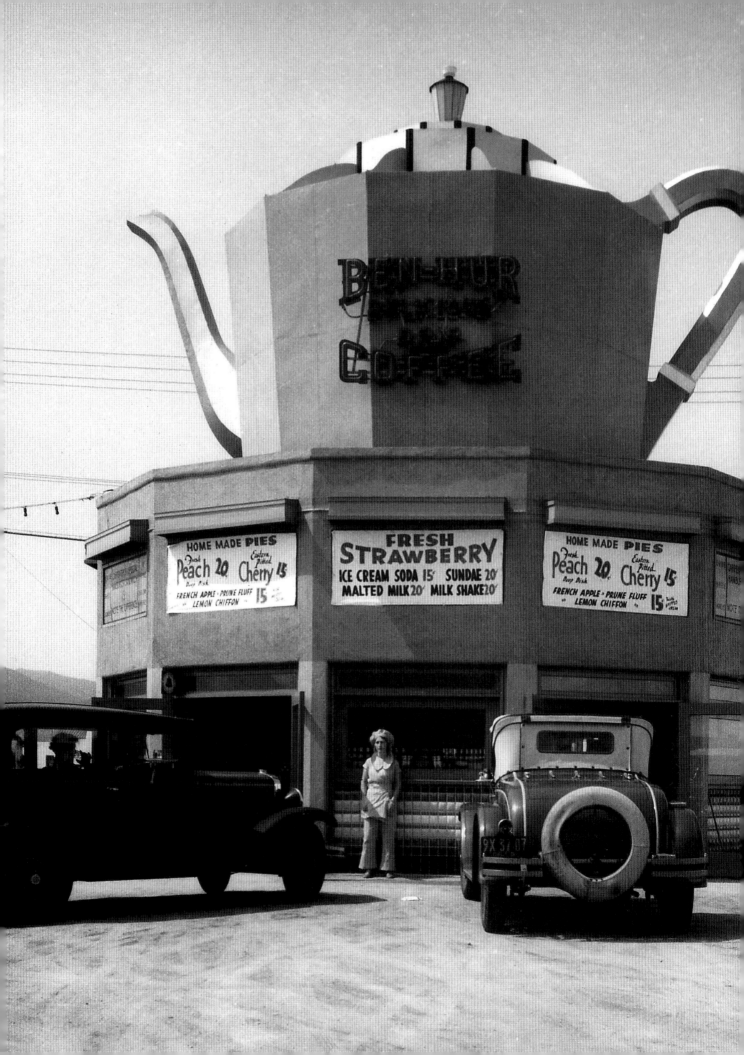

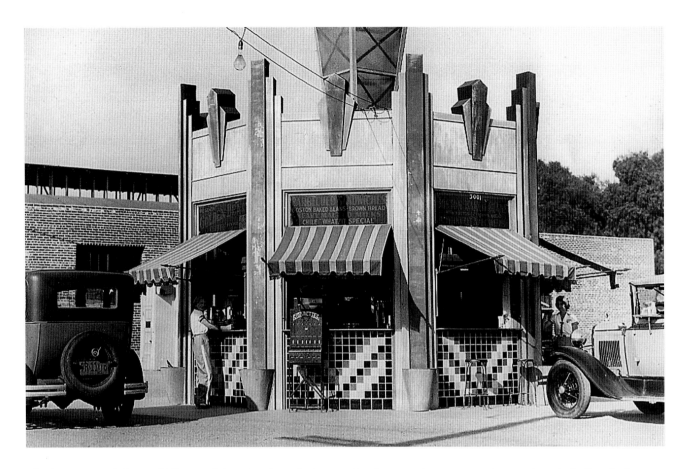

which punctured the roof. The resulting visual confusion caught the motoring customer's attention. A similar design was

used in Los Angeles, on the corner of Beverly and Western, by the McDonnell's drive-in

chain. Again an oriental treatment dominated, but this time with an octagonal base and

additional sign panels atop the tiled roof. At the very visible corner, a large sign with a

painted, Buddha-like figure holding a clock continued the Chinese motif.

Drive-ins throughout the United States carried out this theme of the electic, coined

"bizarre architecture" by pundits of the time. In a trend that began in the '20s, developing commercial strips took on a

surrealistic air as giant apples, barrels, ice cream freezers, pigs, teepees, and castles dotted the landscape. The home to

most of these structures, of course, was the land of the giants: Los Angeles. By the '30s, the Los Angeles flatlands were

dotted with drive-ins using novelty as their drawing card. The building as signage was a natural progression for the ever-

important task of customer-baiting. That it reached its fulfillment in Los Angeles is no surprise, given the region's

simplistic building codes and mild climate, which permitted the use of materials such as chicken wire and stucco in con-

struction that could be converted into almost any imaginable form. Censure by architectural critics and review boards

was nonexistent—this was Hollywood.

Above. Typical of many early Los Angeles drive-ins, this compact octagon embellished its exterior with decorative Art Deco detailing and elaborate tilework, setting itself apart from more conventional businesses. Opposite page, top. A miniature replica of a southern mansion, the Colonial Drive-In was one of the few drive-ins on the Sunset Strip. Middle. A second story eating area was a novel addition to a typical early '30s, octagonal drive-in in the Viewpark section of Los Angeles. Bottom. Clad in Robin Hood-inspired uniforms, car hops serve customers at Glenn's Drive-In on El Cajon Boulevard in San Diego, California.

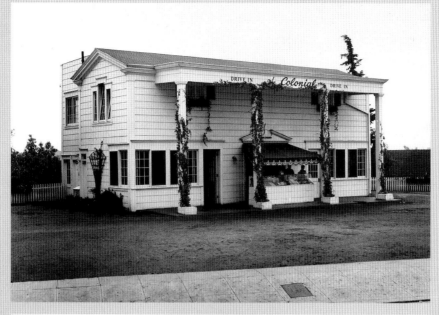

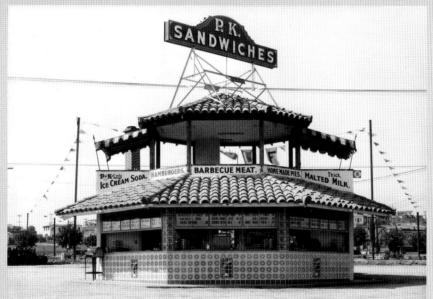

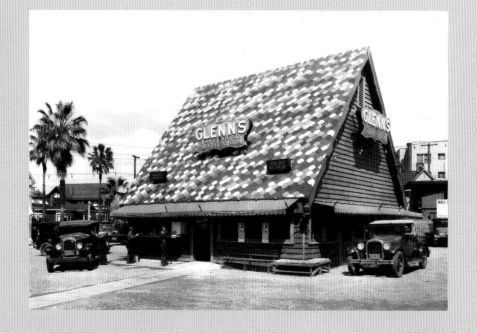

In contrast to the fantasy architecture, several stylistic developments were evolving that would eclipse the light-hearted road stands. Modernism and streamlining represented the optimism of the future. In the midst of the Depression, cultural renewal was an important idea for a populace that needed to believe that better times were just ahead; abandoning the past was seen as good. This belief in the advances of science, technology, and the machine had been apparent for several decades, with World War I marking the transition from old to new values. Paring the elements down and getting to the essentials was a theme consumers were becoming accustomed to. Speed was paramount, as was newness and cleanliness.

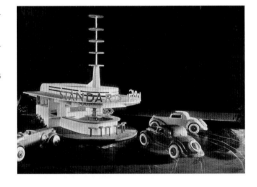

By the '30s, most aspects of everyday living were touched by streamlining. Teapots, airplanes, radios, and automobiles were being aerodynamically tuned. Buildings also adopted these symbols of efficiency and economics of line. The drive-in restaurant was a prime candidate for streamlining and had been incorporating many of its aspects even before the style and ideal became widespread in popular American culture.

Los Angeles, with its wealth of innovative architects and open-minded clients, again led the way in automobile-

Top. *A combination juice stand and drive-in promised quick stops and casual meals with eye-catching appeal.* Bottom. *A model for a proposed drive-in reflects the influence of streamlining in the early '30s.*

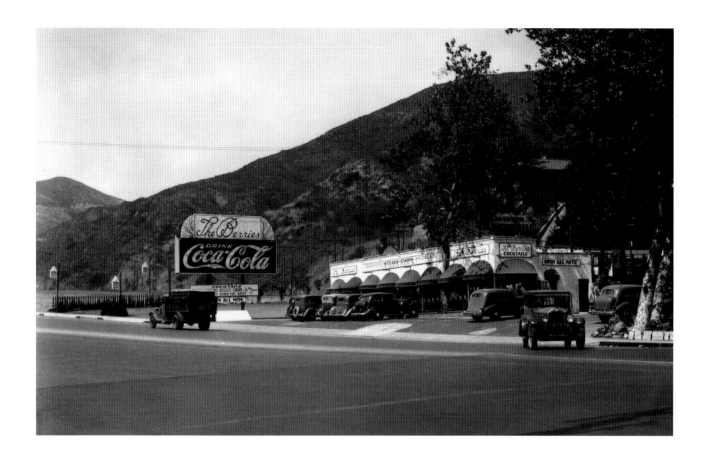

oriented architecture. Their understanding of the region's mobility and horizontal landscape allowed such name architects as Rudolph Schindler, Richard Neutra, and Lloyd Wright to be stylistically inventive. Their influence on commercial buildings was eventually expressed in the drive-in restaurant through the hands of relatively unknown commercial architects operating throughout Southern California. Douglas Honnold, Harry Werner, and Wayne McAllister were among the outstanding designers of drive-ins. Their ties to the film community brought a variety of commissions that resulted in store, nightclub, and restaurant designs.

The bridge to drive-in design was a short one and soon these and other architects were creating the blueprint for hundreds of drive-ins. Wayne McAllister typifies this group of commercial architects working in Los Angeles in the '30s. His informal architectural education in San Diego culminated with an elaborate commission to design the casino and resort of Agua Caliente in nearby Tijuana. After he moved to Los Angeles, McAllister tallied up an impressive array of jobs in which he adapted both historic references, primarily Spanish colonial revival, and modern design. When asked to build a drive-in for the Simons organization on Wilshire Boulevard in 1935 (a departure from their lunch counters in downtown Los Angeles), McAllister included many of the basic drive-in elements, but he packaged them in a stylish, complete unit. His circular design was the logical step in trimming the hard-edged octagon.

Located in the Cahuenga Pass, a stone's throw from the Hollywood Bowl, the It's the Berries Drive-In had a fruitful business for several years, until it was demolished for a road-widening project.

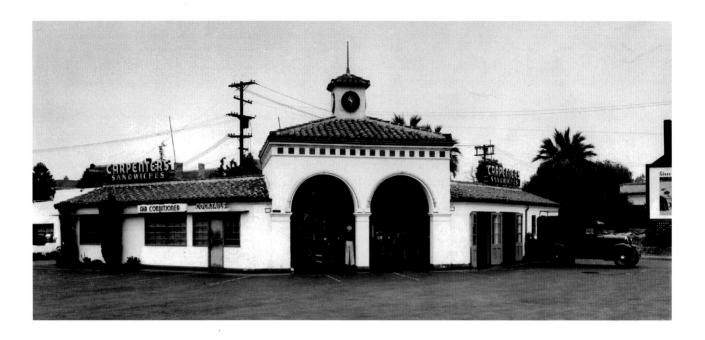

The evolution of this widely copied style was visible in his work for another chain, Roberts Brothers. The Roberts drive-in at the southwest corner of Wilshire Boulevard and Vermont Avenue (opposite Carpenter's drive-in) retained vestiges of the octagon, but included the addition of a short overhang canopy that introduced a circular element and offset the familiar octagon. A large rectangular neon sign supported a simple open-girded tower that capped the building. A second unit at the well-traveled intersection of Pico Boulevard and Western Avenue (opposite the first California Pig Stand) was a remodel of the Roberts Brothers' first building at that location. It remained faithful to the octagon-circle shape, but replacing the simple signage was a stacked Art Deco tower with vertical neon lettering spelling out "Sandwiches" on one face and "Roberts Brothers" on another. Added to the circular canopy were three-dimensional back-lit letter forms announcing menu items. By the time the Roberts Brothers outlet at the corner of Pico and Sepulveda Boulevards was constructed, McAllister had in place all the classic elements of the circular '30s drive-in. The canopy overhang now extended eighteen feet beyond the building to cover car and server. A stark vertical column served as an advertising pylon with the word "Roberts" stacked in glowing neon.

The circular style overshadowed other drive-in designs in and around California because it was functional and easy to see; however, a wide range of other building styles were also used to establish different identities. The popular Spanish colonial revival, found in every manner of public and private architecture in the region, was applied to numerous drive-ins, including the Carpenter's at Wilshire and Vermont, McDonnell's at Fairfax and Wilshire, and Carl's at Flower and Figueroa. Historical revivalism was played out at the Carl's Viewpark at Crenshaw Boulevard and Vernon Avenue, where

The widely used Spanish Colonial style was a popular image for California drive-ins, including this Carpenter's Drive-In at the corner of Wilshire Boulevard and Vermont Avenue in Los Angeles. In addition to car service, a dining room and counter offered other eating options. Opposite page. The evolution of these three Roberts Brothers drive-ins illustrates the rapid change of styles during the '30s. To a plain octagonal structure topped with a girded tower, a mid-'30s Roberts added stacked Art Deco towers accentuating the advertising pylon. By the end of the decade, a minimalist building featured an extended circular overhang and abbreviated neon signage suspended from a vertical pole.

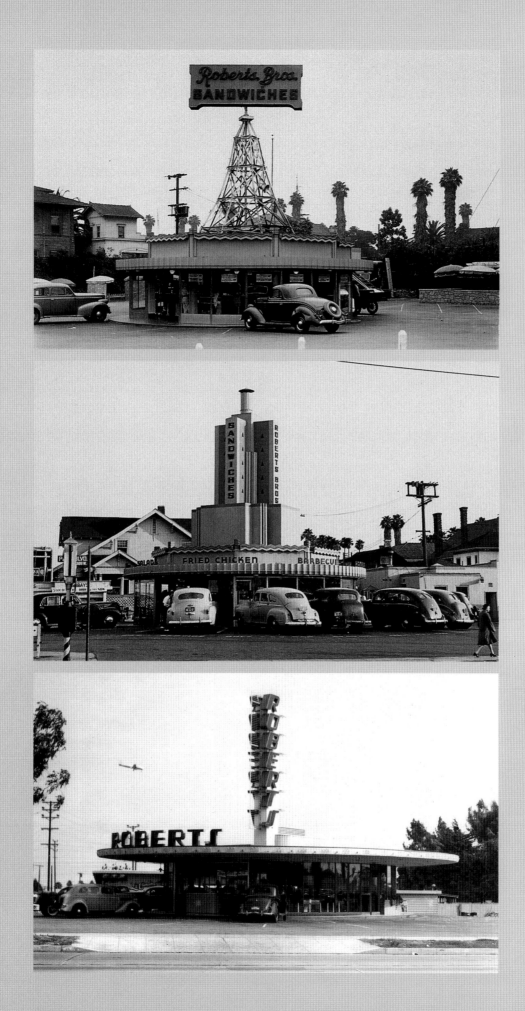

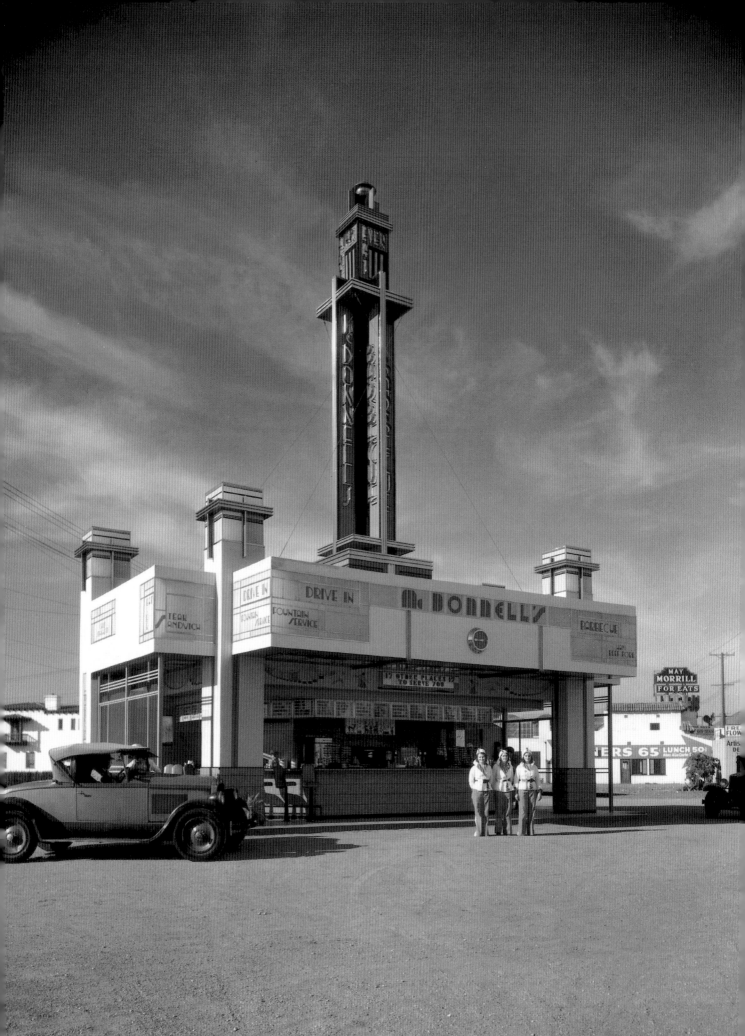

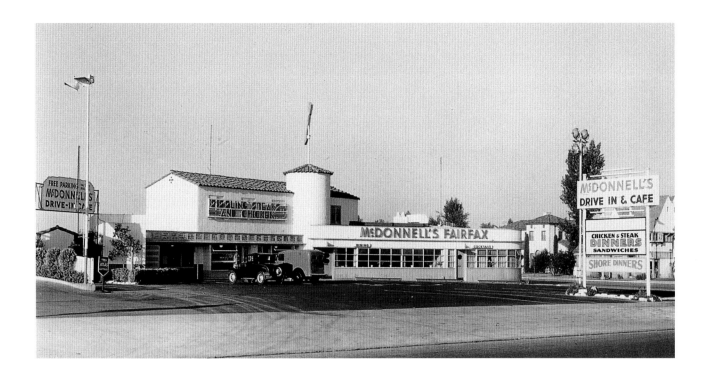

a neoclassical structure reminiscent of Mount Vernon was built. On the Sunset Strip, the Colonial Drive-In also used the early-American look to convey respectability and cleanliness. In San Diego, Glenn's Drive-In hinted at something vaguely European, but its massive roof, tongue-and-groove siding, and crazy-quilt shingles defied cataloguing.

The 1931 McDonnell's angled at the northwest corner of La Brea Avenue and Beverly Boulevard anticipated the

architecture of Chicago's Century of Progress Exposition by several years. Architect Frank Schaefer's minimalist box was supported by four square columns raised above the roofline and had signage that was back-lit and flush with the wall surface—a subdued treatment compared to other drive-ins of the time. A cruciform pylon complete with a beacon heralded motorists traveling down the crossroads, sending the message that here was an eating place that was clean, quick, and up-to-the-minute. It was a machine-age building with a dose of street theater. Unique among drive-ins of its period, McDonnell's had Modernist leanings that were evocative of Richard Neutra's office building and

restaurant, built the same year for Universal Pictures head Carl Laemmle, at the intersection of Hollywood and Vine. This modernist link was an important influence for architects working in Los Angeles, for it allowed them to view and informally exchange the new ideas sweeping the region.

Throughout the '30s, the "modern" look was the style of choice for most owners because it spoke a direct language that informed customers these drive-in establishments were new and fresh in all aspects. The hybridization of styles by

Opposite page. *The McDonnell's Drive-In (on the northwest corner of Beverly Boulevard and La Brea Avenue in Los Angeles) realized Modernist influences in a striking building.* Above. *Styles collide as Streamline meets Spanish style at the McDonnell's Drive-In on the southeast corner of Wilshire Boulevard and Fairfax Avenue.*

local commercial architects and contractors created additional variations of the modern style, and it was not uncommon to find a drive-in sporting a tile roof, curved corners, portholes, and an Art Deco tower.

The influence of these California-designed drive-ins was far-reaching. Contender to the title of most drive-ins was Texas, where curb service was born. There, building design tended to follow similar stylistic patterns: square or rectangle followed by octagon and circle embellished with Art Deco, Streamline Moderne and Modern elements. Other influences were also evident, such as regionalism and historical revival, with hybrids and the occasional novelty completing the mix. While there is no doubt that other regions of the United States were exposed to and sought out these influences and integrated them into their businesses, California and Texas, with their built-in advantages of climate, clients, and land, dominated drive-in design.

Once Prohibition ended, the drive-in trade added alcohol to the items they were serving. In an effort to avoid the negative association of a saloon or bar, and because they were anxious to distance the drinking trade from family cars, owners began to add separate cocktail lounges where customers could eat and imbibe. Some drive-ins modified existing space to include a lounge, while others designed compact bars that were intergrated into the restaurant's overall plan. Another option, if space allowed, was to construct a building away from the main restaurant. Owners were careful to call these spots cocktail lounges in order to draw the appropriate clientele. The creation of these rooms was further proof of the drive-in's increasing respectability and underscores the drive-in's transformation from the humble hamburger stand of old. The fact that cocktail lounges also generated healthy revenues was an incentive to open them and the trend blossomed throughout the '30s and into subsequent decades.

The Roberts Brothers' Wilshire Boulevard location illustrated the free-standing cocktail lounge at the back of the drive-in lot. It housed two mahogany bars that were fitted with stools upholstered in padded ivory leather. Overhead was a modernistic shield that followed the contours of the bar top. Adjoining the building was a patio with sun umbrellas and serving tables enclosed by a stone wall, projecting a smart look that undoubtedly was appreciated by shoppers of the neighboring Saks Fifth Avenue and Bullocks department stores.

Other Los Angeles drive-ups sported similar lounges with names like the Top Deck, the Victory Room, La Cantina, the Starlite Room, and the Rhumba Room. The extent to which stylistic flourish could be taken was made evident in a trade magazine description of the colonial-themed Carl's Viewpark, a combination dining room, bar, and car service. Located in Los Angeles's tony Leimert Park development, the bar "…which is located in the second story of the great bayed wing is circular in form and built of California Walnut. The glass for the curved windows was brought in from the

Opposite page. By the 1930s, drive-ins were no longer an isolated novelty but could be found throughout the United States. Though they appeared in a variety of shapes and sizes, they all sought the automobile eating trade. Clockwise from top right. Garland's Drive-In, Oklahoma City. Royal Cafe and Drive-In, Del Rio, Texas. Martin Brothers, New Orleans, Louisiana. Towers Cafe, Texarkana, Arkansas. The Tower Drive-In, Charleston, South Carolina. Phillips Drive-In, Hot Springs National Park, Arkansas. Dixie Drive-In, Tucson, Arizona. Katsons, Route 66, Albuquerque, New Mexico.

38

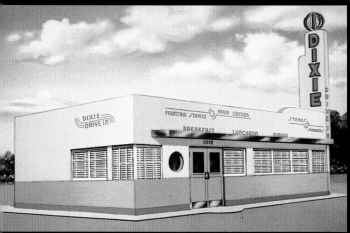

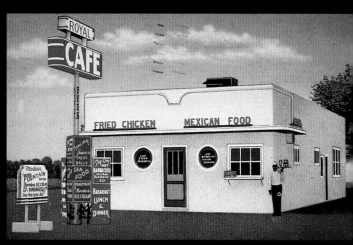

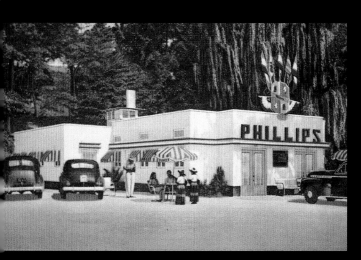

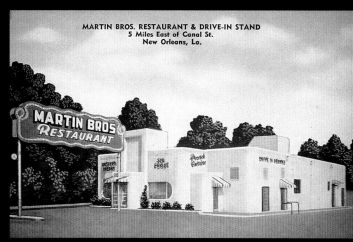

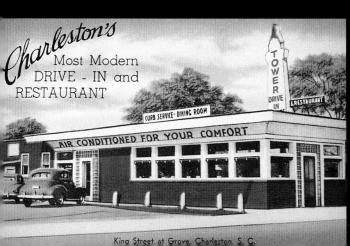

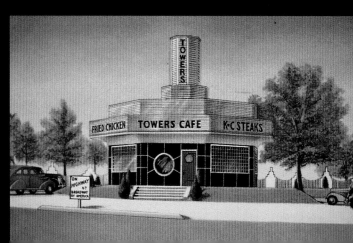

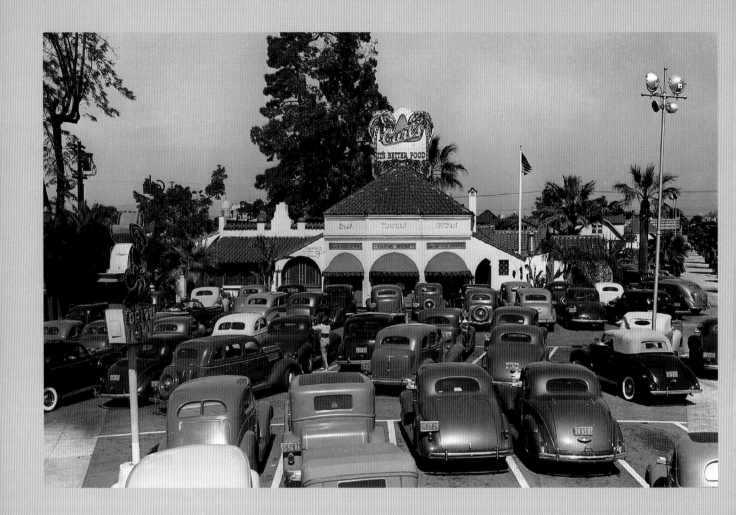

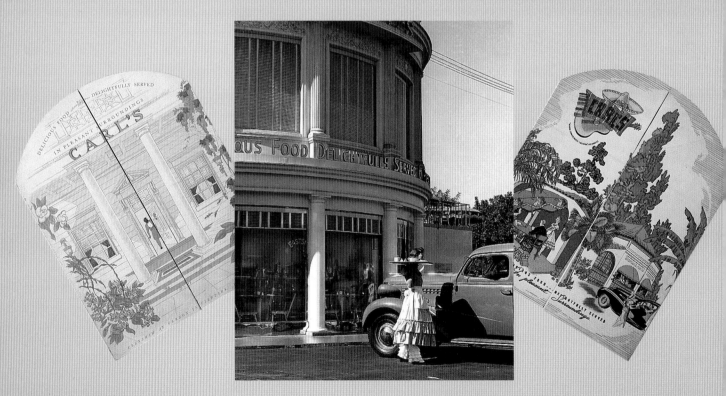

Top. Adjacent to the USC campus, Carl's Drive-In, "Where Flower Meets Figueroa," was jammed for several decades with collegians who made it their eating headquarters.
Bottom. Inspired by its location at Vernon Avenue and Crenshaw Boulevard, Carl's Viewpark in Los Angeles used the imagery of the old South and Mount Vernon to create a grand dining experience.

 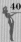

East. Tiny wood rimmed tables for two stand at each window. The outer face of the bar is upholstered with leather and cross-patterned with large brass rails. Walls not taken up by the high windows carry murals of plantation scenes with banjo players and negro cabins; old Mississippi steamers; followers of the hounds, and, of course, the typical Colonel being served his matutinal mint julep. The waxed circular burst of floor covering is in green, black, terra cotta and white."

At another unit of their chain, Carl's Sea and Air Cafe in Santa Monica, the buffet dining room was combined with the cocktail lounge and was described as "…being in the moderne architectural style— as new and interesting as tomorrow's newspaper." Located on the second floor of the building, the cocktail lounge "…commanded a fine sweep of beach and ocean through its broad windows. The nautical motif is preserved and around the walls are interesting framed lithographs of old whaling boats, clippers, etc. The booths, seats, and chairs are of matched brown leather, giving a feeling of trimness similar to a ship's dining salon. The bartenders wear commander's uniforms."

Top. *Carl's Sea and Air Cafe, on the Roosevelt Highway just north of Santa Monica, California, combined its curb service with indoor dining, a motel, and a gas station, creating a mini–beach resort.* Bottom. *The colorful interior of the cocktail lounge of Carl's Viewpark Drive-In.*

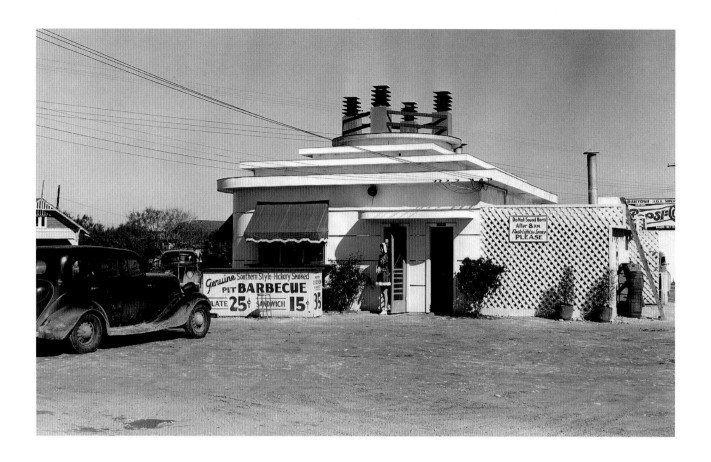

The Melody Lane Drive-In, at the corner of Wilshire Boulevard and Western Avenue, had a cocktail lounge called the Starlite Room, and owner Sidney Hoedemaker spent a year researching its "…starry constellation and signs of the Zodiac theme." His research included hiring Astronomical Society member and Griffith Observatory employee Archie M. Newton to create "the zodiacal decorative effects in the swanky bar."

The issue of parking was also formalized in this decade. The drive-in and park-where-you-wish practice had never been questioned before—this informal parking arrangement seemed to work just fine and was in keeping with the concept of casual dining. From the '20s through to the mid-'30s, dirt or gravel was the common lot surface and worked well as long as the sun was shining. Rain or snow could reduce a drive-in to a muddy patch. But by 1935, just as buildings had received detailed attention, the surrounding lot also came under similiar scrutiny. The desire to establish some sense of order resulted in paving the lots and marking specific spaces in which cars could park. Also considered were landscaping and patterns of traffic flow. With space sometimes at a premium during peak hours, customers were allowed to revert back to double and even triple parking. Sometimes this required drivers to do a great deal of maneuvering, but the situation was usually worked out with an unwritten courtesy code honored by most customers.

With many design issues resolved by the late '30s, the drive-in entered its peak years. Several Los Angeles drive-ins

Above. Clad in a fur-trimmed uniform, a Corpus Christi car hop awaits customers from a drive-in seemingly inspired by a massive generator. Opposite. Located near early Hollywood studios, the Tam O'Shanter was a favorite dining spot in the '30s for celebrities including Walt Disney, shown lunching at his favorite table.

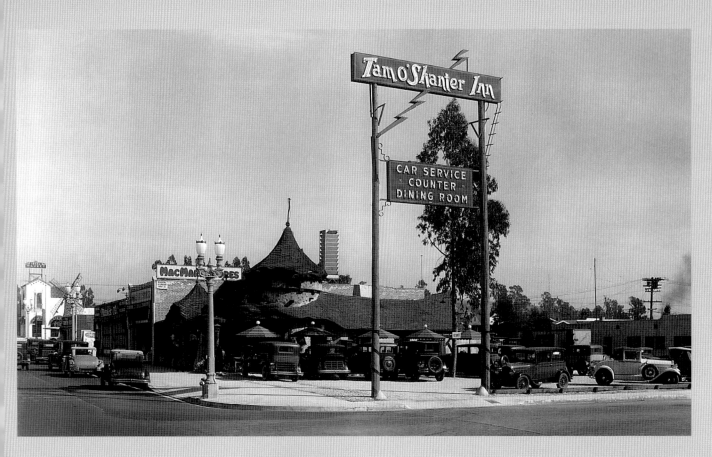

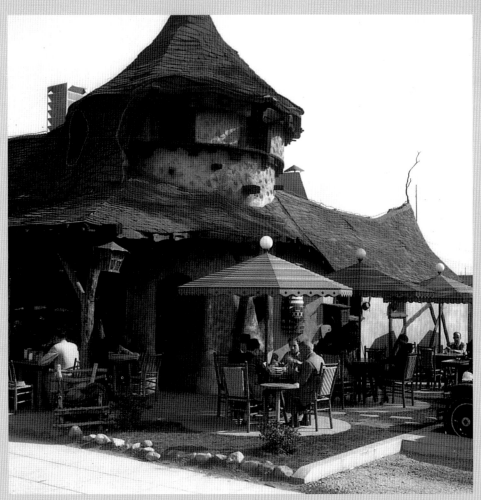

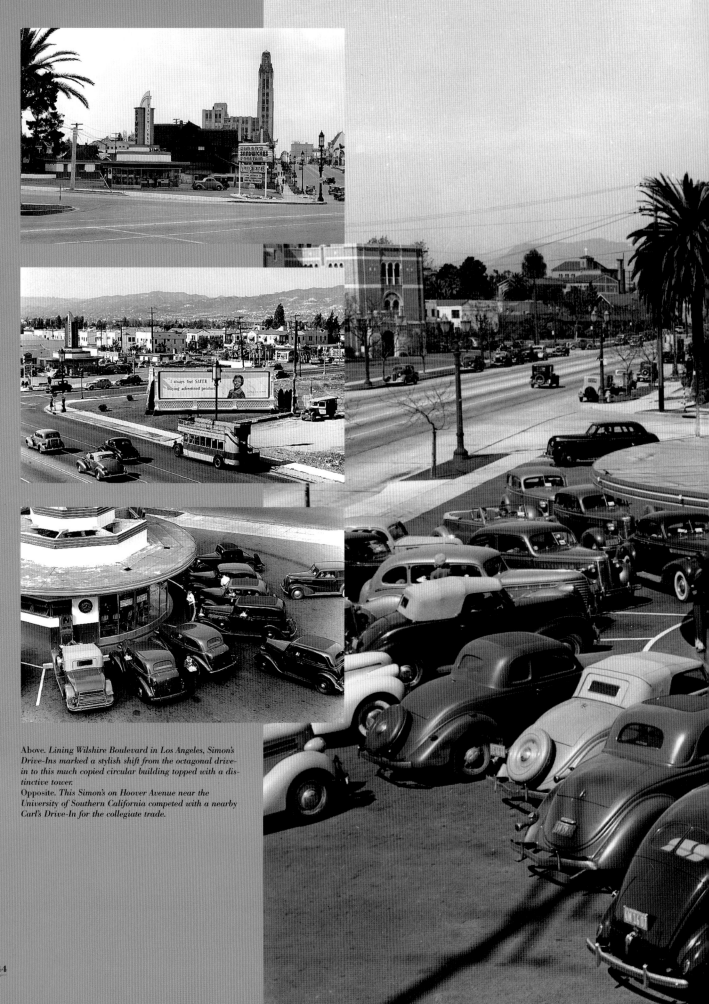

Above. *Lining Wilshire Boulevard in Los Angeles, Simon's Drive-Ins marked a stylish shift from the octagonal drive-in to this much copied circular building topped with a distinctive tower.*
Opposite. *This Simon's on Hoover Avenue near the University of Southern California competed with a nearby Carl's Drive-In for the collegiate trade.*

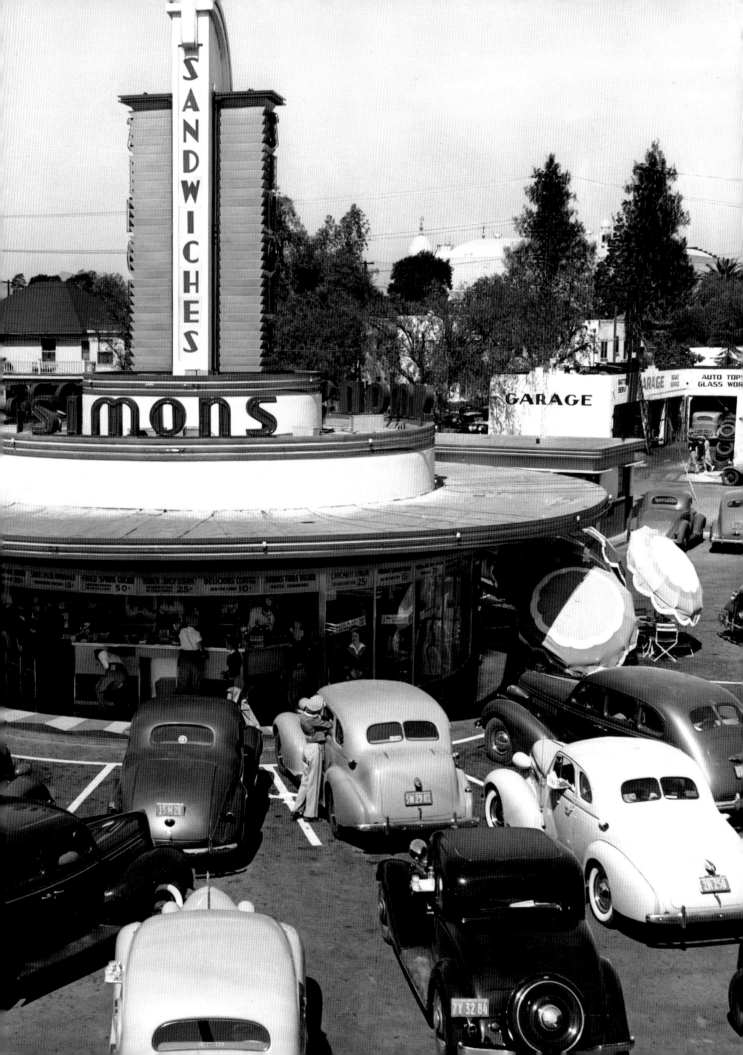

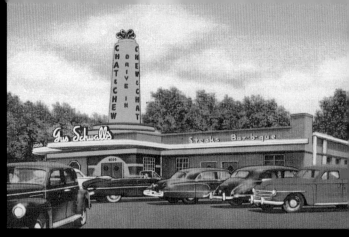

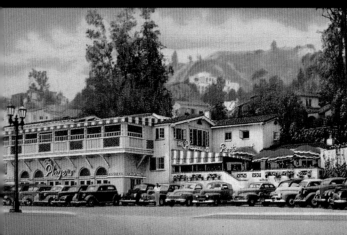

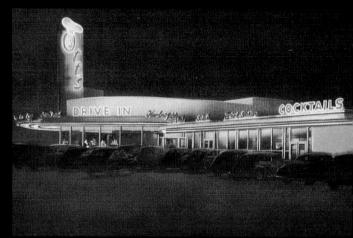

Wagners' Drive-Inn Grill, Daytona Beach, Florida

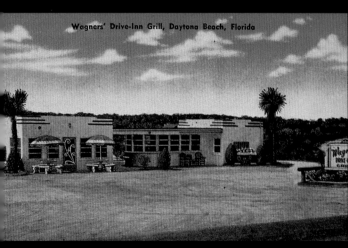

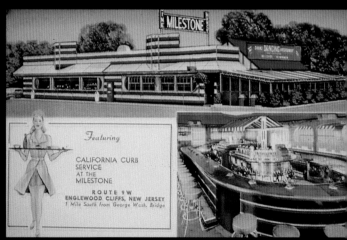

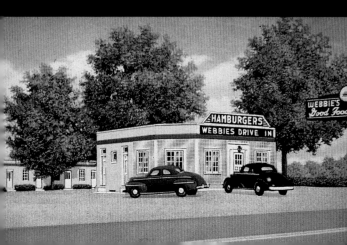

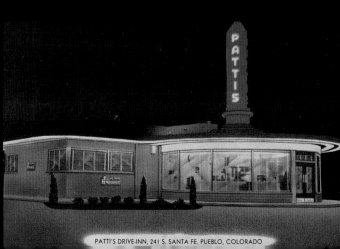

PATTI'S DRIVE-INN, 241 S. SANTA FE, PUEBLO, COLORADO

epitomized this high point of drive-in style and their description in trade journals reveals how serious the commitment to and investment in feeding people in their cars had grown: "The Roberts establishment is located on Sunset Boulevard between Cahuenga and Ivar and has a three-way front to make the place easily accessible to the traffic in this busy section of Hollywood. The building is of modern design, glass enclosed and with an overhanging roof. There are twelve comfortable booths inside, and twenty-six seats at the semi-circular counter. Besides the main building, there is a picturesque dining patio with cleverly covered, individually-styled cabanas providing fourteen tables to accommodate a total of 56 patrons. An outstanding feature is the novel cocktail bar designed to resemble the top deck of a pleasure yacht, and aptly called 'The Top Deck.' Daylight neon lighting has been installed above the canvas ceiling to create an unusual effect in this clubby bar, which is built to accommodate approximately forty people. The exterior of the structure is lighted with fluorescent neon, which creates a spectacular appearance. The new establishment, representing a $65,000 investment, was built by Noel M. Calhoun and designed by Wayne McAllister, whose work includes a number of outstanding drive-ins throughout Southern California."

These snazzy drive-ins became so popular that they were expanded to include dining rooms, counter service (which was being called a coffee shop), cocktail lounges, and banquet rooms. The Carl's chain pioneered this tiered service, beginning in 1931 at their original location, "Where Flower Meets Figueroa." Their 1938 restaurant, Carl's Sea and Air Cafe, on the Roosevelt Highway one mile north of Santa Monica, added a motel and gas station for a complete resort-like complex. It was described in Western Restaurant magazine as "a glorified drive-in restaurant facing one of the finest beaches in Southern California, combined with a modern, beautifully furnished roadside hotel where rates permit spending a pleasant and reasonable vacation. Being a seaside spot it is only natural that the exceptionally attractive waitresses carry out the nautical theme with colorful French sailor uniforms. Waitresses in the dining room wear blue and white middy uniforms and bus boys are fitted with ensign's coats. In addition to the usual drive-in menu, items peculiar to the beach are featured, such as fish and chips, shrimp, crab and scallop cocktails. The roadside hostelry consists of twelve completely furnished bungalow apartments. The furnishings are modern and attractive, all rooms are carpeted and each room has broad windows affording an excellent ocean view. Each apartment is provided with an outdoor terrace. The catering operations are open from 9 am until 2 am. A badminton court is available for guests, sea bathing is very popular, and during pleasant afternoons the outdoor terrace is used for card parties and games. When completed Carl's Sea and Air Cafe will cost in excess of $175,000."

Beyond Southern California, drive-in activity spread at a slower, albeit consistent pace. Wherever urban sprawl was

Clockwise from right. *Chat & Chew, Denver, CO; Ott's, San Francisco, CA; Milestone Drive-In, Englewood, NJ; Patti's Drive-Inn, Pueblo, CO; Webbies Drive-In, Cincinnati, OH; Wagner's Drive-In Grill, Daytona Beach, FL; Players Drive-In and Restaurant, Hollywood, CA; Allen's Pilot Drive-In, Salt Lake City, UT.*

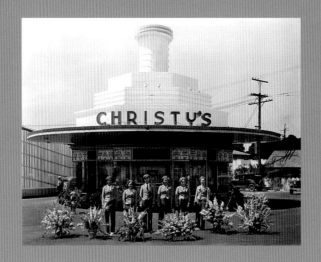

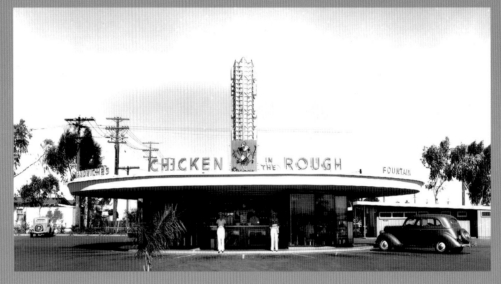

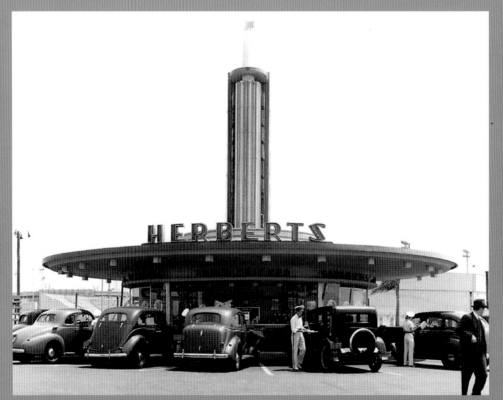

present, drive-ins prospered. The Bay Area surrounding San Francisco was fertile ground for drive-ups, as were the Portland and the Seattle/Tacoma areas. In Texas, the Pig Stands continued their growth in both company-owned and franchised outlets, spreading to Louisiana, Mississippi, Florida, Oklahoma, Arkansas, and Alabama. In Houston, Prince's (founded in 1927 as a hamburger stand by Doug Prince) and rival Sivils, founded in 1938, were joined by Earl Abel's and Christies in San Antonio, as well as hundreds of independent drive-ins throughout the state.

In Oklahoma City, Mr. Beverly Osborne created a nationally popular menu item. Opening a drive-in in 1936, fifteen years after he opened his six stool waffle shop, he introduced to his menu "Chicken in the Rough." The inspiration for this wildly popular drive-in special supposedly came while Mr. Osborne and the missus were on their way to California to scout ideas for their new drive-in. The couple stopped at a roadside stand and bought some fried chicken to go. Once they were back on the highway they opened the box only to discover that there were no utensils. Proceeding to eat it with their fingers, Mrs. Osborne proclaimed, "This is chicken in the rough." Back from their vacation, Osborne remembered this tasty dish and having tried a similar meal at Topsy's Roost in San Francisco, decided to 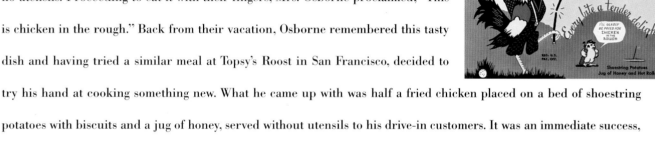 try his hand at cooking something new. What he came up with was half a fried chicken placed on a bed of shoestring potatoes with biscuits and a jug of honey, served without utensils to his drive-in customers. It was an immediate success, so Osborne copyrighted the idea and sold franchises in more than thirty-four states, complete with a trademarked chicken nattily dressed in golfing togs with a golf ball in the rough.

On the East Coast, a good part of the informal food service business was held by diners, though the Hot Shoppes founded by J. Willard Marriot commanded a hefty chunk of that region's drive-in trade. With twenty drive-ins spread from Washington, D.C., to Philadelphia and from Chicago to Georgia and into Florida, the Hot Shoppes were a well-recognized food venue. Competing with the Howard Johnson chain (which had no drive-in service) for the family trade was tough nonetheless—the Hojo chain had 125 outlets by 1940.

In Georgia, the Varsity, opened in 1928 by Frank Gordy, was an established Atlanta landmark at 55 North Avenue. Made popular in part by its proximity to Georgia Tech, car service was exclusively male. Because of the heavy traffic volume, Gordy initiated a car identity system by placing a number on each windshield as a car entered the lot so car hops could keep track of their customers. This idea spread to other drive-ins.

White Towers and White Castles were spread out over the Midwest and East Coast and competed for the same, primarily urban, customer. In the '30s they added car service at suburban intersections with quick, clean, and consistent

Opposite. Considered to be the classic drive-in design, various circular drive-ins dotted Southern California. Pictured are: Top. Christy's at the intersection of Crenshaw Boulevard and Western Avenue. Middle. Keith's Drive-In on 5th Avenue in San Diego. Bottom. Herbert's on the southeast corner of Beverly Boulevard and Fairfax Avenue in Los Angeles.

49

quality meals, setting the stage for fast food operations nationwide a couple of decades later. Their drive-in buildings

were gleaming textbook streamline complimenting the sun-belt's circular architecture.

The centerpiece of every '30s drive-in menu was the hamburger and it was constantly being modified to offer that

unique something special. One Southern Californian was doing just that in 1926 and reportedly created the cheese-

burger. As recounted in the 1937 food industry journal Pacific Coast Record, eighteen year-old Lionel Sternberger, a

Glendale resident, traded his vintage Jordan automobile for the Hinky Dink Barbecue Stand at the top of the Colorado

Boulevard hill leading into neighboring Pasadena. Changing its name to the Boulevard Stop, Sternberger started exper-

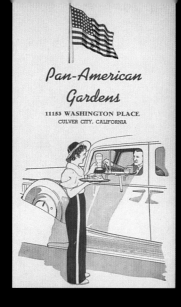

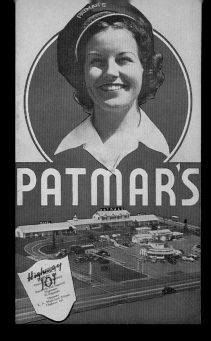

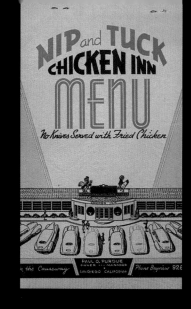

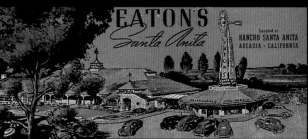

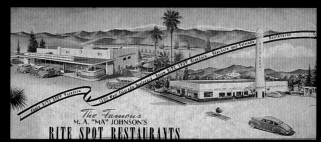

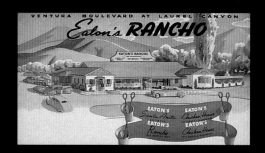

imenting with the sole item he served: the hamburger. Knowing he needed to come up with something catchy and new

if he wanted to compete with other hamburger joints, he added sauces, relish, and lettuce and crowned his burger with

cheese, christening it the "Aristocratic Hamburger with Cheese." It proved to be the trick that brought customers in, and

the Boulevard Stop got to be known as the right spot to get almost a complete meal at a very low cost. At his friend's

urging, Sternberger changed the name again, this time to the Famous Rite Spot, and promptly opened a second Spot in

1928 and then a third in 1929, which became a drive-in. The first location added car service in the mid-'30s and claimed

to serve three hundred cars.

Another Glendale boy also would lay claim to culinary legend a few years later. Bob Wian started his career working in his high school cafeteria. Straight out of school, in 1933, he started washing dishes at a small Los Angeles hamburger chain called The White Log Tavern. He became manager at age nineteen but moved on to a local teen hangout, the Night Owl, becoming its fry cook. When he learned a neighbor's six-stool lunch stand was for sale, he sold his car for $350 and purchased the place at 831 East Colorado Boulevard for $300. He added four more stools and hired the sign painter across the street to create a sign that read "Bob's Pantry." A local six-year-old named Richard Woodruff, who happened to weigh a robust ninety pounds, began hanging around the stand. So Wian gave the child miscellaneous chores to do, paying him with ice cream or a burger and nicknamed him "Big Boy." Friends of Wian's who were in the Chuck Foster Band used to stop in regularly after their engagements at the Biltmore Hotel in downtown Los Angeles. One night in 1938, band member Harry Lewis said to Wian, "Hamburgers! Don't you have anything different?" So Wian proceeded to cut a sesame bun into three slices, added two hamburger patties, cheese, lettuce, mayonnaise, and a special relish and handed it to him. Soon everybody wanted this special.

Another of Wian's regular customers was a high school chum named Benny Woshem. Woshem, an animation artist at Warner Brothers in Burbank, sketched the familiar barefoot kid in checkerboard pants with suspenders, who was always chomping a burger. The Big Boy became Wian's trademark and Bob's Big Boy hamburger went on to be a much-copied hit.

By the end of the '30s, it was obvious the drive-in restaurant was an institution enjoyed by a sizable number of Americans who preferred their food on the go. The mainstream press had validated the drive-in as more than just a passing fancy. The *New York Times* pointed out its seriousness in an article that stated, "There are more than 200 of these places in and around Los Angeles and they represent an investment of something over $2,000,000. It is conservatively estimated that about 100,000 Angelenos dine each day at these sit-and-sup establishments."

The drive-in enjoyed a few more years of unbridled activity but as another decade was about to begin, the specter of war loomed over the horizon—an event that would change the nation and the restaurants that served it.

Opposite. *At night, neon transformed drive-ins into glowing landmarks.* Top. *This Simon's at Wilshire Boulevard and Fairfax Avenue in Los Angeles seems to levitate, as glass panels make walls invisible.* Middle left. *Roberts Brothers Drive-In at Victory and Olive Boulevards in Burbank.* Middle right. *The jutting signage of the Goody-Goody Drive-In in Los Angeles was a forerunner of Googie style, which would appear in force in the second half of the '40s.* Bottom. *Van de Kamps Twin Drive-Ins at the intersection of Fletcher Drive and San Fernando Road in Los Angeles.*

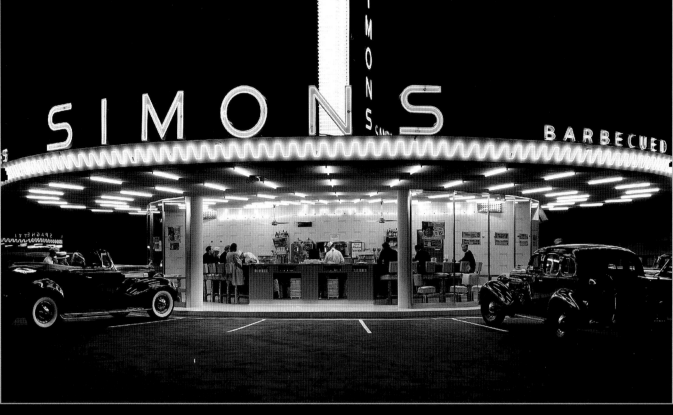

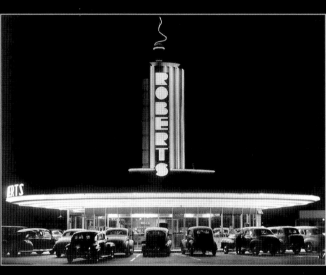

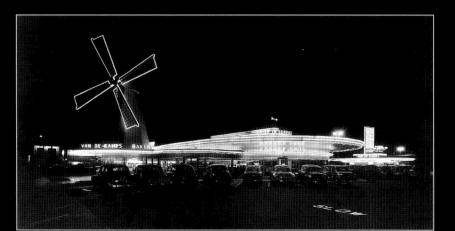

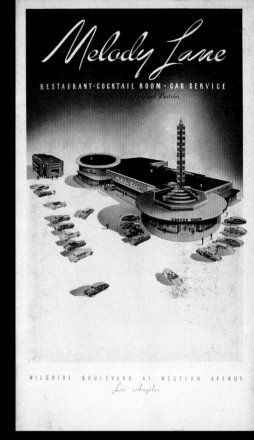
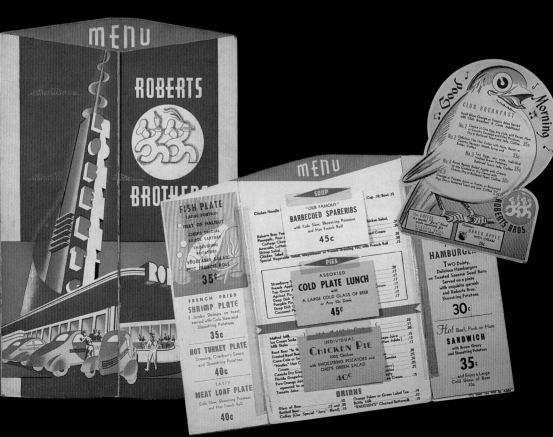

ST. CLAIR'S
Circle

NEW ORLEANS FRIED CHICKEN

LAKEWOOD BLVD. and STATE ST.
LONG BEACH, CALIF.

menu

BUSCH'S

Northwest's Outstanding Drive in

38TH and SO. TACOMA WAY
HIWAY 99

It's TOPS
FOR DELICIOUS FOOD

BREAKFAST MENU

THE PARK

CHICKEN BREAKFAST

THE
PARK
DRIVE-IN

5823 PACIFIC BOULEVARD
HUNTINGTON PARK

FAT BOY

SALADS CHICKEN FOUNTAIN SANDWICHES

FatBoy
DRIVE IN
SERVICE IN YOUR CAR
Redwood City
EL CAMINO REAL
U.S. 101

4508 WEST SLAUSON

WICH STAND
DRIVE-INS

DRIVE IN

WICH STAND

ZEP
COCKTAIL
LOUNGE

7111 SOUTH FIGUEROA

Glamburger Girls, Belles of the Boulevard, Car Hoppers, Hops, Tray Girls, Curb Hoppers, Car Hostesses, Curb Operators—they were the oil that kept the drive-in machine running smoothly. The car hop was the central figure of the drive-in world, playing an essential role in the mobile meal business.

CAR HOPS

The first servers to the curb were at Harold Fortune's Memphis drugstore, where gentlemen customers were allowed to take fountain items to their ladies waiting in carriages. As this serving option became popular, runners were employed to perform this job. True car service was initiated with the Dallas Pig Stands in 1921, when their male servers performed the chore of carrying food on trays to customers. Clad in traditional waiter's garb of white shirt, bow tie, black pants, ankle-length apron, and white cap (all to emphasize cleanliness), they claimed their customer by hopping on the car's running board as it drove up to the barbecue stand—hence the name car hop.

Initially, in the '20s, car hops were primarily male, mirroring the restaurant industry's standard employment practice. This was the case of the Sacramento-based A&W chain, which employed men to serve trays laden with frosty mugs of root beer and food to their customers. A&W called these employees tray boys. An exception to the all-male

Opposite. *Decked out in sombrero and Mexican uniform, a snappy car hop at Carl's Drive-In delivers a meal.*

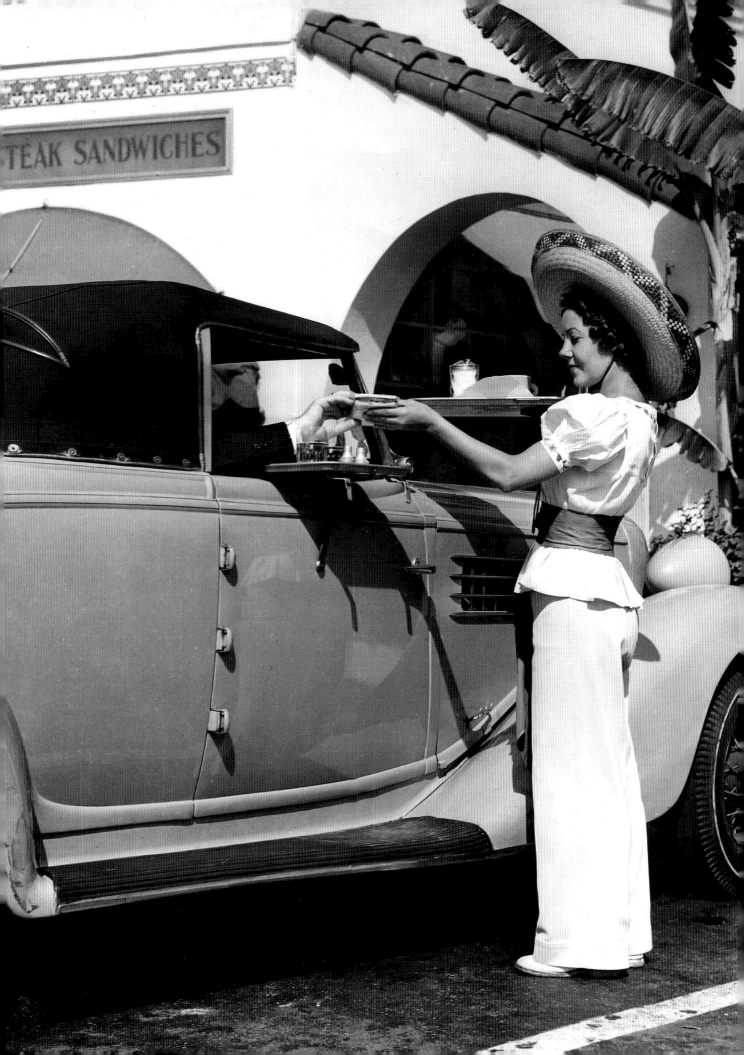

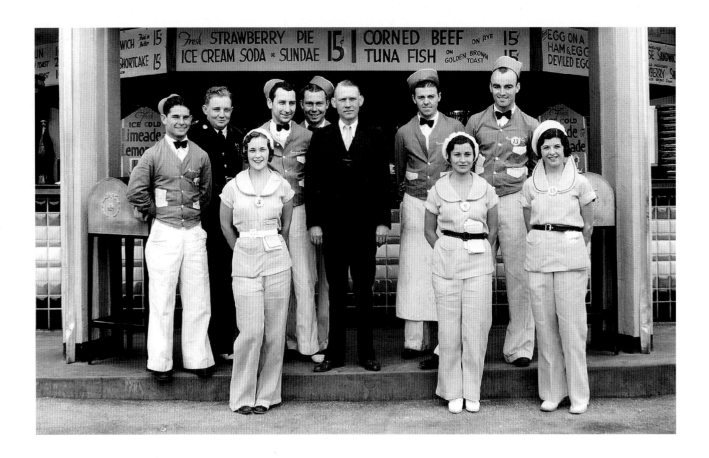

norm was at the Tam O'Shanter, where women had been servers since the restaurant had opened in 1922. In an effort to reinforce the restaurant's Scottish image, in 1923 Henrietta Frank, the wife of one of the owners, and her sister-in-law, Marion, designed "jaunty plaid costumes to transform the waitresses into Scottish lassies." This relationship between the server's uniform and the atmosphere of the restaurant wasn't a first, but it led to the practice of costuming car hops to emphasize their appeal and differentiate them from their competitors. The use of one-of-a-kind costumes would soon be mandatory for all drive-ins. Once women were introduced to the car hop trade, as they were at the A&Ws where they became tray girls, an increase in profits was immediately noticed. Women soon took over the field and a smiling, feminine face became the drive-in's preeminent icon.

By 1930, with drive-ins secure in their cultural niche, car hops began their ascent as an American institution. California's dominance in the drive-in field, combined with the associative power of Hollywood and the press that car hops generated, catapulted their image to glamour status. Tourists brought home tales of eating at novel "carfeterias" in the bright Los Angeles sun and of the charming girls who served them, "a square meal in a round bun." Writers noticed car hops too, and one early 1930s account of a Carpenter's car hop at the Hollywood intersection of Sunset and Vine illustrates the charismatic appeal of being a Hollywood hop. "One of the most famous car hoppers in town is Wally

Above. Drive-in owner Harry Carpenter poses with some of the members of his drive-in staff in front of his Hollywood restaurant at Sunset and Vine. Opposite top. Weber's, an early drive-up in Texas, featured female car hops in traditional waitress garb. Middle left. The almost all-male crew of a Texas Pig Stand poses in front of one of the chain's pagoda-like buildings. Middle right. The crew of the Hollywood Pig Stand posed ready to serve. Bottom. Hollywood car hops at It's the Berries Drive-In model California casual uniforms.

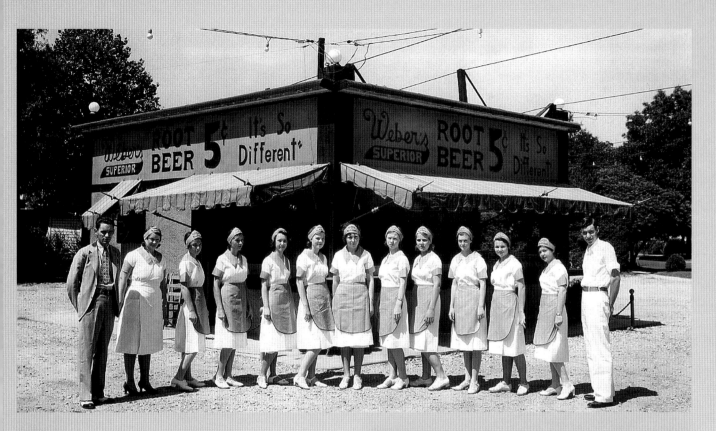

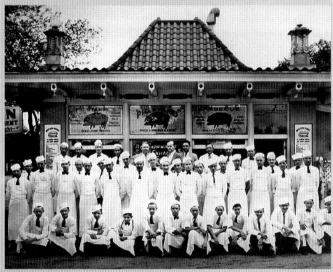

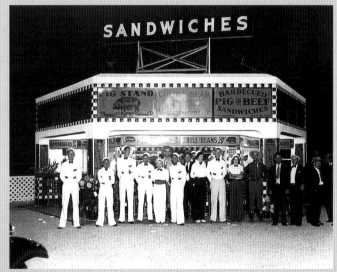

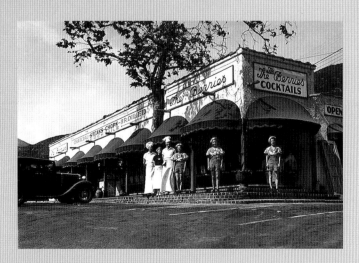

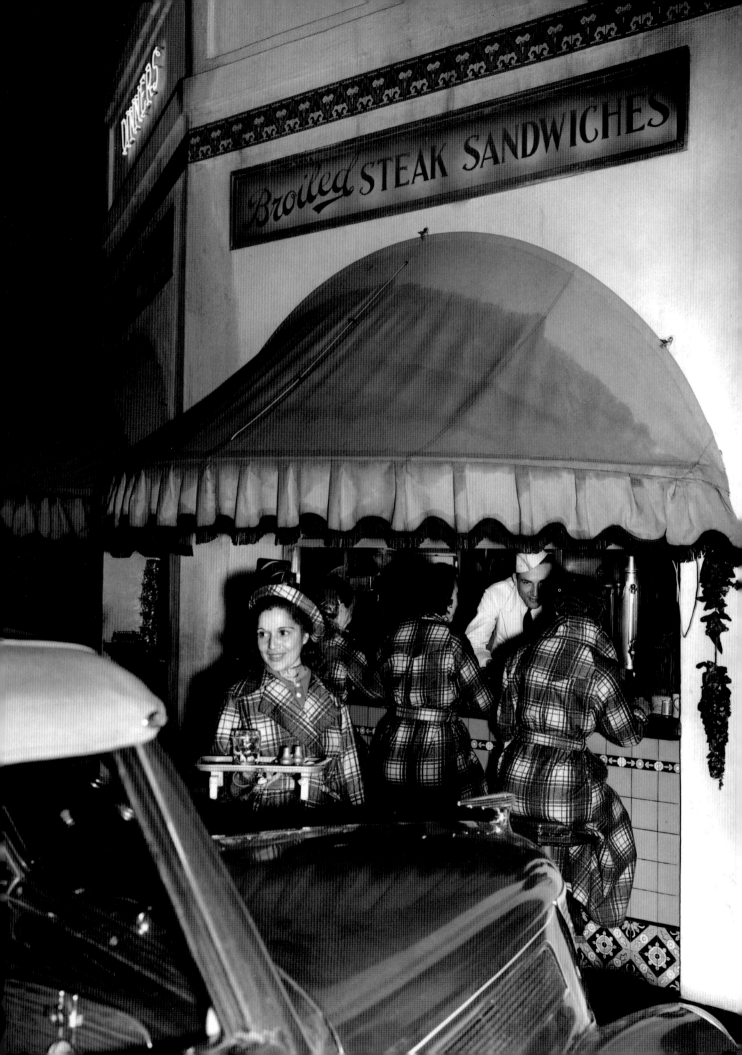

Hardy, young, good-looking and extremely popular with the world's film heroes and heroines. One of the first stars she met was Jean Harlow. 'I hadn't been a car hop long and so far I hadn't met anyone important. So you can imagine how

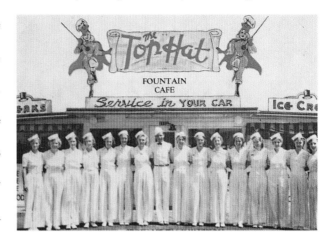

thrilled I was when she drove up. She came in a big, white coupe and I recognized her instantly. She wore a white sports outfit, and I thought she was the most beautiful girl I had ever seen. Her hair—well there isn't anything like it in the world. She ordered a small glass of orange juice, and when I brought it I was so shy I couldn't say anything. She must have thought me awfully rude. When I returned to get the tray she insisted I take a tip. A big one, too. Forty cents. Harlow's not stingy.'"

Wally's favorites also included George Raft, who "looks just like Fifth Avenue… his teeth are so white that they almost

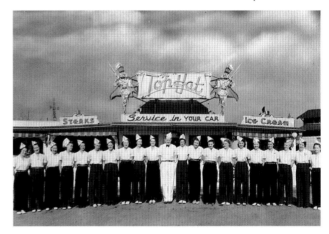

blind you when he smiles." Another was Bing Crosby. "Once he had two pork sandwiches and a glass of milk. He autographed a menu and left a big tip, fifty cents." Her least favorite? Spencer Tracy. "He comes in late at night and there are always two men with him. Maybe his chauffeur and bodyguard. His favorite game is knocking the trays off car doors, which isn't funny to me. Then too, he demands a lot of attention, and blows his horn continually. He doesn't leave much of a tip either. But he comes back all the time, and of course, that's the important thing."

Other star sightings included Lupe Velez and Johnny Weismuller, "who either read the paper or fought." Katherine Hepburn appeared one afternoon in trademark brown slacks and consumed a bowl of chili "heavy on the onions." Fred Astaire ate hamburgers. Oliver Hardy usually consumed three in one sitting. Clark Gable once appeared with a month's growth of beard and ordered a hamburger with onions. Sensing Wally's

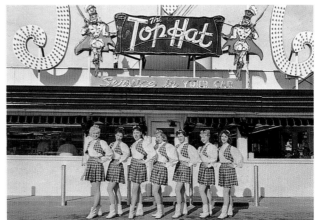

displeasure, he said he would return in one hour clean shaven, which he did, proclaiming that, "once in a while, I man-

Opposite. These California hops donned plaid robes in rainy weather. Above. Three decades of car hops from Spokane's Top Hat Drive-In stand at attention.

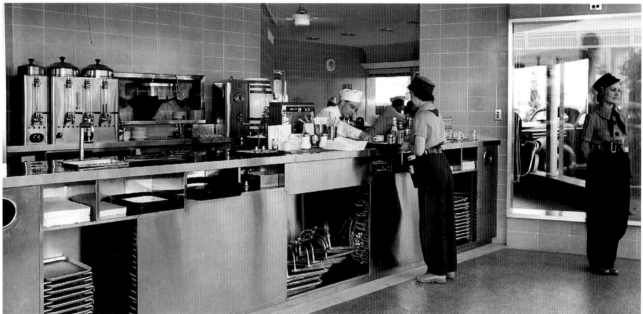

age to look quite respectable." Such was the life of a Hollywood car hop.

With tales like these, the lure of car hopping was magnetic. And there were other factors that encouraged women to join the drive-in ranks. One was pay. Standard practice for car hops was to work for tips only. This, in effect, made them independent vendors whereby they purchased the food from the restaurant and then re-sold it to the customer. In California, hops were guaranteed a minimum-wage salary, which by 1940 was $16 a week for women. In 1933, George Sanders, owner of the giant coffee pots drive-in chain, claimed his eight servers received $1,000 a month. Divided among

Top. Both male and female hops donned bell-bottom pants at McDonnell's Los Angeles drive-in in the early '30s, setting a standard that many drive-ins would follow. Bottom. At Van de Kamp's Twin Drive-In in Los Angeles, crisp Dutchboy outfits in several shades of blue matched the spotless stainless steel environs of the serving area.

them, that was an average $31 a week, a handsome sum for Depression-era salaries. By comparison, a female Chicago factory worker was making twenty-five cents an hour, or $10 for a forty-hour week in 1932. An executive secretary in New York could bring home $16 for the same time period.

In 1938, one car hop reported making $1.50 for an eight-hour day and $5 in tips, sometimes bringing in $50 to $80 a week during the high season. Another hop in California reported making $20 a week in tips, sometimes as high as $35 or $40, plus the minimum wage in 1941. A female riveter at an aircraft plant started at fifty cents an hour for a forty-hour week. In that same year, California drive-in owners formed an association to try to stop the State Industrial Welfare Commission from enforcing a rule which said tips could not be counted as wages, an indication of the problems to come.

While these salaries were attractive, they reflected wages for urban areas and high-volume restaurants. There were other variables that affected how much a car hop could earn. One was the shift she worked. Mornings and afternoons were dead, but the opposite was true of the night shifts, when there were many customers and a high turnover. The best season by far was summer, when mild temperatures prevailed. Car hops developed an unofficial rating system for tippers. Women-tippers were considered the worst, college and high school students a bit more generous, middle-aged men could be counted on to shell out a hefty sum, but hands-down the very best tippers were sailors. One seasoned Hollywood hop named Joan gave her 1938 view to a reporter. "Who are the best tippers? Well, women are the worst except for an old lady once in a while. Studio people are the best. We are only a few blocks from two of the studios and lots of the movie people drop in. The bulk of our tips are dimes. Only a woman will give you a nickel. Twenty-five cents is exceptional. If you get more than that, they are either drunk or are going to make an attempt to date you." Another Los Angeles hop observed that a car with a Washington state license plate was almost always a stiff—no tip.

With lucrative salaries as an incentive, competition was fierce for jobs at the most popular locations. Aware of this, employers sought out the girls who could make the cut and had that special something—the more charm, personality,

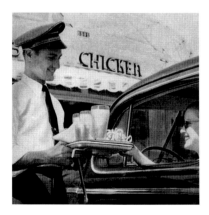 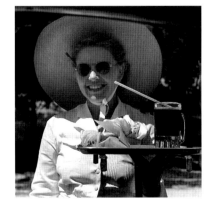 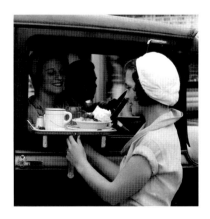

Hanging trays was a car hop's specialty.

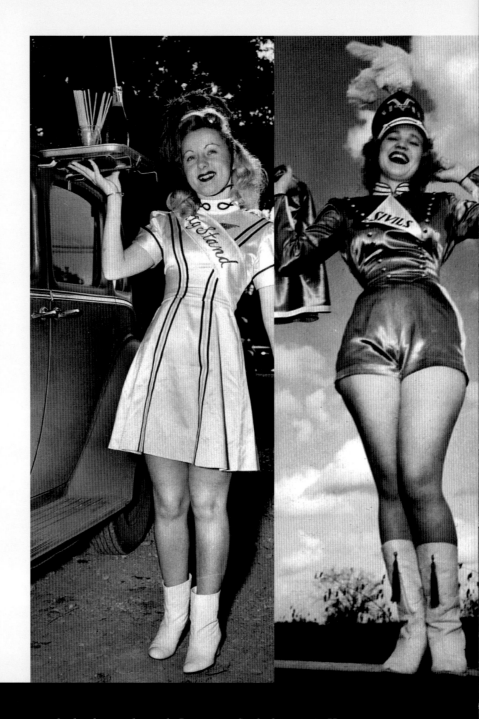

and beauty a girl had, the better her chances were for landing a plum job. In 1940, at Sivils drive-in in Houston, prospective hops had to pass the scrutiny of the owner's wife, twenty-one-year-old Mrs. J. D. Sivil, who made sure applicants were "…between 18 and 25, have good figures, a high school education, health cards and 'come hither' personalities." Once hired, they were expected to smile, stand erect, memorize the menu, and endeavor to sell large orders of food. A cardinal rule was that the female hop could not touch a customer. Change was placed on the tray, not in the customer's hand. Also, she was not to touch the car or leave the lot during her shift. Trays were to be balanced on one hand and

Above and opposite. A bevy of car hop beauties display a range of costumes worn in the 1940s. The short pants worn by the Prince's and Sivils car hops brought a flurry of criticism and were eventually lengthened.

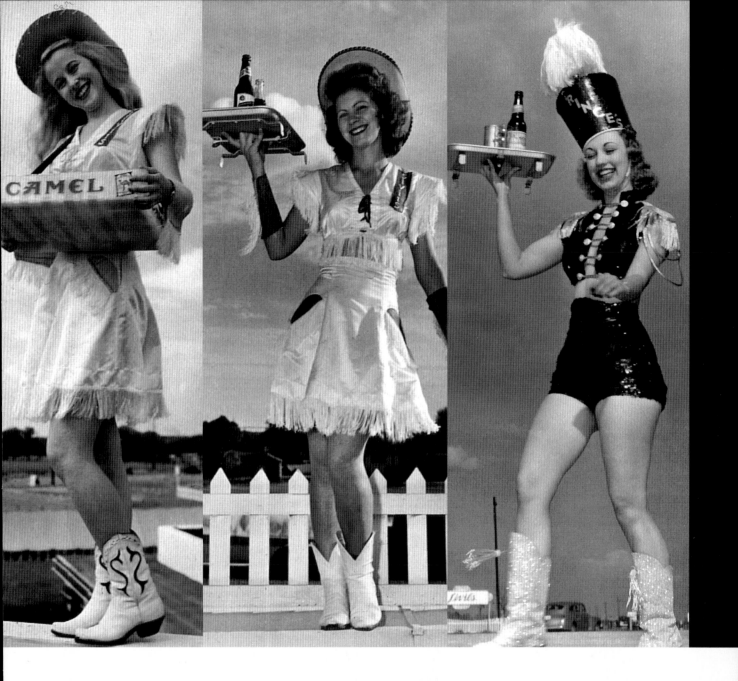

carried at ear level. The two costumes that the girls purchased for $37 (boots were an additional $5) were to be kept

absolutely spotless. Mrs. Sivil coached the hops in diction, deportment, and the importance of laughing at customers'

jokes. Punishment for small infractions, such as carrying a tray too low, was folding a thousand napkins. Larger offenses

merited immediate dismissal.

 For this they got to work at Sivils, one of the most noted drive-ins of its time due in large part to a Life magazine arti-

cle that featured a Sivils car hop on its cover. Josephine Powell was fresh out of high school when Life photographers

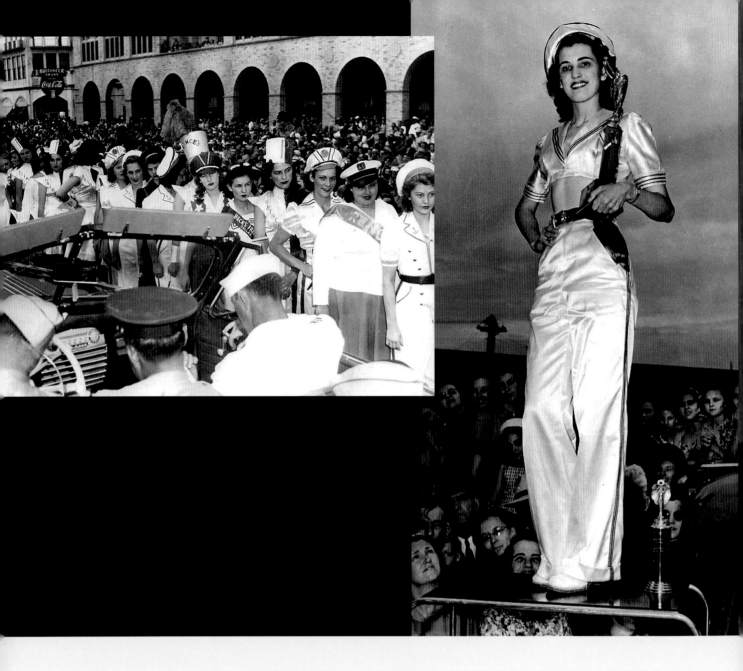

snapped her picture. She recalled, "I don't know why they picked me to be on the cover. I remember they were

going to pick the most photogenic, but I didn't have any idea it would be me." After being a cover girl she was inundated

with job offers. "The people at Chesterfield tobacco wanted me to be the Chesterfield girl and Goodyear wanted me to

model bathing suits." But a bout with appendicitis railroaded her career and Powell returned to car hopping.

Other car hops had similiar brushes with fame. Dolores Moran, a soon-to-be Warners starlet, was a sixteen-year-old

San Jose car hop in 1942 when a local apricot grower pulled into the drive-in she was working at and ordered a cup of

coffee. So smitten was the grower with the striking hop that years later when he died he left his entire $300,000 estate

Above and opposite. By 1940, the car hop was an American institution, with contests held in Galveston, Texas, to choose the top hop.

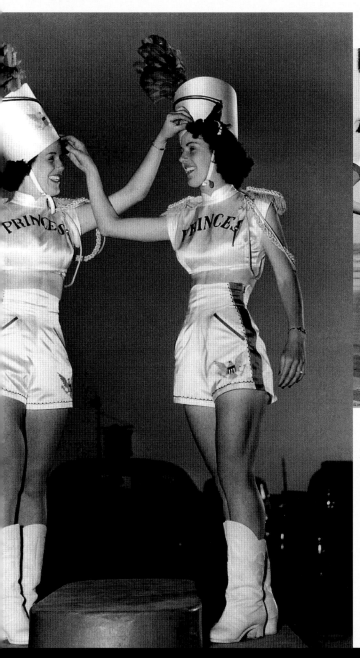

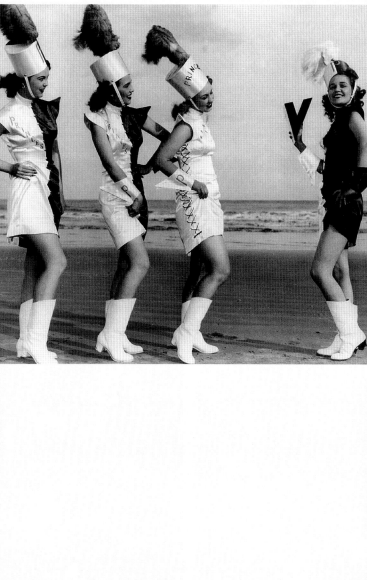

to Moran, having never seen or spoken to her again.

Of course Hollywood drew hundreds of motion picture job hunters to area drive-ins. These young hopefuls all wanted that elusive break—being spotted by an agent or studio head. In 1938 Paramount Pictures public relations representatives made the rounds of drive-ups, selected a hundred for a look-see, and chose one for a bit part in a long-forgotten movie. It was more flackery than fame guaranteed.

The attention car hops received outside of Hollywood could be a bit more genuine. Capitalizing on the publicity generated by Life magazine's car hop article, the city of Galveston, Texas, initiated a car hop contest in conjunction with its

Splash Days festival opening their resort season. A statewide gathering of car hops paraded on the sea wall and performed a series of restaurant maneuvers while judges sat in an open convertible. Contestants were judged on their charm, figure, courtesy, technique, and quickness of repartee. Balancing a tray filled with bottles of Coke, Seven-Up, Dr. Pepper, and beer, car hops were cheered on by thousands of onlookers celebrating "this newest and most popular of modern institutions."

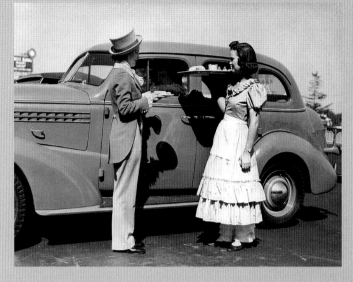

The most noticeable feature of the girl car hop was her wardrobe. Elevated from mere work clothes, car hop outfits were unique to a restaurant's business. Originally, servers' outfits were carried over from the restaurant business. Some A&Ws, for example, dressed their tray boys and girls in a wardrobe common in the '20s—for the men it meant white shirts, ties, and black slacks, for women it was a dress with apron and maid hat. Uniforms assumed a number of styles throughout the United States, but it was left to California to lead the way. The Tam O'Shanter lassies inspired other places to experiment with theme dress. Having a consistent thread run through a whole business was an important marketing tool, plus identically clad waitresses made a restaurant easier to remember.

Loose-fitting overalls in bright patterns with wide-brimmed straw hats for summer and corduroy trousers held up by suspenders and sweaters for winter were one drive-in's fashion solution in 1930. Another early '30s favorite featured high-waisted, bell-bottomed pants, a long-sleeved jacket with an oversized collar, and a tam hat. This ensemble could be found at most drive-ups in the first half of the decade. Rain brought out ankle-length plaid robes with hats to protect car hops at one drive-in, while another provided transparent raincoats to cover their girl's jade-green pajamas.

The casual look for women disappeared in the mid-'30s as Simons, Carpenter's, and Herbert's introduced a clipped, military-inspired uniform of crisp pants and fitted waist jacket with white blouse. This combination proved to be an enduring classic, with variations of it lasting well into the '50s.

Meanwhile, the Carl's chain opted for a theme look, and at their outlet near the University of Southern California campus, car hops were garbed in sombreros, sashed peasant blouses, and wide, loose pants. Of their Colonial-theme Viewpark restaurant, Western Restaurant magazine delivered this description "…waitresses are dressed in white gowns dotted with small flowers, puffed short sleeves and ruffled pantalets. The drive-in service girls are costumed like the

Above. Clad in top hat and tails and ruffles and pantaloons, car hops at Carl's Viewpark Drive-In in Los Angeles were the epitome of theme restaurant service attire. Opposite. Two hipsters are served in style at a Simon's drive-in.

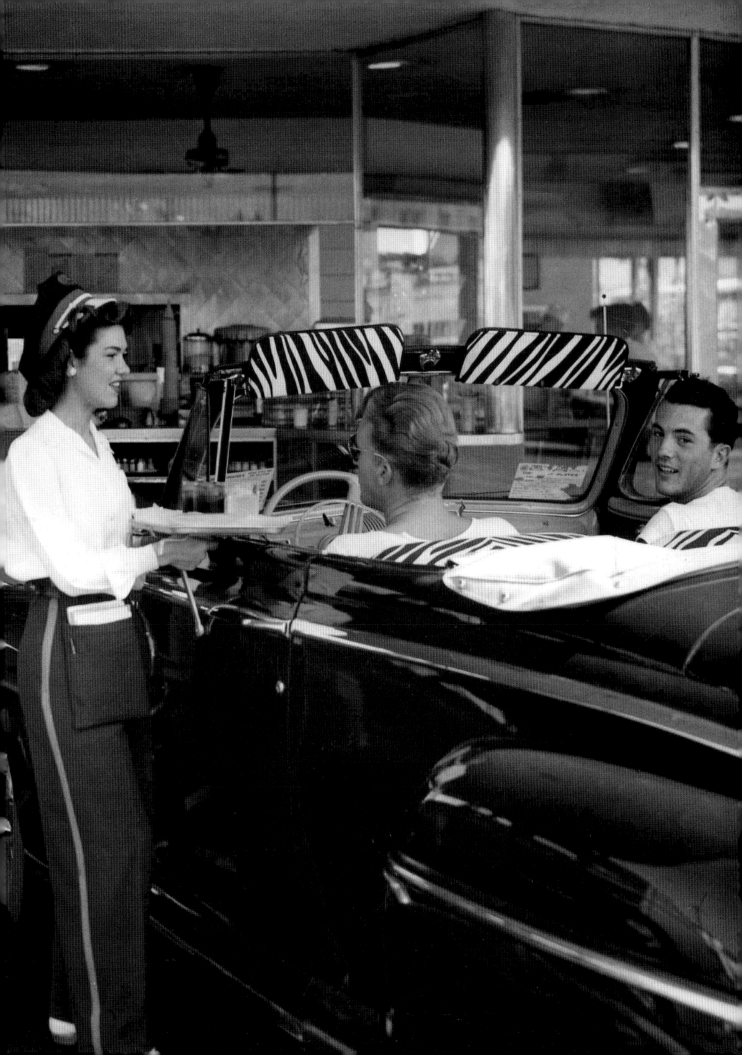

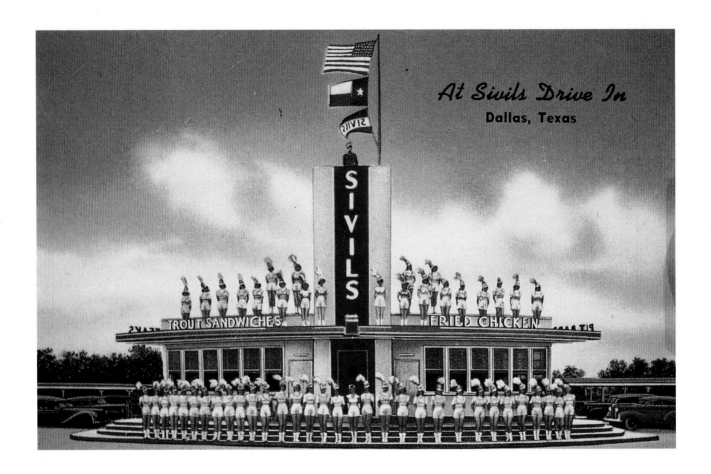

dandies of the Old Dominion—long tailed coats of blue material with gray collars and white bow ties; gray pants, white dickeys with standing white collars; low crowned gray top hat worn at a rakish angle and a gold fob with a ribbon." This elaborate attention to car hop garb could also be found at the Van de Kamp's drive-in, where servers wore stylized starched Dutch hats and aproned dresses. Curb hoppers wore a mildly fascistic Dutchboy costume in different tones of blue. A whirl around the town revealed car hops who were clad like Robin Hood with feathers stuck in hunting caps, while others wore cowgirl fringe skirts, or Santa Claus outfits trimmed in fur or sailor suits, or a dirndl. The only rule that seemed forbidden was a lack imagination.

Deep in the heart of Texas, Sivils Drive-In dressed their hops in what would become the epitome of car hop fashion. Mrs. Sivil introduced to the drive-in world an abbreviated costume of satin shorts and bare midriff top crowned with a foot-high plumed majorette hat that caused a sensation across America. She also garnered the wrath of churchgoers who frowned on revealing so much leg. Hems dropped, but not before dozens of other drive-ins had adopted the style.

Throughout the '40s and into the '50s, car hop fashions stabilized. The more elaborate costumes were abandoned for practical reasons, but the utilitarian short jacket, blouse, and side-striped pants remained. Sometimes a pillbox hat was

Above. Fresh from being featured in Life magazine, the whole crew of Sivils Drive-In poses in all its car hop glory. (Note the parking lot director atop the central pylon). Opposite top. France's Drive-In at La Brea Avenue and West Washington Boulevard in Los Angeles was widely known for the food and entertainment in its cocktail lounge, the Parisian Room. Bottom. California cool was perfectly expressed at Carl's at the Beach Cafe on the Roosevelt Highway in Santa Monica.

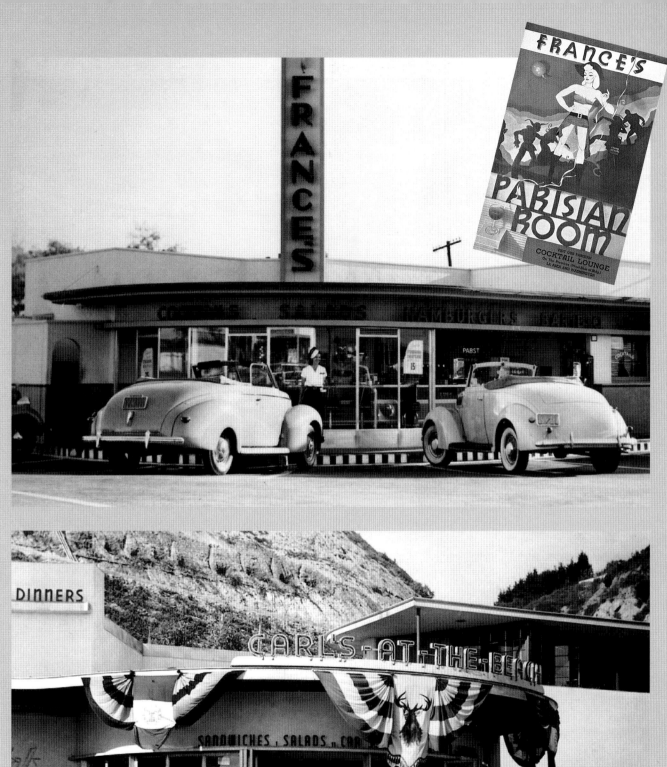

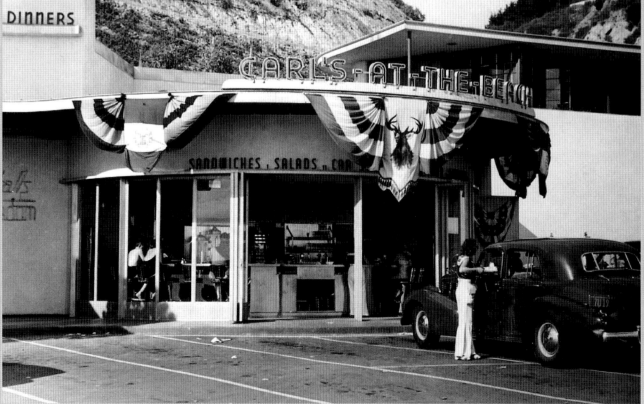

added or saddle shoes substituted for tasseled boots or perhaps sleeves were neatly rolled up for variety, but for the most part, styles remained static. At Ott's in San Francisco, Eisenhower jackets with modified baseball caps made a post-war appearance. In the '50s, costumes showed little variety for drive-ins located in large cities. Small town drive-ins were more flexible in dressing their car hops and current fashions were easier to accommodate. Short shorts, quilted skirts, and pleated jumpers were options exercised on a lesser scale. At MacKenzie's Ice Cream Drive-In in Keene, New Hampshire, owner "Ma" MacKenzie dressed her car hops to match her ice cream specials; so when peppermint stick was the flavor, girls showed up in red striped dresses, while pineapple called for hula skirts and leis; butterscotch brought out Scottish kilts and so on.

Periodically, novelty styles popped up. Eckard's Drive-In in Canton, Ohio, outfitted their car hops in clown gear and roller skates. Only males were solicited, and the mostly college and high school boys who applied were expected to learn fast service and clean humor. The roller-skating car hop fell mostly into the novelty category. As verified by owners and customers alike, the hazardous nature of serving food on trays while skating on a gravel or asphalt lot made their presence short lived. Still, the image of a fast–moving car hop whizzing by on skates was a compelling one whose appeal has persisted, giving mythic status to what, in reality, was just a passing fad.

A car hop at the Frontier Drive-In in San Antonio, Texas, displays the skill and hard work that accompanied a job perceived as glamourous.

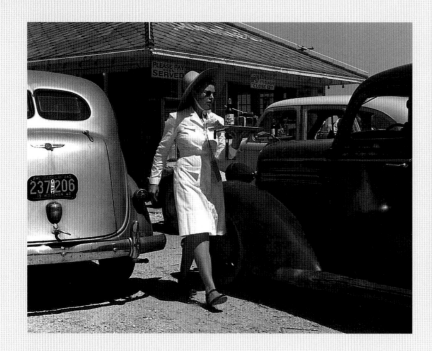
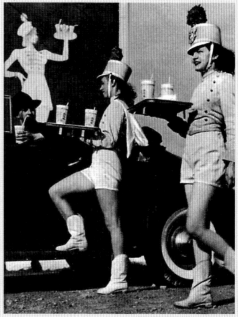

Once women had become confirmed successes in the drive-in trade, the presence of men greatly diminished, except behind the counter. The male car hop was here and there but never in the quantities that women were. One hop estimated that for every one male hop, there were two female hops. Still, there were drive-ins that relied on male help exclusively. The Varsity in Atlanta was one, and Dolores's in Los Angeles was another. The Hot Shoppes and White Castle employed males as many others also did, but the picture that was presented to the public was that of a cheerful, feminine face, and that was the image that indelibly remained.

The focus on appearance and costumes often drew attention away from the real work a car hop performed. Glamour aside, hoisting trays eight hours a day was tough and owners had job standards that often seemed medieval. The list of dos and don'ts filled manuals and countless trade magazine articles. Hody's Drive-In, a model in car hop procedure, offered these instructions: "KEEP SMILING. Uniform clean and pressed at all times. Nails clean and manicured—polish may be worn if applied properly. No jewelry or pocket handkerchiefs. Caps to be worn in the prescribed manner. Each employee is allowed 30 minutes to eat during a shift. Caps will be removed while eating. Onions should not be eaten before or during a shift. Employees will eat only at allotted times. Keep the lot clean and free of paper. Don't chew gum on duty. Don't discuss personal problems with other employees while on duty. Don't scratch your head, pick your teeth or clean your nails in presence of guests. Get rid of sitters on lot—Keep cars turning as rapidly as possible."

The workplace was rife with other tedious rules and obstacles that lessened the purported glamour of the job. Drive-in etiquette required hops to conduct themselves to reflect the reputation of the restaurant. That meant no fraternizing

Left. A sun hat protects a Texas car hop delivering her tray. Right. Stylish Hot Shoppe car hops sport drum majorette–inspired fashions.

with the customers. When asked, most girls complained that they were too tired to go out on dates after work, but if a customer persisted in dogging her for a date, diplomacy was called for. Female hops might signal one of the boys, a male coworker, to step in if someone got out of hand or use one of the male hops as a ruse, claiming him to be their fiancé.

Hops at some restaurants were encouraged to write the license number of the cars they served on the back of their checks to prevent run-outs. Other operators felt their hops should be well-informed and be able to offer highway locations and travel tips. Keeping unruly teenagers in their cars was the chore of the attendant on duty, though sometimes a uniformed guard might be hired to keep order.

To avoid confusion when claiming a customer driving in (if they weren't assigned sections), one policy dictated that each incoming customer belonged to the hop who stepped off the waiting-step first after the customer set his brake. Other lots worked differently. Experienced car hop and former restaurant man Wayne Allison gave further explanation of drive-in protocol. "At some drive-ins the car hops worked sections or stations and at others, they worked an open-call car lot, which meant that if a car hop had no orders ready to serve and no cars with lights on, then they could call a car

Above. A rare photo of rolling skating car hops at the Parkmore Drive-In in Montgomery, Alabama. Opposite. A novel approach several drive-ins attempted was service to airplanes. More a publicity stunt than a practical venture, hops were expected to scale the airplane's wings to serve their flying customers. Bottom. Like the Fly-In-Drive-In, this curb service to helicopters was strictly for publicity purposes.

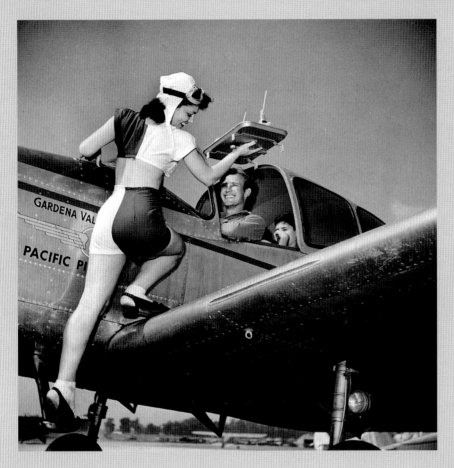

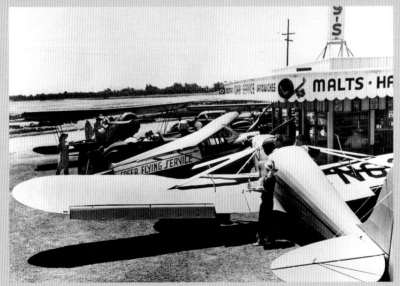

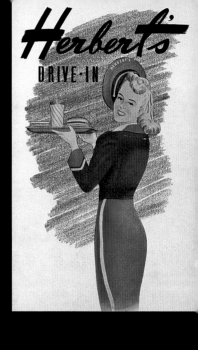

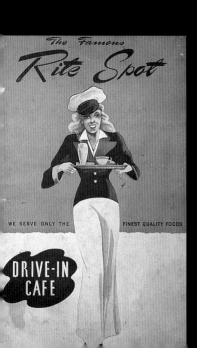

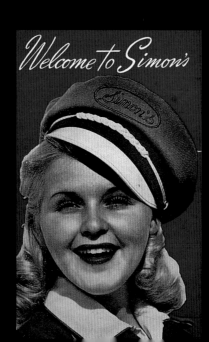

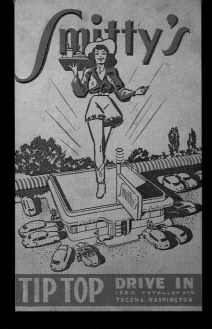
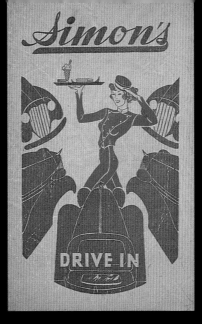
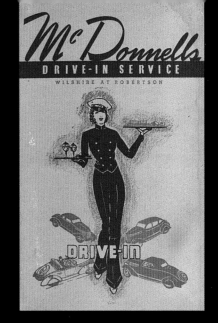

approaching the drive by calling out 'C.I.' (car in). Sometimes they would also identify a car coming in by its color or position 'up the hill,' 'first turn,' 'second turn,' etc. To identify the car that belonged to them, hops used what was called a 'pie card,' which was placed on the windshield of the car. The side facing the driver had a list of pies and desserts (thus its name), while the other side had the car hop's name or number."

Competition of a different sort was expressed by several female hops who said they preferred brunettes to blondes as coworkers, with platinum blondes considered poison. Some, it was claimed, would rather resign than compete with them. Another irritant was the novice customer who honked rather than flashed his lights. Hops complained that you couldn't tell where a horn was coming from.

Speed was promoted to keep the customer's food hot and tempers cold. The Dixie Drive-In in Hazel Park, Michigan, guaranteed their hops would be at a driver's window in just thirty seconds after the customer entered the lot. To handle this traffic, each car hop was supposed to wait on between eight and twelve cars at a time, which was, approximately, the accepted number countrywide. A Houston drive-in claimed to serve six cars every minute when handled by two girls. Despite the endless litany of rules and regulations, experienced car hops took most of this in stride. Rules were simply part of the job and conforming to them was not an obligation, but a source of pride.

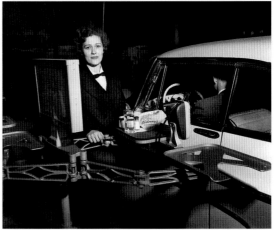

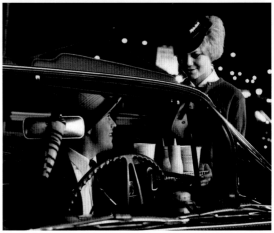

Even with this dedication, the price of maintaining a staff was a burden many owners watching their purse strings wanted to trim or even eliminate. In the late '40s, as other dining options surfaced, owners began to investigate cost-saving measures that circumvented the car hop. A whole decade's worth of mechanical and self-serve alternatives were employed to dethrone the car hop. Teletrays, radio communication, and meals dispensed on a conveyor belt all promised service sans smile, tipping, and personality. The '50s proved to be the last surge of glory for the car hop, and though drive-in service maintained its momentum, other forces were at work that would signal the demise of the car hop.

When drive-in service began to wane in the mid-'60s, the car hop as American icon was slowly becoming extinct. In small-town America, car service survived in small pockets, but these were its last repositories. Vestiges of the drive-in's heyday managed to carry on a dying tradition but were headed for obsolescence nonetheless. A few chains, like the Midwest-based Sonic Drive-In, still maintain service to cars today, and periodic retro-restaurants strive to recreate a nostalgic facsimile, but the real McCoy has been retired to memory.

Top Left. *At car hop school, future servers are given instruction in the finer points of curbside service.* Top right. *Orders transmitted by phone still required a car hop helper.* Bottom right. *Classic '60s service at a White Castle Drive-In.*

CAR HOP JARGON

To streamline ordering most drive-ins developed their own colorful language used by the counter man, cook, fountain man, car hop, and waitress. Drive-in lingo was a world unto itself. Herewith, a vocabulary list:

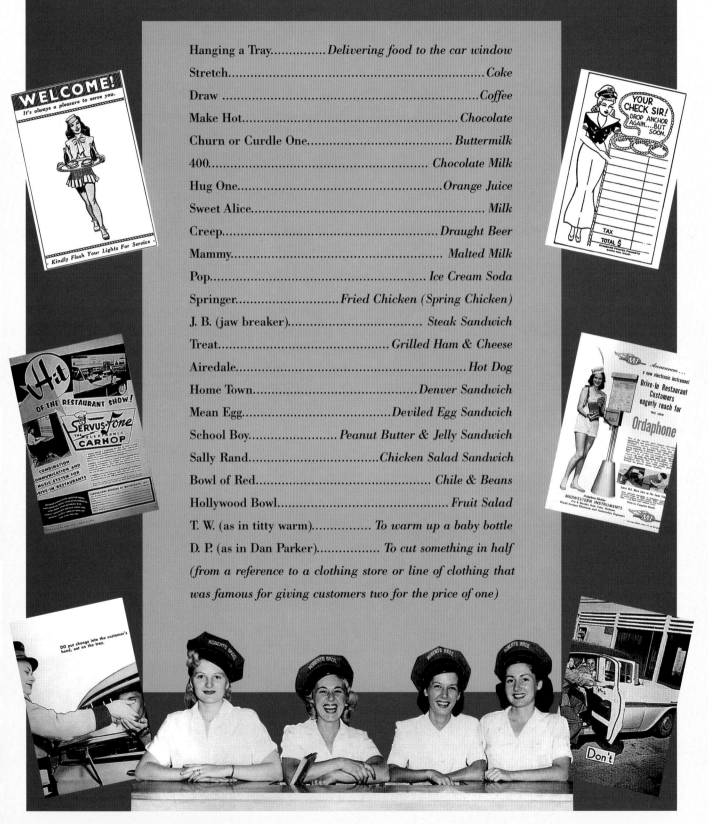

Hanging a Tray...............*Delivering food to the car window*

Stretch..*Coke*

Draw ...*Coffee*

Make Hot..*Chocolate*

Churn or Curdle One....................................*Buttermilk*

400...*Chocolate Milk*

Hug One...*Orange Juice*

Sweet Alice...*Milk*

Creep..*Draught Beer*

Mammy...*Malted Milk*

Pop..*Ice Cream Soda*

Springer.........................*Fried Chicken (Spring Chicken)*

J. B. (jaw breaker)...................................*Steak Sandwich*

Treat...*Grilled Ham & Cheese*

Airedale...*Hot Dog*

Home Town...*Denver Sandwich*

Mean Egg......................................*Deviled Egg Sandwich*

School Boy.......................*Peanut Butter & Jelly Sandwich*

Sally Rand..................................*Chicken Salad Sandwich*

Bowl of Red..*Chile & Beans*

Hollywood Bowl...*Fruit Salad*

T. W. (as in titty warm)...............*To warm up a baby bottle*

D. P. (as in Dan Parker)................*To cut something in half*

(from a reference to a clothing store or line of clothing that was famous for giving customers two for the price of one)

Before the outbreak of World War II, the drive-in restaurant enjoyed the overlapping success of a boom in building activity and thriving business from the previous decade. Restaurant sales were up 11 percent in 1941, and there were more than 150,000 eating places with a total seating capacity of 11.6 million. The trend of eating away from home resulted in a whopping twelve million meals being served to the tune of $1.5 billion a year.

People were also on the move. In 1939, more than 30.7 million cars were registered, which meant there was one car for every four people. Those numbers were music to the ears of drive-in owners. With its increased exposure the drive-in

also invited controversy. At its annual convention in 1940, the National Restaurant Association took a long look at short skirts. Considerable debate focused on the rise of hems eleven inches above the knee and whether car hops should start "dressing up," a discussion sparked, no doubt, in response to Sivils in Dallas and their abbreviated car hop uniforms.

The last gasp of pre-war expansion included many neon extravaganzas, representing a drive-in style that was not to reappear on the same scale after the war. The Van de Kamp's Twin Drive-In, designed by Joseph Feil of the firm Plummer and Feil, was indicative of this era. Described as the "Last Word in Roadside Catering," its giant windmill, faced with

Opposite. Drive-in restaurants attained the ultimate accolade when car hop Josephine Powell of Sivils Drive-In in Dallas, Texas, was featured on the cover of Life *magazine.*

LIFE

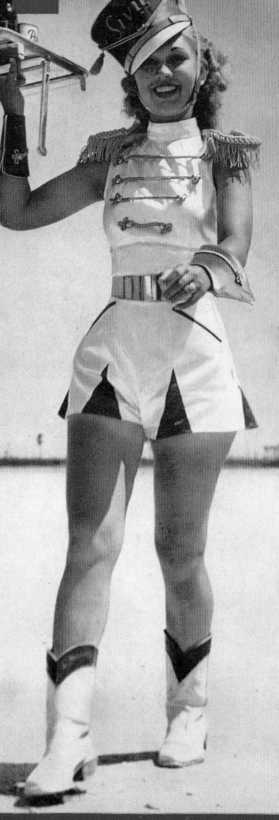

ADSIDE SERVICE

FEBRUARY 26, 1940 10 CENTS

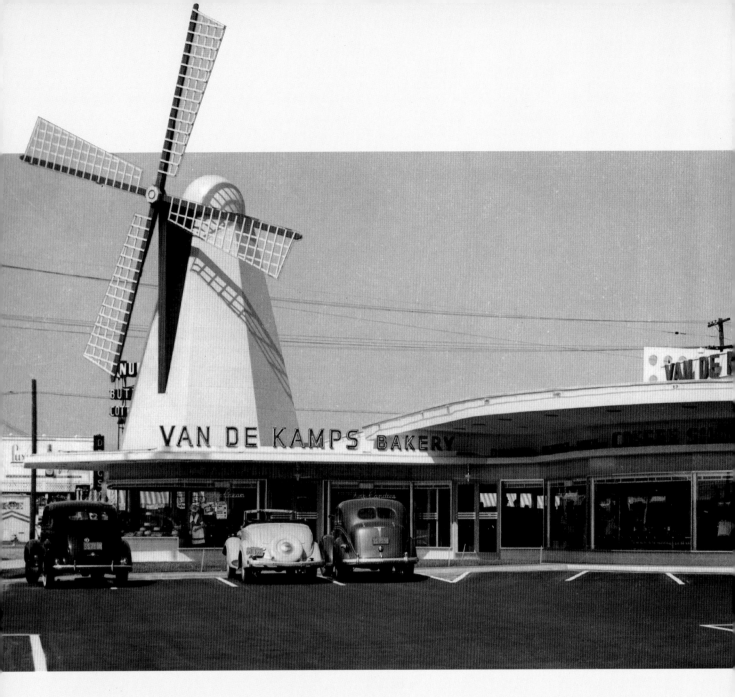

blue porcelain enamel panels, rotated. Trimmed in neon, it sat above the retail bakery outlet that was part of the restaurant. Stainless steel, soon to disappear with wartime shortages, was everywhere: doors, counters, coffee urns, cigarette machines, and refrigerators were all made from it. The interior counter ran the circumference of the restaurant and was sheathed in plate glass. Car service radiated from the circular overhang that was part of a larger rectangle with a pylon jutting out from the roof. This main restaurant was joined a few years later by a second building designed by Wayne McAllister. Though smaller in proportion, it was just as impressive in style and was a vision of streamlining. This square addition had a duplicate back-lit advertising pylon rising from its roof and had an 18-foot overhang banded in neon to protect cars from the elements. Recessed wall heaters and steampipes under the terrazzo kept car hops warm. This com-

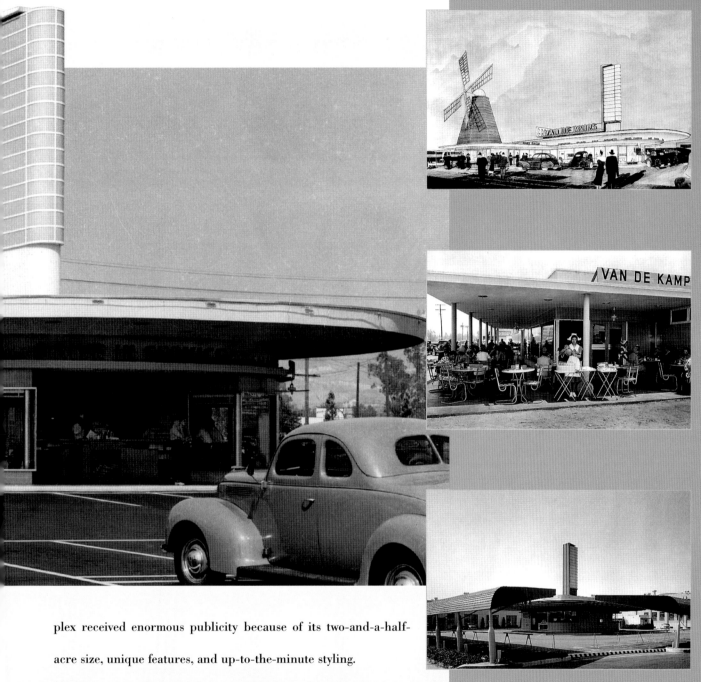

plex received enormous publicity because of its two-and-a-half-acre size, unique features, and up-to-the-minute styling.

Another pre-war look that was almost as pervasive as the circular form was the Colonial Moderne style. Owing its associative imagery to an imagined past, it could impart a message of prestige, formality, and cleanliness, and drive-in designers freely made use of it. This quaint package of early America was universally understood by the public. Initial drive-in examples rarely veered from the prescribed formula, as seen in the Colonial Drive-In on Los Angeles's Sunset Strip or Carl's Viewpark restaurant where a replica of Mt. Vernon was constructed. Architects later combined some of the drive-in's successful elements, primarily the octagon and semi-circular base, with traditional colonial features. Often

Van de Kamp's neon wonder, at the Los Angeles intersection of Fletcher Drive and San Fernando Road, was a showcase of drive-in architecture. An odd blend of Streamline and mimetic components, its imagery was nonetheless clean and appealing. Bottom Right. A second restaurant built on the same massive parking lot was designed by Wayne McAllister, and the complex was called the Twin Drive-In.

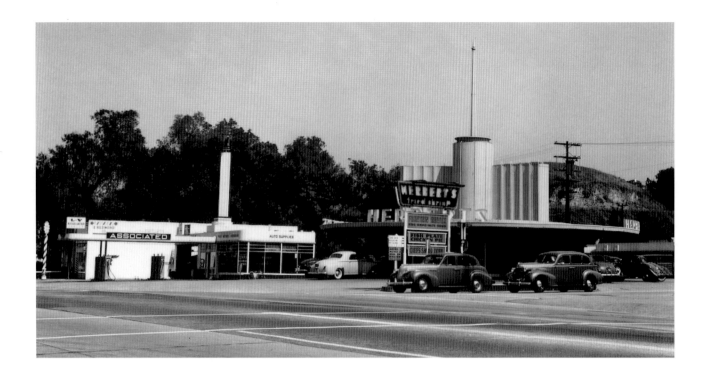

the concrete or stucco canopy was replaced with a metal or canvas awning to evoke an East Coast tradition more in keeping with an old-fashioned style. Often a second story could be added in the shape of small octagon box with a decorative balustrade along the roof line. Wood siding, weather vanes, and shutters completed the look. A neon-trimmed cupola served as the advertising pylon. It was a curious blend, but one that felt instantly familiar to the customer.

Many restaurants, flush with the experience of some very successful years, were beginning to develop menu strategies. One was to trim the number of products they offered, concentrating on a few high-volume items, anticipating the post-war fast-food trend. These changes came none too soon, because by 1941 the threat of war was being felt in the form of food and material shortages.

The bombing of Pearl Harbor and the United States's entry into World War II signaled a temporary slowdown in the drive-in business for most of the country. Civilian auto production ended in 1942 and, at the same time, rubber and gasoline were rationed. Recreational driving came to an abrupt halt. Blackouts made night driving a risky proposition until the threat of air raids subsided. Restaurant owners found china plates and restaurant equipment a scarce commodity. Parts couldn't be ordered and remodeling, expansion, and the replacement of worn equipment had to wait. Rationed sugar was substituted with honey and corn syrup. Nothing was sacred, not even that hot cup of joe. Coffee disappeared for almost a year, but eventually made it back onto the menu.

Drive-in employment was also affected by the war. Housewives suddenly stepped out of their kitchens and onto the

The circular design continued to dominate drive-in architecture for the first half of the '40s. Pictured here is Herbert's Drive-In at the Los Angeles intersection of Laurel Canyon and Ventura Boulevards.

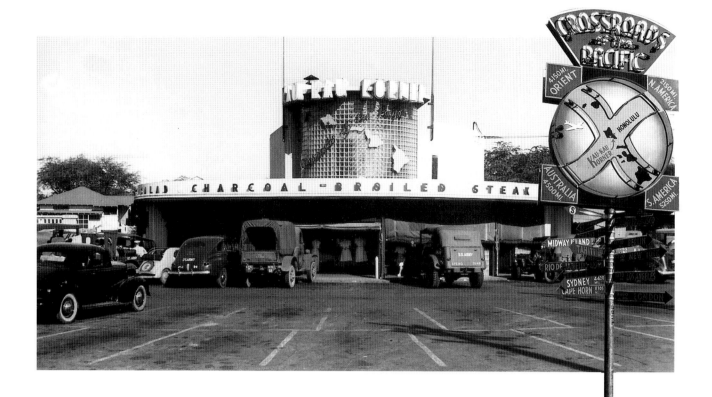

assembly line. In 1943 they made up nearly one-third of the work force and became customers of the

drive-in rather than car hops. Together with men who enlisted or were employed in defense work, they left a shrinking

labor pool for drive-in's which had to accept young and inexperienced help. Owner Clyde Wycoff of Wycoff's Oasis in

Mankato, Minnesota, acknowledged a slip in service at his busy drive-up due to the shortage of experienced employees.

During the war his car hops were high school girls who, with the exception of the head girl, were under the age of six-

teen. They were, as Wycoff put it, "young and unreliable."

These changes all affected the drive-in, but resilient Americans coped. After an initial adjustment period, drive-in

business resumed, with a few new restaurants opening. Los Angeles, which had one of the nation's largest areas of

defense production, continued to buzz with drive-in activity. Drive-ins stayed open twenty-four hours a day at these

manufacturing centers, accommodating swing shifts and round-the-clock diners.

New places, like Sidney Hoedemaker's Melody Lane, wowed war workers, six hundred of whom worked staggered

shifts in a twenty-four-hour work day across the street from Hoedemaker's Wilshire Boulevard and Western Avenue loca-

tion. Hoedemaker, one of Los Angeles's premiere restaurant men, created a lavish five-room restaurant centered around

car service. Hampered by priority requirements and a shortage in building materials, he nonetheless fashioned a show-

piece. The exterior was a gleaming circular drive-in with an extended canopy overhang that housed a large dining room

and cocktail lounge. A separate building contained a candy store. Two hundred and fifty cars could be parked on its

Military vehicles line up at the popular Kau Kau Korner, a magnet for servicemen in wartime Honolulu, Hawaii.

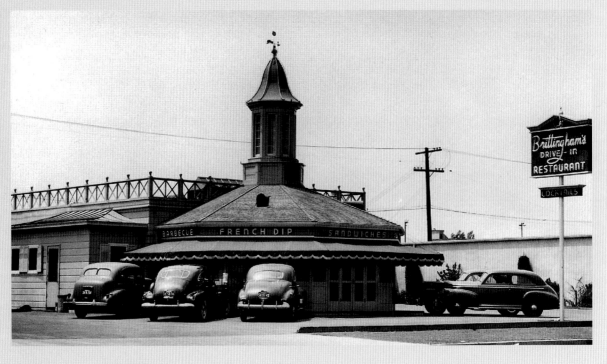

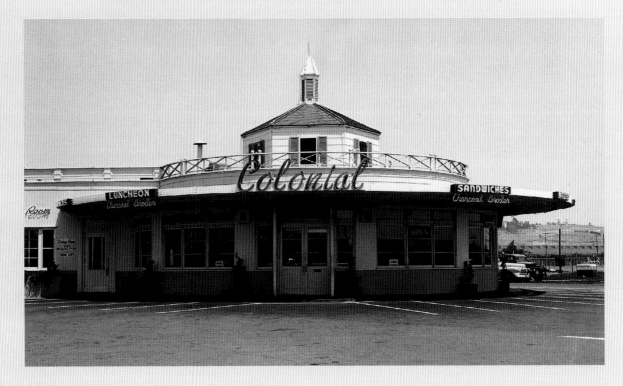

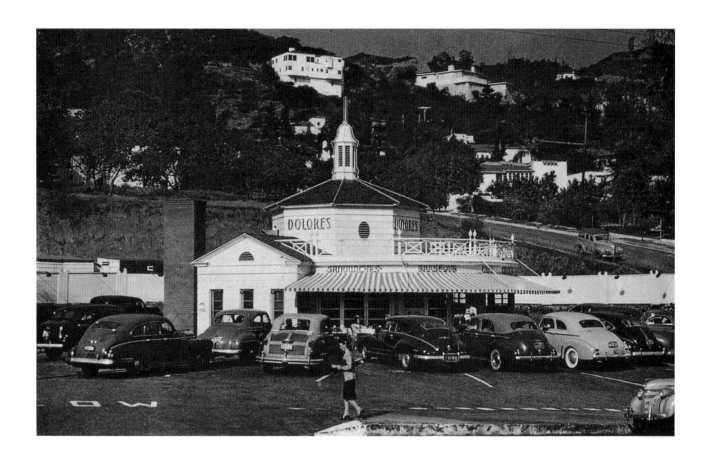

block-wide lot. The entire building was bathed in neon for a "World of Tomorrow" look. Inside, customers were treated to a peach and turquoise solarium and a coffee shop painted in eight shades of tan and brown. The imposing cocktail lounge was the restaurant's centerpiece. The Starlite Room was built around the theme of the zodiac and had walls covered with flocked silk-rayon. Hassocks replaced chairs and a "record operator" would play requests on a stand flanked by copper-backed, peach-colored mirrors. The seats at the bar were joined by several bar stools that would accommodate three people in "bar couches." The shallow dome above the bar was painted with "an exact representation of the stars, planets, and constellations as they were in place above Los Angeles in February of 1942," while a translucent globe depicting the zodiac rotated in the center above a pyramid of cocktail glasses. The carpet was dyed in fluorescent colors and black-lit. And all this grandeur amidst the shortages and rationing!

Yet the Starlite Room wasn't the only instance of building drive-ins on such an extravagant scale during the war. In Kansas City, Missouri, the Forum Drive-In duplicated a California circular, going one step further by adding a ninety-six-foot telescoping tower on a stepped roof that was lit by a changing cycle of colored floodlights. Located on a 180-by-240-foot lot at Ward Parkway and Main Street, it was near apartment dwellers in the Country Club Plaza district who became the eatery's primary clientele.

Opposite. The colonial architectural theme was widely applied to drive-ins, which sold customers on its clean, solid, and sophisticated image. Top. Brittingham's Drive-In at 18th Street and La Cienega Avenue. Middle. DeMay's Drive-In at Slauson and Fairfax Avenues in Los Angeles. Bottom. The Colonial Drive-In in San Diego. Above. The Dolores Drive-In on L.A.'s Sunset Strip was located on the current site of Tower Records.

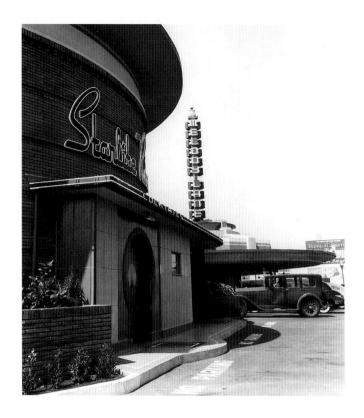

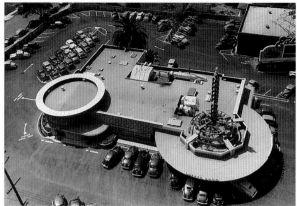

On a smaller scale, more in keeping with mainstream drive-ins across the United States, the Harbor Drive-In in San Pedro, California, took over an existing drive-in and catered to the local shipyard workers and neighborhood folk. No fancy stuff here: during these war years, when there were dim-outs, car hops ushered in customers by flashlight. Owner Nick Oreb's Aloha Room bar was a converted annex covered in bamboo wallpaper and tapa cloth wainscoting. Slavonian spaghetti, steaks, and burgers were his specialty.

Likewise, the Wheeler Drive-In on the outskirts of Indianapolis offered customers a pleasant drive-in experience with a touch of swank. Conforming to the style of roadside restaurants outside of the sun belt, its plain, rectangular build- ing with tiled hip roof had an unpretentious block tower faced with back-lit glass brick giving it that modern touch. A bit of neon and some floodlighting made it quite attractive at night. The interior, which contained a jukebox and nicely upholstered booths, was typical of the drive-ins most Midwesterners experienced.

As the war progressed, large restaurant chains such as the Hot Shoppes and Howard Johnsons kept afloat by aug- menting their car-based revenue with the managment of military and defense plant cafeterias. The Hot Shoppes kept their car-service on target and running by also providing large-scale meals to an Alexandria, Virginia, torpedo plant, supplying food to airlines, and locating a restaurant near the very busy Pentagon and the National Airport.

Anticipating the end of the war, drive-in operators were optimistic about the direction of drive-in service. Though

Above. Cocktail lounges were introduced as adjuncts to drive-ins at the end of Prohibition and reached their stylistic zenith in such places as the Melody Lane's Starlite Room in Los Angeles. An aerial view illustrates the vast acreage that popular drive-ins demanded. Opposite. These color views of a Roberts Brothers and Simon's restau- rant in Hollywood offer a rare nighttime glimpse of classic drive-in architecture.

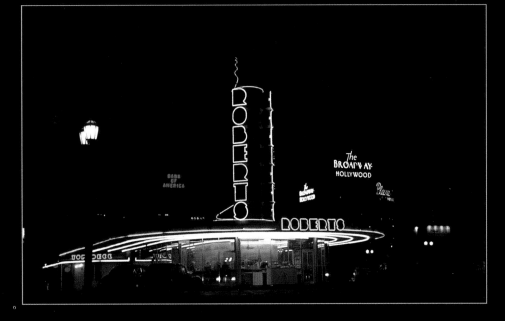

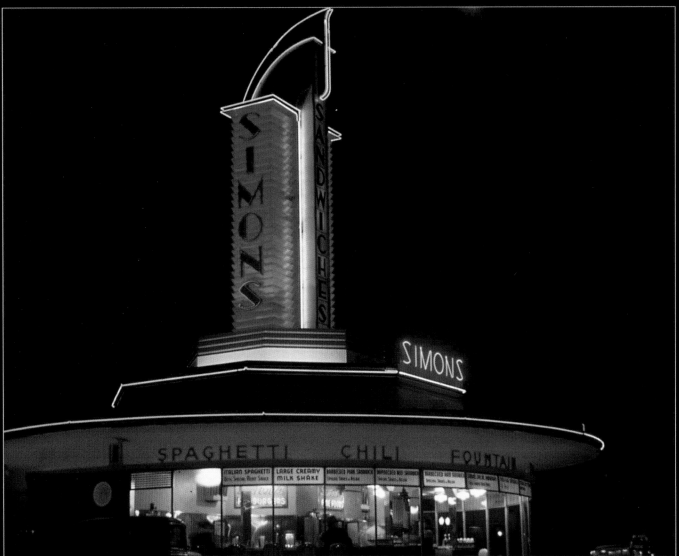

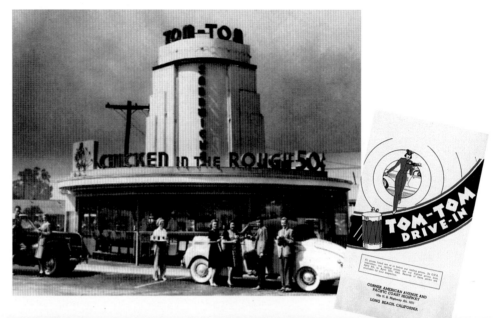

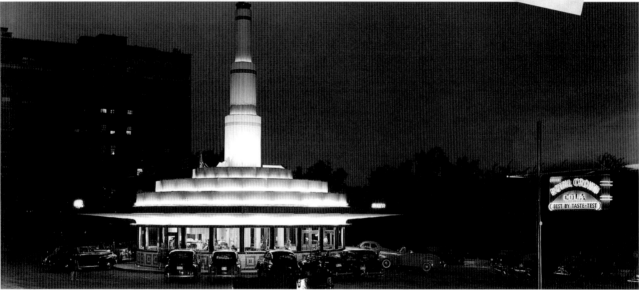

sacrifices had been made, the war years taught the drive-in industry how to operate more efficiently and creatively. In addition, the mass movement of workers and military personnel across the country increased eating out in a way that had only been suggested by the casual dining habits of the populace before the war. Drive-in dining had become a necessity for some and a frequent alternative to dining at home for others. This era also saw an increased family trade develop, which was a large segment of the dining public and was hungrily sought by every restaurant operator.

Immediately after the war there was still a vacuum in good, experienced help for drive-ins. The returning civilian work force, accustomed to better pay, turned to more lucrative lines of employment. As a result, owners initiated a thorough training program for new employees, and some owners offered additional incentives, such as profit-sharing and

Top. In Long Beach, California, the high school hangout Tom-Tom Drive-In was an interesting variation on the circular building design. A broad, stepped advertising panel sits above an abbreviated overhang. Bottom. The Forum Drive-In in Kansas City, Missouri, basks in a neon glow designed to draw customers off the street.

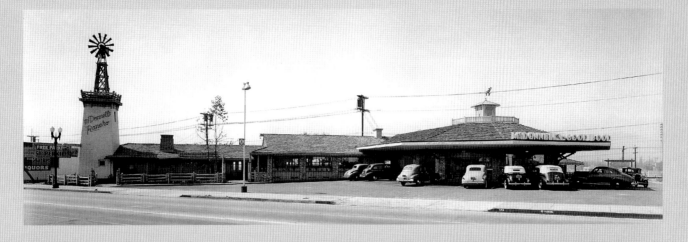

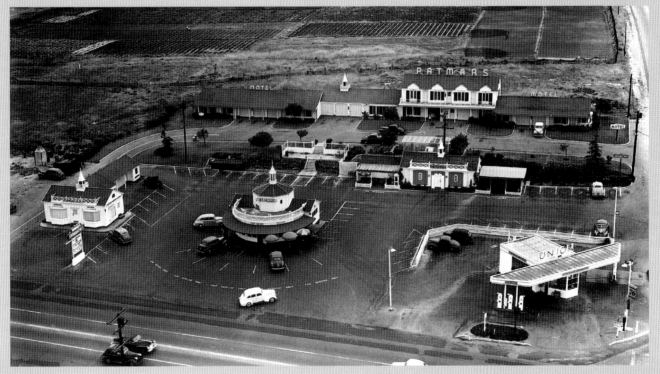

other benefits. Slowly, quality service was restored.

The experience of rationing and shortages left an American public anxious to pursue the future that it had been promised before the war. Americans wanted the world of the future for the sacrifices and pains of yesterday. Everywhere the lure of newness beckoned. The "New Look" was introduced in the fashion world. New cars were in production, and there was money to buy them. There were new families, new highways, and new destinations to be reached.

The commercial vernacular caught this theme, which had been gestating for over a decade. Some of the more sophisticated designers of the '30s began, in the latter part of that decade, to incorporate elements of the Modern with period decoration. The resulting hybrids, such as neo-Baroque and Hollywood Regency, led the way to more expressive imagery.

Top. A sprawling ranch-style drive-in, McDonnell's Rancho, located at 6345 San Fernando Road in Glendale, California, combined car service, indoor dining, and a cocktail lounge in the sort of complex that was becoming quite common in the '40s. Bottom. Near the Los Angeles Municipal Airport and several aircraft manufacturing plants, Patmar's Drive-In, at the corner of Sepulveda Boulevard and Imperial Highway, not only had a separate cocktail bar but also included a motel and a gas station.

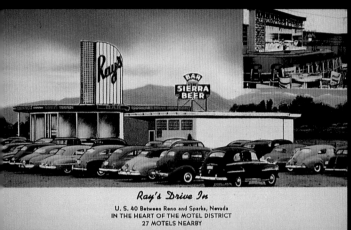

Ray's Drive In

U. S. 40 Between Reno and Sparks, Nevada
IN THE HEART OF THE MOTEL DISTRICT
27 MOTELS NEARBY

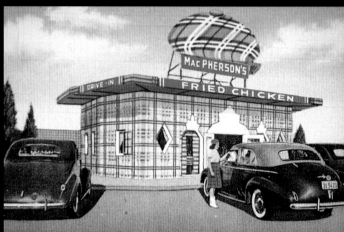

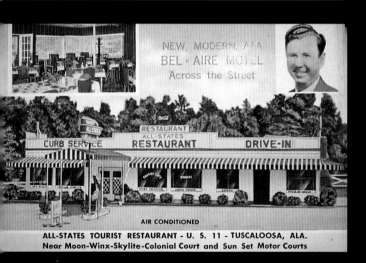

ALL-STATES TOURIST RESTAURANT - U. S. 11 - TUSCALOOSA, ALA.
Near Moon-Winx-Skylite-Colonial Court and Sun Set Motor Courts

RUSTY'S DRIVE-IN, BATON ROUGE, LA.

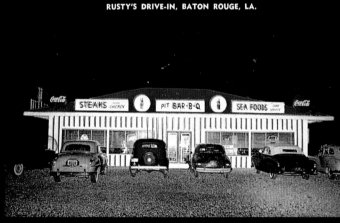

TWIN OAKS . . . U. S. 17 South . . . Brunswick, Ga.

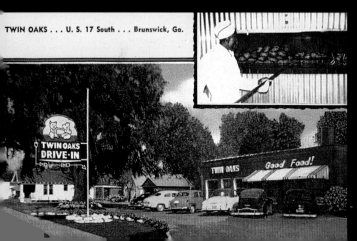

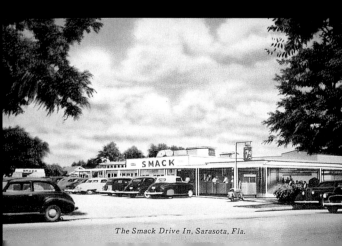

The Smack Drive In, Sarasota, Fla.

The pre-war work of Douglas Honnold, George Vernon Russell, Burton Schutt, Paul Williams, and others conveyed many of these elements in small buildings, movie theaters, nightclubs, and roadside restaurants. Ignored prior to the Great Depression, these commissions were now taken up because of the creative freedom they offered and because they provided a decent paycheck.

In reconsidering the accepted Art Deco, Zig-Zag, Moderne and Streamline styles, architects eliminated soft curves, replacing them with hard edges. Flagstone and redwood were used in favor of stucco and cement. Angles protruded. Palettes, once pastels and white, were now startling combinations of canary yellow, mahogany brown, and chartreuse. Lettering became expressive and free-form. Plastic and plywood joined a whole new vocabulary of building materials developed during the war. It was the frank expression of the structure and its decorative treatment. It was imaginative realism. It was Exaggerated Modern and it looked new. Pulling these elements out of a design centrifuge, a younger-minded generation of architects comfortably produced the new drive-in.

Henry's Drive-In in Glendale, designed by John Lautner in 1947, was one of the first to express this diversity of forms convincingly. Heeding the first commandment of the roadside, "Grab the Motorist's Attention," the roof shot out toward the street. Bare steel trusses supported a trellis awning in the patio. A stark pylon held a simplified chevron with the word Henry's in neon. The overhang for car service defied symmetry and jutted around the building. Two years later Lautner would design a Googies coffee shop, which would set the standard for that building type for years to come. As other architects drew upon similar inspirations, more of these types of post-war drive-ins appeared. Though Los Angeles was still an incubator for the best drive-in designs, new styles were also appearing elsewhere in the nation.

The Hot Shoppes unloaded their vaguely colonial style after the war, adopting the tasteful expressions of field stone, brick, and glass for an understated but sophisticated look that said "suburban."

Rettig's Drive-In in Houston, designed by Mackie and Kamrath, angled out to incoming traffic, a canopied flap rising up from a shingled facade like an eyelash revealing its customers behind a glass-paneled eye.

Further modernist links to functional expressionism could be found at Waddle's Drive-In, by Pietro Belluschi, in Jantzen Beach, Oregon. A plain box paneled in wood siding housed the main restaurant. An extended, covered walkway accommodating car service acted as a finger that beckoned motorists to drive in. This style became a favored post-war form applied to numerous restaurants, including the Parkmoor Drive-In in Dayton, Ohio, as well as several Gwinn's, by Bissner and Zook, in Southern California.

As these new drive-ins appeared across the United States, a distinctly divergent restaurant type was evolving. The

Opposite page: Clockwise from right. *Sissons Dairy Bar, Norwich, NY; MacPherson's Drive-In, Long Beach, CA; Rusty's Drive-In, Baton Rouge, LA; Smack Drive-In, Sarasota, FL; Twin Oaks Drive-In, Brunswick, GA; All States Drive-In, Tuscaloosa, AL; Ray's Drive-In, Reno, NV; White Turkey Drive-In, Orlando, FL.*

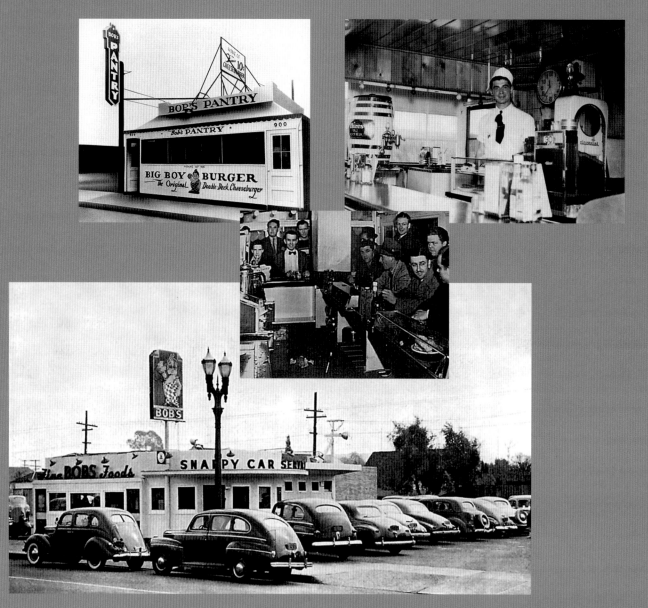

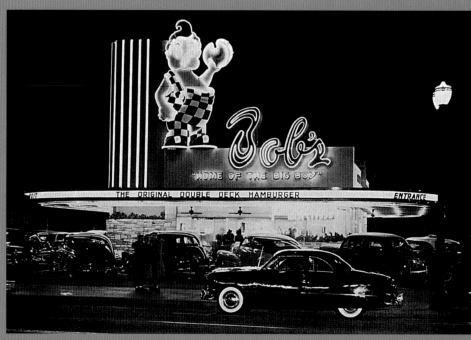

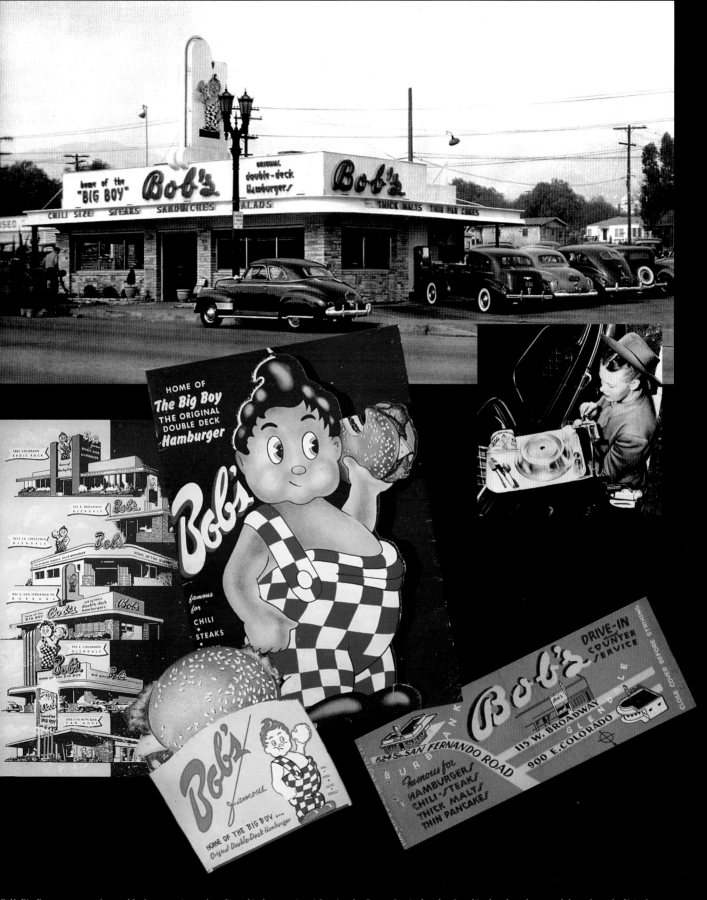

Bob's Big Boy restaurants featured both car service and traditonal indoor seating. A Los Angeles fixture for six decades, franchised outlets also spread throughout the United States. *Opposite top left.* Bob's original Colorado Boulevard diner in Glendale, California. *Top right.* Owner Bob Wian on opening day, 1936. *Inset.* Band members gather to sample a Big Boy Burger. *Middle.* Car service at the remodeled original location. *Bottom.* Packed with local high school students, Bob's Drive-In, shown at its original Glendale location at 901 East Colorado Boulevard, was the quintessential teen hangout, day or night, for Southern California teens in the late '40s through the '60s. *Above.* Bob's Burbank restaurant located at 624 South San Fernando Road.

coffee shop, once considered a part of the drive-in, was branching out as an independent venue. In the late '40s it appealed to a similar customer, used the same tactics to draw patrons and could do so without the sizable land and large staff of drive-ins. It was a trend that would severely erode the popularity of the drive-in and jeopardize its future.

There were also holdouts to the '30s type of drive-in. Ott's in San Francisco typified the neon-encrusted semicircle still being built in 1949. This style was beginning to look dated in comparison to the fresh models down the road. In Kansas City, the Nu-Way Drive-In, by Voskamp and Slezak, fused old and new styles in a modern box with large, plate-glass frontage. A nod to the past was the abridged display tower, banded in neon, that resembled the pylons of the '30s.

Most of the drive-ins erected in the post-war boom were simple, honest structures. In cities and towns across the nation, existing restaurants converted to curb service, which meant simply adapting the structure as it was or adding small touches that could be interpreted as drive-in imagery. A touch of neon or an enlarged highway sign could do the trick. Occasionally a new structure would rise and, budget permitting, a building with corresponding drive-in iconography would be constructed. Many owners just added the words drive-in, which meant that you drove into the parking lot to get to the restaurant inside, skewing the original meaning of the term car service.

The push for a competitive edge consistently motivated owners to search for the innovative and the novel, mainly through exterior design and interior equipment. Several drive-in operators reached further into their bag of tricks with some surprising results. One was The Track, at 8123 Beverly Boulevard in Los Angeles, which owner Kenneth Purdy called his motormat. The idea of eliminating car hops (and thus excess overhead) was gaining momentum, and at the motormat food was distributed to cars on automated conveyor belts radiating from a central kitchen. The covered boxes in which the food was shipped to the customer fit snugly against the car and were named after well-known racehorses, reiterating the racetrack motif. "No Tipping" flashed in neon from the roof, a plus Purdy hoped would draw in more customers. At his twenty stall's Purdy claimed he could serve 960 cars in a sixteen-hour day.

In Bloomington, Illinois, the Phil-Kron restaurant and theater opened in 1947, offering a combination movie and meal. The attraction was a drive-in restaurant that was located on both sides of a drive-in theater screen. Car service sans movie was available at the drive-in restaurant accessible from the main highway. For those diners catching a movie, a special area in front of the outdoor screen was reserved for car hop service. During the show, one merely had to place the menu under the windshield to get the attention of the roving hops.

Opposite. Opened in 1947, Henry's Drive-In in Glendale, California, was a significant departure from the rounded, neon-trimmed buildings of a decade earlier. Modern materials and exaggerated angles were now the attention-getting devices. Middle. The clean lines and geometric sharpness of Waddle's Drive-In in Portland, Oregon, were the latest in the style-driven restaurant business. Bottom left. This building design for the Chalon Drive-In in Inglewood, California, was a template for other drive-ins, examples of which could be found throughout the United States. Bottom right. Rettig's Houston Drive-In gave diners a taste of the future.

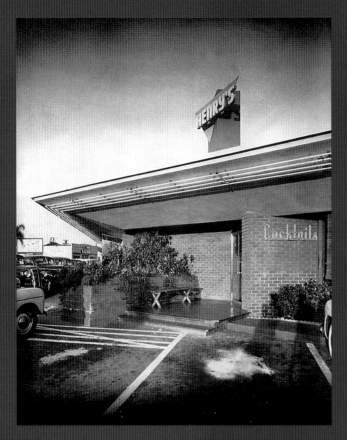

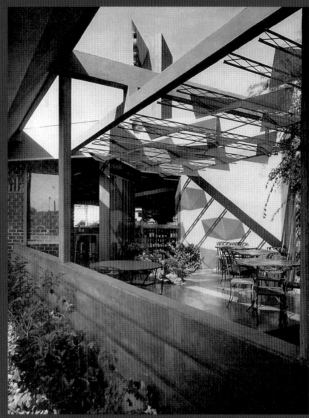

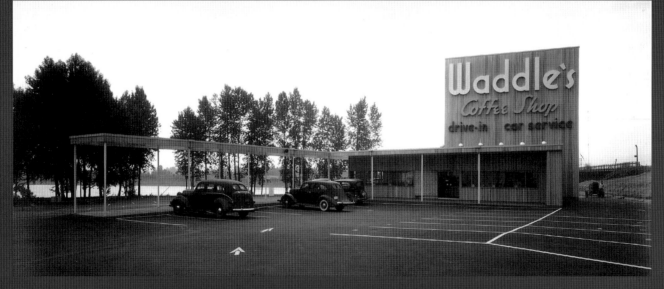

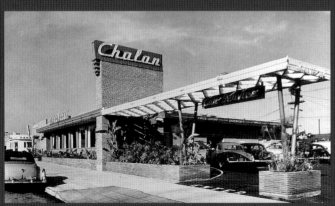

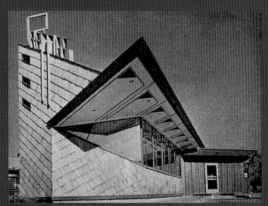

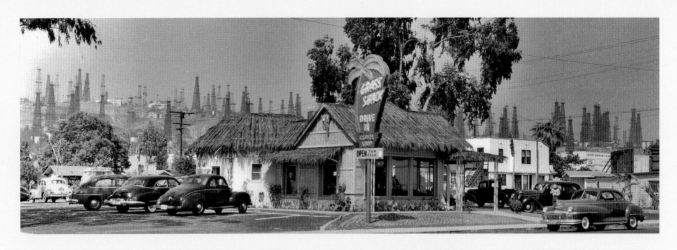

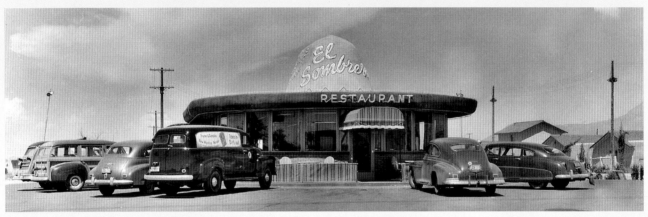

Culver Cadet into the lot, claiming the title of first customer to do so. Service of this sort couldn't be sustained because of the maneuvering and size of the airplanes, let alone the danger posed by rotating propellers. Still, in the late '40s at Elwood, Indiana, Sullivan's Drive-In issued postcards boasting to be the world's first "Fly-In-Drive-In."

Seeds of the drive-in restaurant's teen problem were sown in the '40s, as the drive-in replaced the soda fountain as a favored hangout. As early as January 1945, the Toll House restaurant in Webster Grove, Missouri, reported the kind of teenage rebellion that would plague drive-ins in the future. Stolen silverware, carved initials, paper-jammed jukebox coin slots, slashed upholstery, and other assorted acts of vandalism forced the owner to ban teens from his business. The fact that his regular customers were staying away in droves was a harbinger of events to come.

One thing that for the most part stayed unchanged in the '40s was the typical menu. The hamburger was still king, a fact confirmed by a two-tier study by the Food and Container Institute of the Armed Forces. It was "the most known, most used and best liked food," the institute concluded. Burgers now came double-decked, chili-sized, in squares, with bacon, or naked. The burger's growing popularity was closely watched by drive-in operators, who would soon shift their allegiance from a multi-itemed menu to one that offered hamburgers and little else.

The popularity of odd-shaped architecture for restaurant buildings had reached its peak in the 1930s, but vestiges of this tradition still persisted in the '40s, as shown by the examples on these two pages. Top. The Grass Shack on the Pacific Coast Highway in Signal Hill, California. Bottom. The El Sombrero Drive-In on Route 66 in Albuquerque, New Mexico.

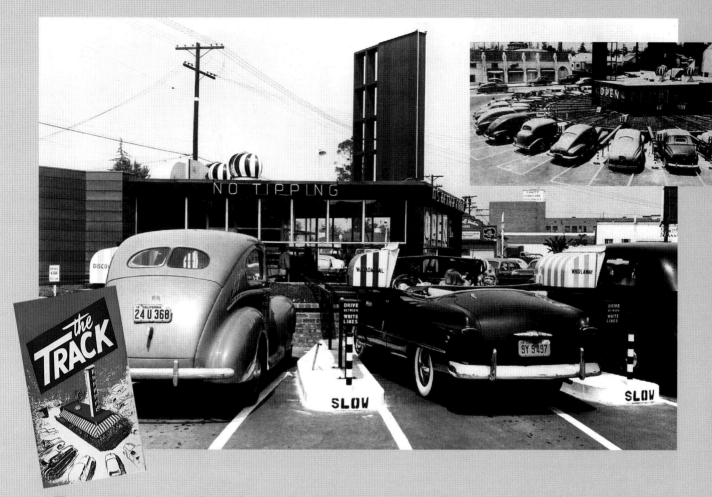

There remained, however, the combination drive-in dining room cocktail lounge restaurants whose menus seemed to ramble on forever. It was possible to get smoked salmon and Swiss cheese on rye, poached eggs on asparagus, codfish cakes with shrimp sauce, or jellied chicken loaf with fruit salad. Dessert choices might include black-bottom pie, mocha cake, or peppermint stick ice cream. This kind of variety over-burdened the concept of fast service and by the end of the '40s, drive-in service eliminated these superficial choices, remaining faithful to a few sure-sell favorites.

With the number of drive-ins reaching a saturation level for the first time, the need for speedy service impelled restaurant entrepreneurs to develop options other than car hops. Employee paychecks were an expensive overhead and were eating up as much as one-third of the owner's gross income by 1947. Owner's search for cost cutting measures resulted in legions of stands across the country that anticipated the fast food outlets of the '50s. Take-out and take-home were dining options that some drive-ins already offered. Now this idea was being proposed as the only way to purchase food. The prevailing message was: "Why sit in your car waiting for your meal when you can order a meal quickly, drive off with it, and consume it elsewhere? No mess. No fuss. No tipping." Though it seemed insignificant at first, this concept was an early indication that the drive-in was in for some stiff competition in the years ahead.

The Track, at 8123 Beverly Boulevard in Los Angeles, was part of an ongoing attempt to speed service and lower overhead by eliminating car hops and delivering food by a conveyor belt from a central kitchen.

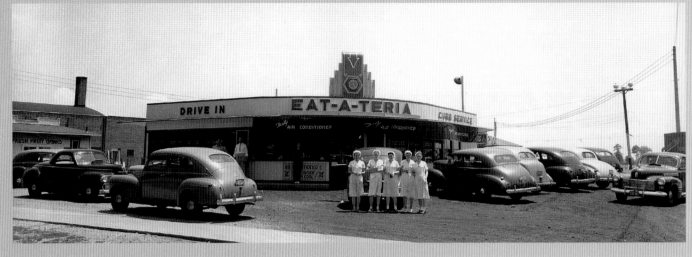

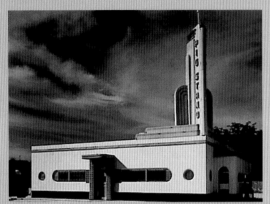

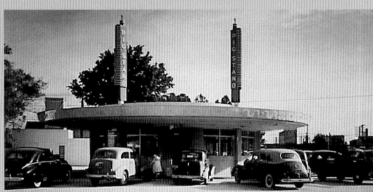

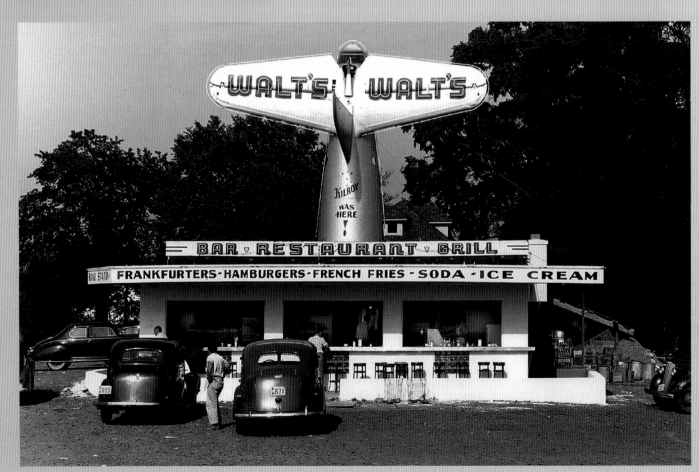

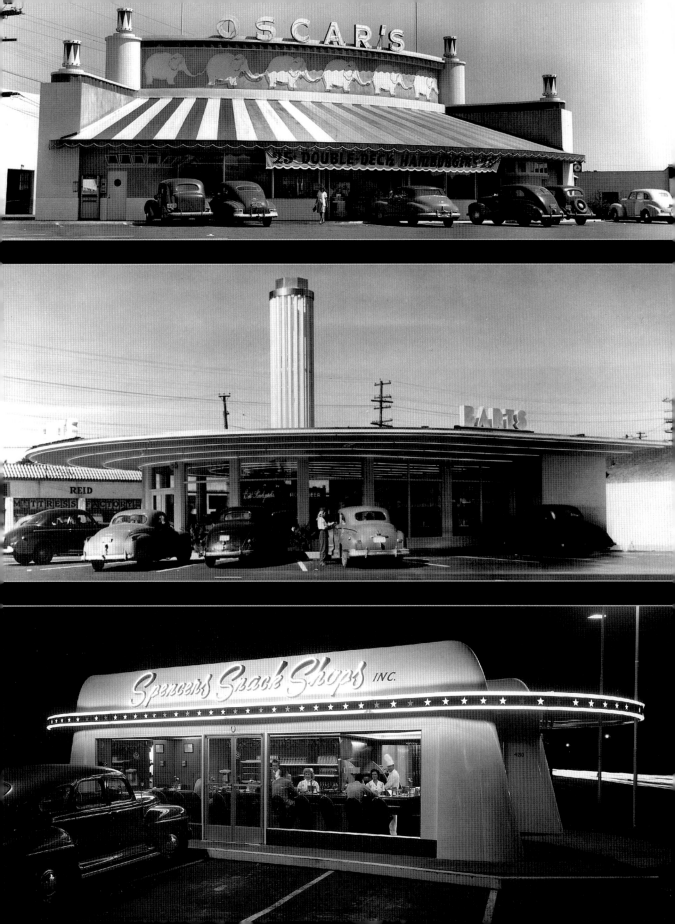

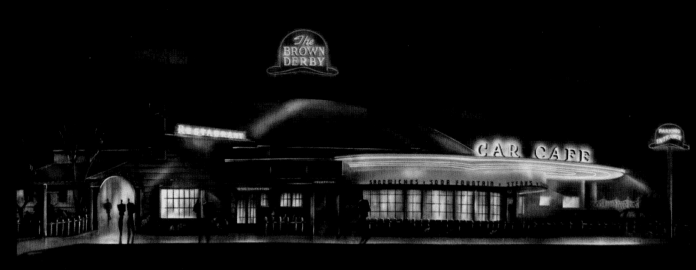

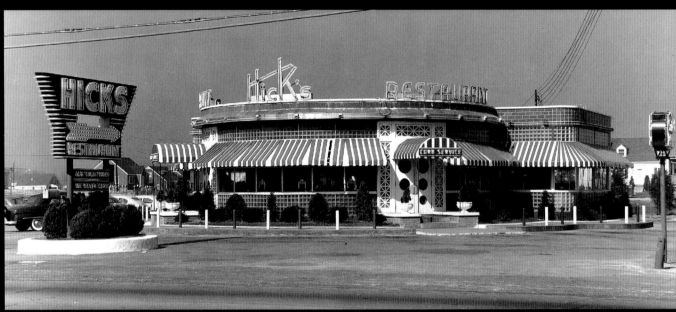

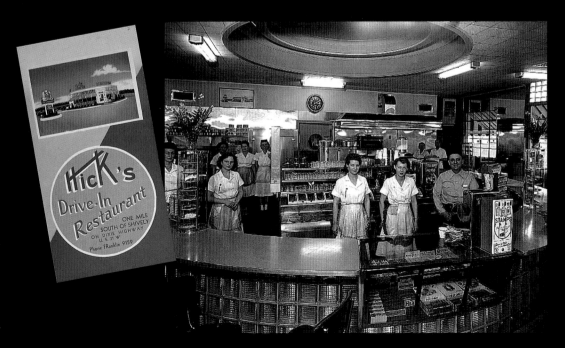

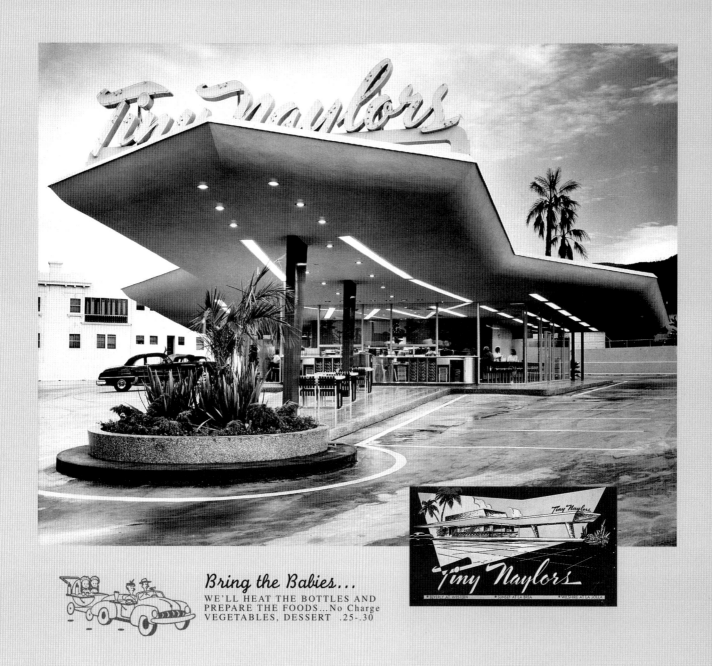

Bring the Babies...
WE'LL HEAT THE BOTTLES AND
PREPARE THE FOODS...No Charge
VEGETABLES, DESSERT .25-.30

Tiny Naylors

BEVERLY AT WESTERN • *SUNSET AT LA BREA* • *WILSHIRE AT LA JOLLA*

Page 100, top. *The Eat-A-Teria in Indiana was a modest structure with high turnover. Middle left. This San Antonio Pig Stand was a model of austere streamlining.*
Middle right. *A Beaumont, Texas, Pig Stand sports twin pylons atop a canopied classic structure. Bottom. Walt's, in rural Kentucky, was a startling roadside drive-up.*
Page 101, Top. *Oscars, at 4751 El Cajon Boulevard in San Diego, effectively advertised its location with a circus theme. The clever use of the circus tent motif as a protective awning for cars doubled as a striking attention-getter. Middle. Barts in Portland, Oregon, exhibits the pre-war styling that dominated the West Coast. Bottom. A post-war beauty, this Spencers Snack Shop, at the northeast corner of Olympic Boulevard and Crenshaw Avenue in Los Angeles, attempted to bridge car service and the coffee shop with a prefabricated food stand that would be efficient as well as inexpensive to operate. Page 102, top. Located in the Los Feliz district of Los Angeles, the Brown Derby added a car cafe to their chain of restaurants. This drive-in addition became a popular spot to glimpse movie stars. Middle. The glass block and brick of Hick's Drive-In in Louisville, Kentucky, demonstrate a transitional style between the Streamline and Modern drive-ins of the post-war period. Bottom. Hick's interior.*
Above. *Soaring into the Hollywood sky, Tiny Naylor's Drive-In, at Sunset and La Brea, was a vision straight out of an imagined future.*

The slow demise of the drive-in began in a period that is generally perceived to be its golden age. In the '50s and '60s the drive-in restaurant was faced with several challenges that would weaken its position in the food service industry and eventually place it on an endangered species list.

Still riding a crest of success in the early '50s, drive-ins were part of a nationwide eating binge that the entire restaurant field profited from. The National Restaurant Association reported in 1953 that eating out was a $16 billion a year industry, fueled by an increased population, a shorter work week, more travel, more suburban restaurants, and, ominously, a greater demand for take-home food.

1950s 1960s

In the early '50s, families and teens congregated at the drive-in, which provided an amicable atmosphere for both groups. The family trade was one segment of the market drive-in owners went out of their way to please and cultivate. Baby bottles were gladly warmed and the kiddies had their own junior menus of smaller portions at reduced prices. A dining room, in conjunction with car service, provided a perfect place for birthday parties. Youngsters at Hody's Los Angeles drive-in gobbled up a free, decorated cake. At the end of a drive-in meal, treats or prizes were handed out by a car hop with a wide smile and a cheery, "Come back soon!" But, when a

Opposite. Teens hang out at a local drive-in, in a publicity shot that masked the real teenage high jinx at '50s drive-ins.

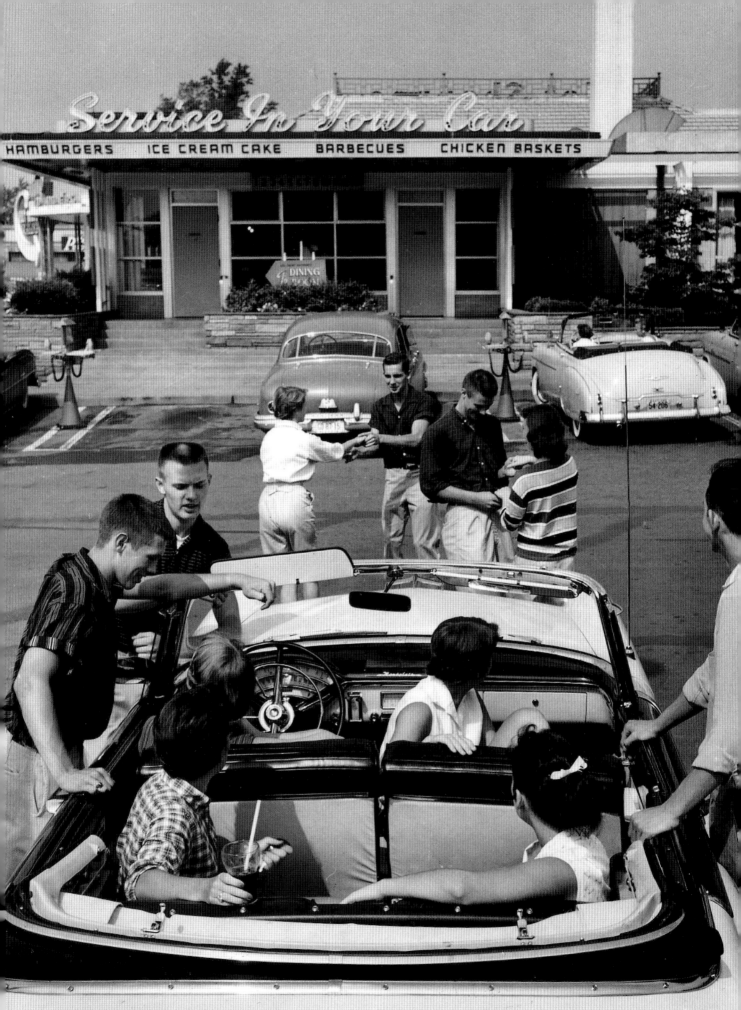

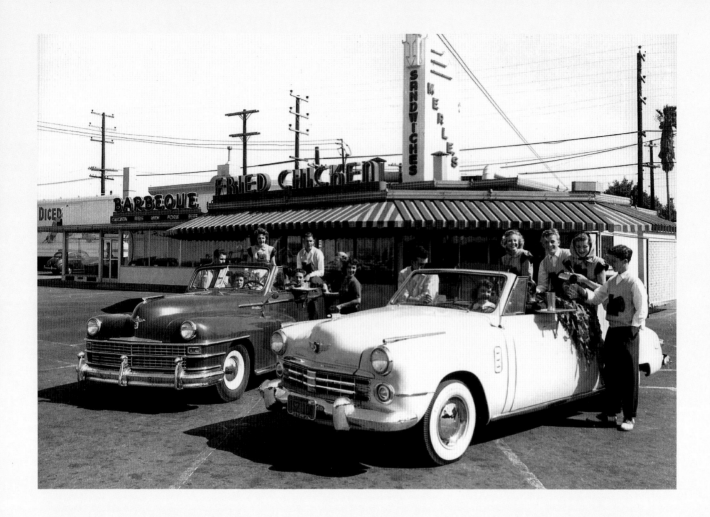

carload of teenagers pulled into a drive-in lot they were neither greeted nor sent off in the same manner. They were becoming a stubborn problem.

The Eisenhower era marked a shift in the mood of the country. There were communists, a cold war, and civil rights issues to contend with. There were beatniks and sputniks; there was Marilyn Monroe, Elvis Presley, and rebels without a cause. What used to be a clear-cut, black-and-white world was now an ambiguous gray and a rock 'n' roll pink.

Teenagers, who for the first half of the century had been known as young adults, discovered a niche for themselves in the fast-moving '50s. Their growing ranks as part of the baby boom had advertisers and retailers catering to their needs as never before. Disposable income and increased mobility or "having wheels" moved hangouts from the local soda fountain to the most logical spot: the drive-in. There teens could either be a blessing or a restaurant's downfall. They were often its downfall, because they never left. A business which depended on speedy service and quick turnaround would bottleneck if customers lingered too long. Teens didn't order large meals, yet they could make them last for hours, and they were a potentially volatile bunch. Radios blared and tempers flared. Most of the time, teens weren't welcome.

Clean-cut teens pose in front of Merle's Drive-In in Long Beach, California, for a high school yearbook photo.

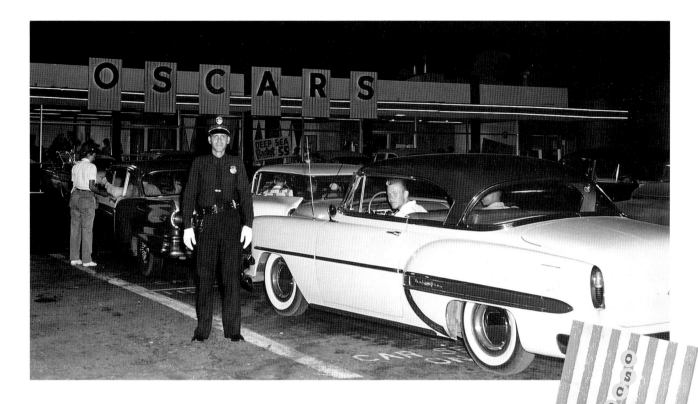

Owners and managers agreed that the teen problem was driving away their most treasured commodity: the family, which avoided the littered lots, the jammed service areas, and the traffic caused by perpetual cruising.

Owners banded together to find solutions for the growing teen dilemma. Some banned teens completely, which was promptly followed by a decrease in revenues. Other tactics included enforcing a minimum order or time limit on lingering. One Lincoln, Nebraska, owner suggested eliminating a tray when serving only coffee or soda so that, "they would move on sooner." A gate system was another solution. It provided tokens to customers who made a minimum purchase; customers returned the token to exit the drive-in's gated lot. If the minimum wasn't met, a token could be purchased for a quarter. Management was careful to point out to regular customers that such a system was installed to improve lot safety and service and to reduce congestion, but the problem persisted. For some teenagers, drive-ins were the high point of their social lives. For owners, the teenagers were a threat, gradually driving them out of business as family trade dwindled. Owners tried to be sensitive to their future customers and attempted to satisfy both the teenagers and the community, but to no avail. Guards were hired and restaurant associations across the country issued teen disturbance policies. In Pasadena, California, residents of a nearby Bob's Big Boy Drive-In sought a county ordinance banning rowdy behavior surrounding the establishment. Neighbors complained that youths were

Beefed up security was meant to keep unruly teens in line at Oscars Drive-In in San Diego.

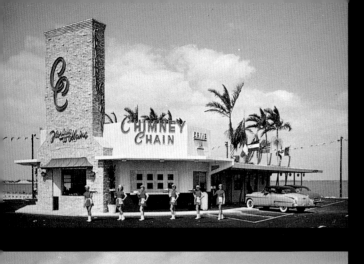

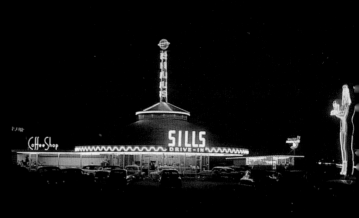

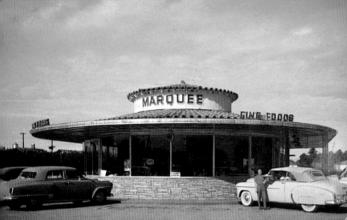

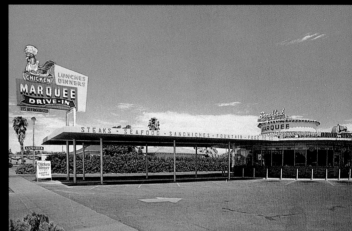

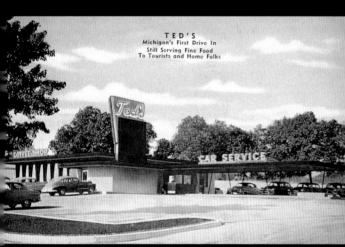

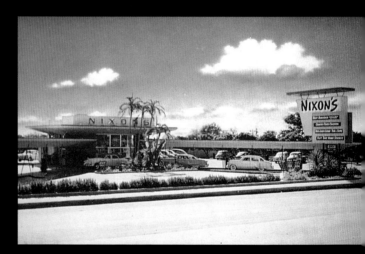

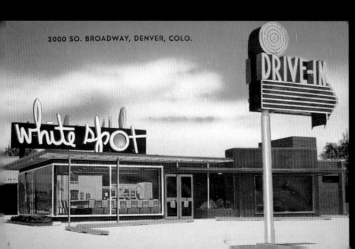

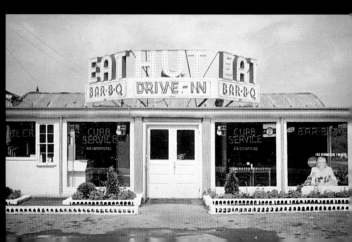

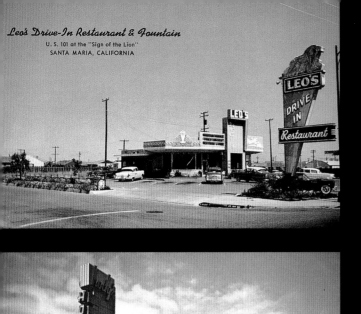

Leo's Drive-In Restaurant & Fountain
U. S. 101 at the "Sign of the Lion"
SANTA MARIA, CALIFORNIA

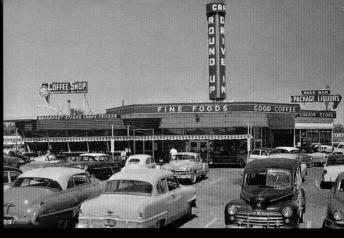

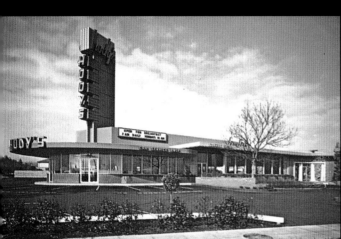

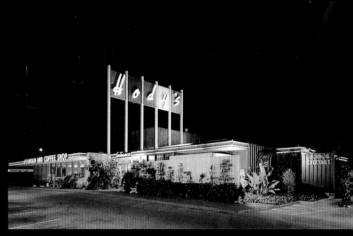

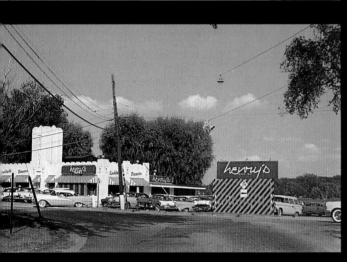

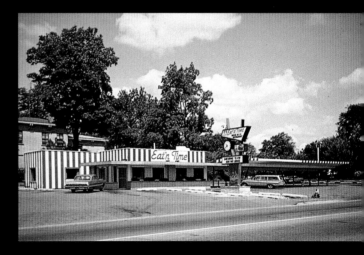

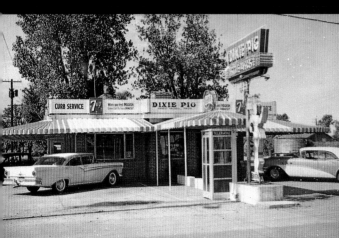

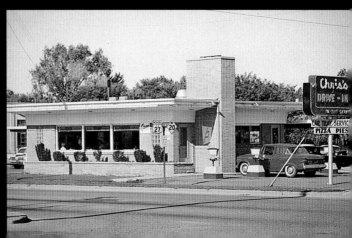

"using loud and indecent language above blaring car radios…The young people throw their beer cans, bottles and litter in the streets and yards with complete disregard for the residents." The Bob's Big Boy organization solved the problem by eliminating the drive-in facility when they expanded the restaurant. In spite of this growing problem, many drive-ins continued to operate smoothly and concentrate on innovative ways to improve building design and service to continue attracting customers.

The modern style of drive-ins introduced in the late '40s continued to exert their influence and proliferate. Tiny Naylor's Drive-In, built in 1949 by Douglas Honnold at the corner of Sunset Boulevard and La Brea Avenue, presaged '50s drive-in design. Taking its cue from the fledgling jet age, the protective canopy overhang, punctured by palms, soared toward the intersection. Drive-Inn Restaurant and Highway Cafe magazine declared it, "startling" and "the world's most modern drive-in." Its $200,000 price tag included a mile of fluorescent lighting and three hundred feet of radiant heating pipes buried in the terrazzo sidewalks to keep car hops and customers warm.

A similar design but with less panache was used in 1951 at Merle's Drive-In in Corona Del Mar, California. The marquee-style overhang zipped out to the highway and was supported and pierced at the end by an inverted pylon. The main building was a clipped octagon with front panels forming glass walls anchored by a slump stone base.

Departing from this stylistic direction, but contemporary nonetheless, the Clock Drive-In, at La Tijera and Centinela Avenues in the Los Angeles suburb of Westchester, was a bit more aggressive in its visual approach. Built as a combination coffee shop and drive-in in 1951, it was designed by the firm of Armet & Davis, soon to become the premiere coffee shop designers of the '50s. This was an example of well-placed imagination, creating a double-take newness appropriate for this type of commercial venture. A continuous roofline dropped into the ground and was visually supported at the entrance by a two-story wedge made of red porcelain enamel that served as the advertising pylon. Facing the street, the coffee shop was a low-slung horizontal box, its facade a wall of plate glass broken by triangular struts. Located behind the coffee shop, drive-in service facilities received a less dramatic treatment.

While several combination drive-in coffee shops successfully applied this architectural style, such as the Wich Stand in Los Angeles, the self-contained coffee shop made the best use of this imagery, developing a whole catalogue of distinctive buildings and forming a separate architectural genre soon to be coined Googie.

On the East Coast, another drive-in style made its debut in the '50s. The Virginia Gentleman Drive-In in Front Royal,

Page 108, clockwise from right. *Sill's Drive-In, Las Vegas, NV; Marquee Drive-In, Mesa, AZ; Nixon's Drive-In, Whittier, CA; Hut Drive-In, Middlesboro, KY; White Spot Drive-In, Denver, CO; Ted's Drive-In, Pontiac, MI; Marquee Drive-In, Mesa, AZ; Chimney Chain Drive-In, Miami, FL. Page 109, clockwise from right. Round Up Drive-In, Las Vegas, NV; Hody's Drive-In, Los Angeles, CA; Eat 'N Time, Delavan, WI; Chris's Drive-In, Mt. Pleasant, MI; The Dixie Pig, Blytheville, AR; Henry's Drive-In, Algonac, MI; Hody's Drive-In, Los Angeles, CA; Leo's Drive-In, Santa Maria, CA. Opposite, top. Martin Brothers Restaurant, a New Orleans Drive-In, offered curb service in combination with standard dining. Middle. Sun belt drive-ins had an easier go of it, as is made clear by this snow-bound Pryor's Drive-In in Indianapolis. Bottom. A Florida Pig 'n' Whistle projects a typical Southern image.*

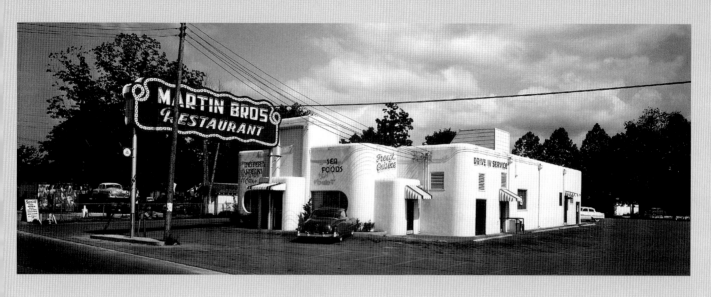

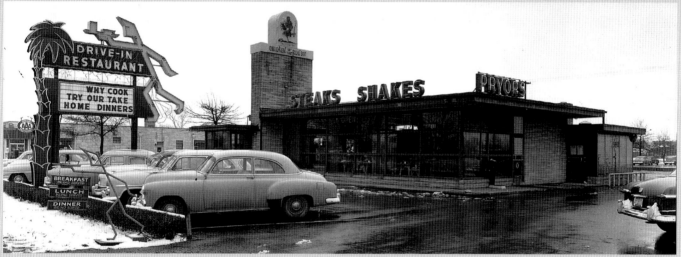

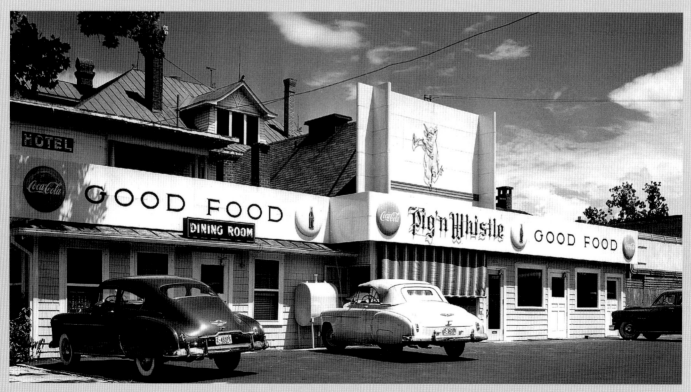

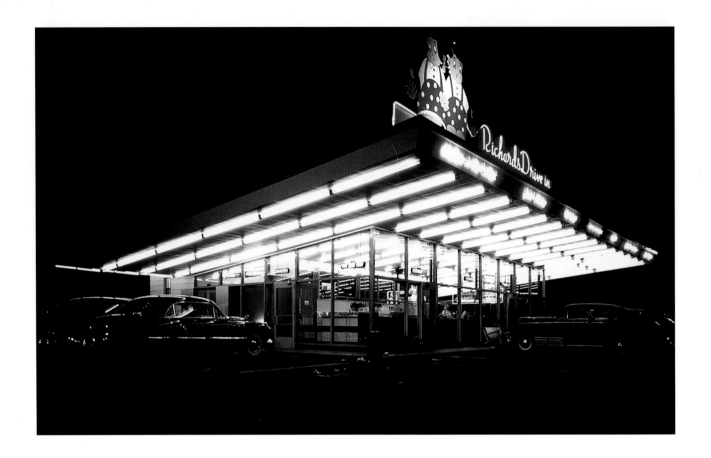

Virginia, by architect Earl R. MacDonald, the Park and Eat in Gulfport, Mississippi, and various Richard's Drive-Ins throughout the eastern seaboard all featured a bare-to-the-bones, two-story industrial hangar structure. An enormous flat roof supported by a glass box held a coffee shop with car service surrounding the building in an oversized lot. Underneath the overhang, banks of fluorescent lights illuminated outside and in, while on top of the roof, free-standing signage announced the restaurant's name. The entire effect was LARGE, but when translated to a smaller scale, this design proved to be a great model for dozens of ice cream stands and burger bars across the country.

The extended canopy, introduced by the Pig Stand in 1931, was one more instance of drive-ins melding function and style. Initially made out of canvas, they were used primarily to shield customers from the weather. They later developed into architectural elements functioning in the same way overhangs did. Their basic shape was usually straightforward and functionally flat, but as their importance to the style of the building increased, a variety of undulating "rock 'n' roll," gull-wing, and multicolored versions appeared. In some instances, the extended canopies could dominate a building, eventually becoming the building itself. In these cases, a clever name like Carporteria Drive-In might be used. At the Drive-O-Matic Drive-In in Hammond, Indiana, a sixty-two-foot conveyor belt ran the length of the aisle beneath the canopy, delivering food on top and returning soiled dishes below. Touted as a labor-saving device, it was one of a long

A wall of glass and a massive roof lined with fluorescent lights gave Richard's Drive-In in Michigan a dramatic highway presence.

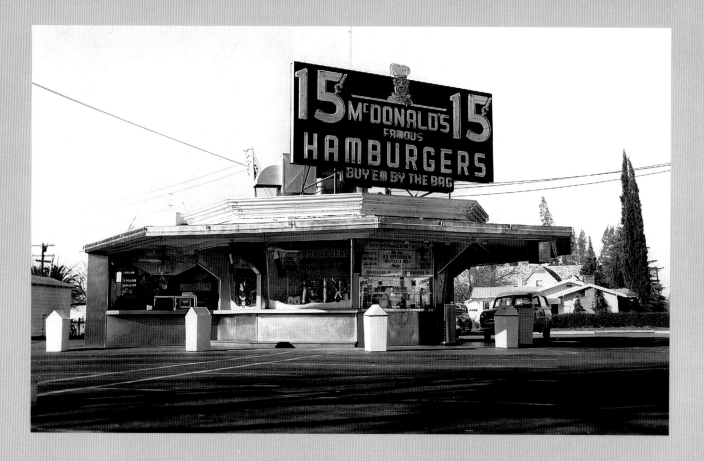

line of ideas developed in the '50s to meet the drive-in's never-ending quest for speed, efficiency, and cleanliness. Fast food service would result from this kind of experimentation. Costly overhead brought on by labor, lease, building, equipment, and food prices prompted drive-in owners to trim any or several one of these factors whenever possible.

Take-home service was an effort in this direction. A convenient sideline to curb service, take-out was a courtesy rather than policy for most drive-ins and at first it was slow to catch on. It was the elimination of the car hop that finally made self service a widespread reality. In 1948, two drive-in owners, brothers Richard and Maurice McDonald, did just that. Having run a small orange juice and hot dog stand since 1937 in Arcadia, just east of downtown Los Angeles, they moved farther east to 1398 North E Street in San Bernadino, where they opened an expanded drive-in with car hops. The brothers had the same problem many 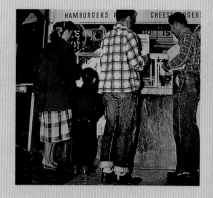 drive-in owners after the war had complained of—employees that were unreliable and of dubious character. So the McDonalds decided to drop car service and concentrate on a specific menu of ten items that a customer would have to get out of his car to buy. A production line preparing the reasonably priced ten-cent burgers, fifteen-cent French fries and twenty-cent malts was installed, with paper replacing dishes and fingers replacing silverware. The meal was bagged

The McDonald brothers revolutionized the restaurant industry with fast food minus car hops and curb service, signaling the beginning of the end for the drive-in restaurant. Top. The McDonald's converted drive-in San Bernadino, California. Bottom. Customers line up for 10¢ McDonald's hamburgers in the early fifties.

in a speedy twenty seconds. Their 192-square-foot octagonal building was slightly remodeled for the carry-out service, with warming lamps placed above the service windows for chilly nights. Initially customers found the familiar drive-in form confusing without the trademark car hop, but once they became accustomed to walking up and either eating at the counter ledge or in their car, they flooded the place. A 1952 article in Restaurant Management featured the McDonald's outlet, running this headline, "One Million Hamburgers and 160 Tons of French Fries a Year." Franchising followed and a few years later a milkshake machine salesman named Ray Kroc became the McDonald's agent, taking the franchise nationwide. A building with comfortable drive-in imagery was sketched by Richard McDonald and realized by local architect Stanley Meston, and the golden arches made their debut in Phoenix, Arizona, in May 1953. The end of the traditional drive-in was fast approaching.

With the climate ripe for this type of service, hundreds of variations of the McDonald's theme began to appear in the early part of the '50s. There was Pay-N-Tak, Thrift-O-Mat, Hamburger Hand-Out, Burger Queen, and the Cheese Hut. All would later be joined by franchises and other fast food outlets by the score.

Along this line of abbreviated service concepts, a Big Boy (no relation to the Bob's Big Boy chain) Drive-In in Billings, Montana, and the Tastee In and Out in Lincoln, Nebraska, installed microphones along their driveways leading to their small, main buildings. After ordering, customers drove the short distance and picked up their drive-thru meal.

In Florida, Burger King replicated the McDonald's idea with eighteen-cent burgers, walk-up service, and their miracle "Insta" machines for making mass-produced malts and burgers. In spite of these developments, traditional drive-in service managed to hold its own. Big chains helped the industry stabilize and Bob's Big Boy, Steak 'N Shake, Sonic, Dog 'N Suds, A&W and others continued to be successful car hop operations. They were joined by the independently owned outlets spread out in every town and along every highway. Some of these drive-ins could be counted on to provide interesting additions to regular dining fare, all in an attempt to drum up business.

Several drive-ins provided entertainment to go along with the meal. Al and Violet Travelstead at their Howdy Pardner Drive-In in Boise, Idaho, transformed the roof of their elongated carport into a stage, complete with piano, for their midweek floor shows. Created by the owners, their "Stage in the Air" welcomed local talent while car hops clad in cowgirl garb served the audience in their cars below. Strictly a family affair, the Travelsteads even concocted special fountain items for the tikes—the Little Pedro Parfait and the Mule Train Maverick sundae.

The Snak Shak Drive-In in Chambersburg, Pennsylvania, invited customers to pass the time at their establishment by playing shuffleboard or dancing on the cement slabs that flanked either side of the main building. This summer-only

Opposite, top and middle left. Stan's Drive-Ins, found throughout California, were a successful restaurant chain that spanned several decades in the Golden State. Middle right. The Manveda Drive-In, at Sepulveda and Manchester Boulevards in the Los Angeles community of Westchester, retained it's '40s-style building while serving '50s customers. Bottom. Cruise time at Kansas City's Dixieland Drive-In.

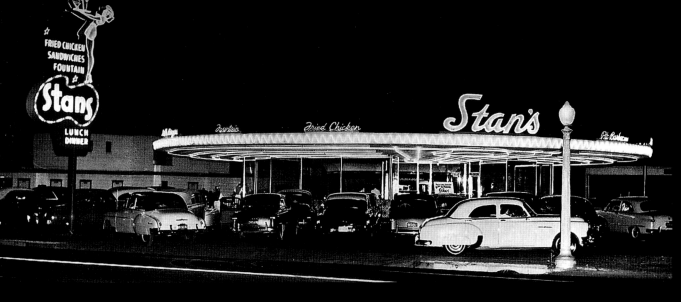

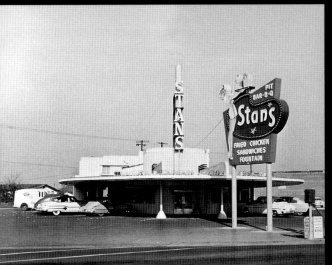

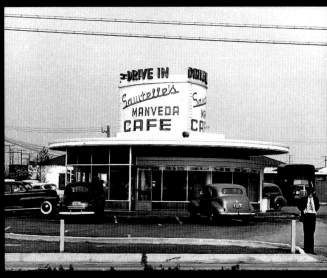

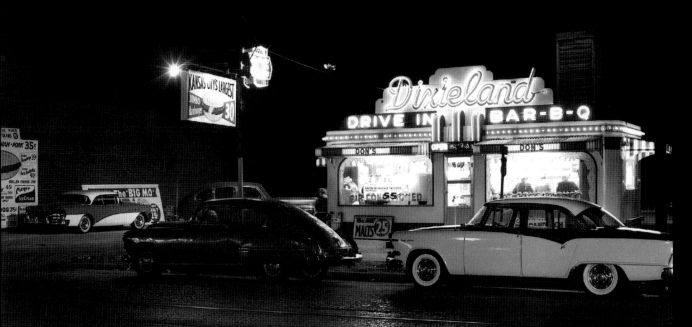

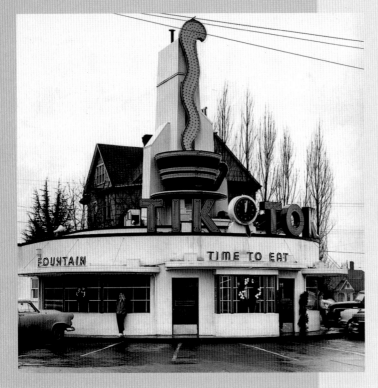

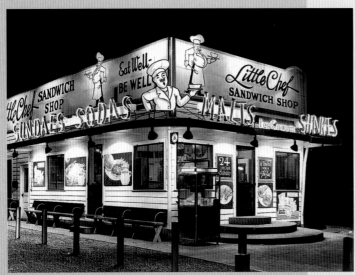

attraction, included a small shed that housed a jukebox and a pinball machine. With these additional diversions receipts doubled. Owner Clara Snyder said, "It certainly has been a real hypodermic for our business."

In Rosemead, California, at the Burger Square, meal-time bargain hunters were encouraged to step up and try the square burger which gave them "four extra bites—one at each corner."

The Little Chef Drive-In in Louisville, Kentucky, claimed that the new electronic opiate, television, was affecting customer sales because patrons were staying glued to the tube and off of the road. Their response was to buy a fleet of trucks as a sideline to their car service and offer housebound viewers home delivery from their menu. By 1955, these mobile kitchens accounted for 60 percent of the restaurant's business.

In warmer climates where heat was a problem, owners anxious to make customers comfortable in their cars introduced individual air-conditioning units. A hose dropped from a unit attached to the overhang and was inserted by the car hop as the menu was given. Two drive-ins that tried it, the Blue Onion in Las Vegas and Stuart's Drive-In in Houston, reported success, but the idea faded due to the expense, maintenance, and the short season the air conditioner was used. Conversely, in colder

Top. A giant cup of coffee blinked atop the Tik Tok Drive-In in Portland, Oregon. Middle. The Little Chef Drive-In in Louisville, Kentucky, offered home delivery service to combat stay-at-home TV viewers in the early fifties. Bottom. In climates where hot weather was an ongoing problem, drive-in owners went to great lengths to keep customers returning. Shown are individual air condition units for drive-in patrons. Opposite, top left. Teletray service at the Totem Pole Drive-In was part of a continuing attempt to phase out car hops. Top right. Various methods were attempted at self service including this early-fifties drive-through, the Tastee Inn. Middle and Bottom. Oscar's in San Diego and Scrivner's, at the former site of a Roberts Drive-In on Sunset Boulevard in Hollywood, were teen central in 1958, when local radio stations broadcast their programs live from the restaurant.

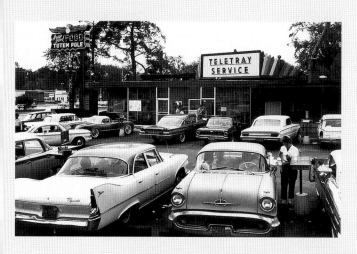

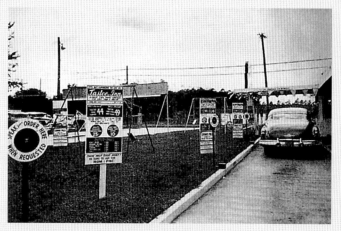

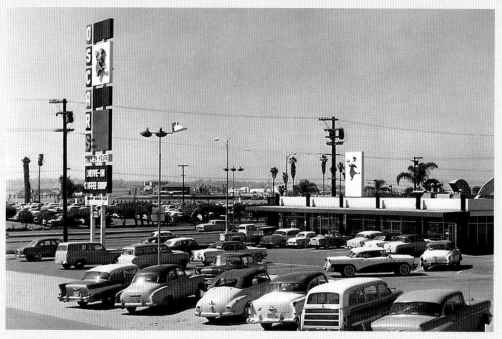

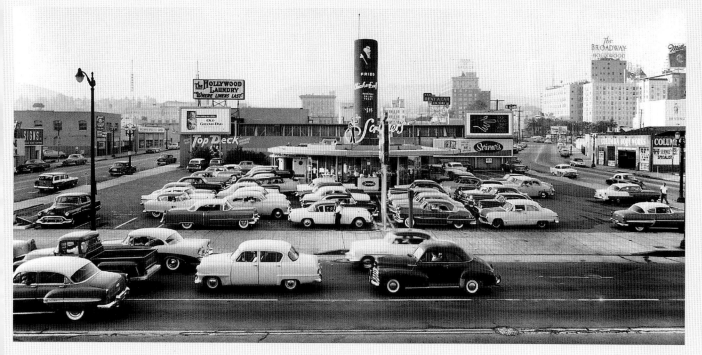

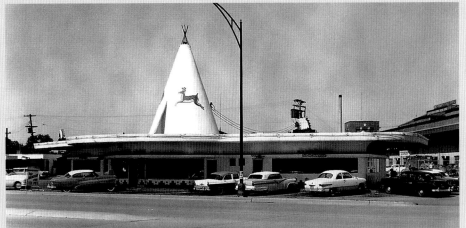

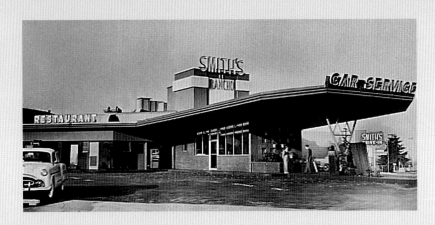

climes, heating units were installed beneath overhangs on poles in an attempt to prolong the selling season.

Electronic ordering equipment flourished briefly in the '50s. A few drive-ins had experimented earlier with walkie-talkies, but most restaurants installed the "electronic car hop," promoted by various companies under names such as Servus-Fone, Teletray, and Orda-Phone. A speaker, similar to the kinds used in drive-in theaters, was mounted on a serving station equipped with a permanent menu and tray table. After pressing a button, a switchboard operator would take the order. The press of another button switched on hi-fi music that entertained the customer until meal and bill arrived via car hop. When the patron was ready to go, the tray was returned to the service table and the customer was off.

Several food items introduced in the drive-in at about the same time became so popular they warranted their own separate eating venues. These food outlets added to the growing competition for the drive-in dollar. The pizza craze of the late '50s was emblematic of this trend. Pizza parlors joined a crowded market that included pancake houses, donut shops, and steak joints, making it clear that a culinary shoving match was in progress.

The drive-in restaurant, in transition as the '50s closed, was breathing its last gasp by the mid-'60s. Though portrayed in the media as a thriving teen haven, the drive-in was dwindling. The collective problems and developments of the

Top. Opened in the '30s, the Tee Pee, one of Indianapolis's first drive-ins, continued its success until the '80s, when it was demolished. Bottom. After World War II, drive-ins developed in Modern architectural style. Indicative of this emerging design shift was Smith's Rancho Drive-In in Arcadia, California. Opposite. Massive parking lots could accomodate the overflow crowds at these 1950 drive-in gems. Top. Yaw's Drive-In, Portland, Oregon. Middle. Allen's Drive-In at 12th and White Streets in Kansas City, Missouri. Bottom. Jim's Burgers in San Antonio, Texas.

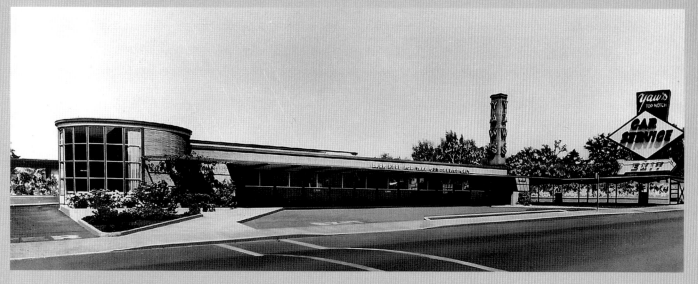

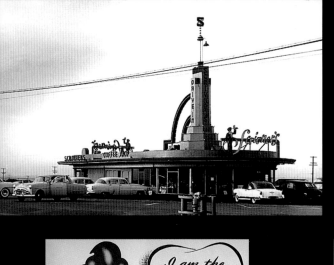

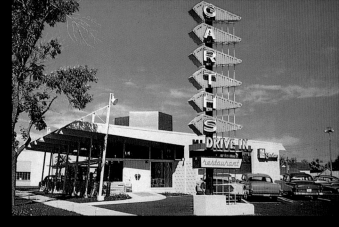

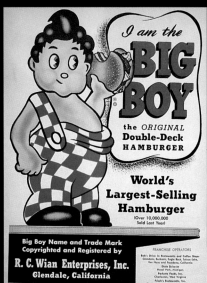

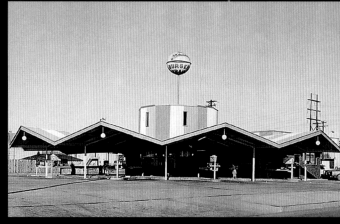

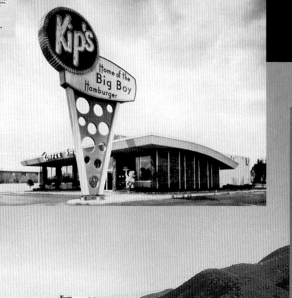

previous fifteen years were now challenging its very existence. In Southern California, the drive-in had flourished for four decades, but an ever-expanding population was forcing land values up, making most of the prime drive-in locations economically unfeasible. Compounding the problem was the highly developed freeway system, which drained the main thoroughfares of their vitality. Other parts of the country wrestled with similar problems. Ultimately the power of the family dollar determined the fate of the drive-in, and fast food outlets won decisively.

One by one, drive-ins switched over to take-home, self-service, or fast food operations…or simply fell into oblivion. The term drive-in now came to mean any restaurant that accommodated a car, but not necessarily service in your car. In the '70s some traditional drive-ins, complete with car hops, dotted the country, but they had become antiquated versions of their former selves. Several chains maintained their car service. Notable were A&W and the Sonic Drive-Ins, which survived the fast food frenzy mainly because of their small-town locations. The independently owned drive-in took a beating from prohibitive start-up and operating costs which left the majority of casual-dining restaurants in the hands of large businesses and corporations. Public indifference and the shifting cultural values evident in the late '60s were also to blame and nailed the drive-in's coffin shut. In 1984, Tiny Naylor's, which had stood at the same Hollywood intersection for thirty-five years, met the wrecking ball. Attempts by preservationists to save the structure were in vain, and in its place a multiunit, nondescript mini mall was constructed. Its destruction was the symbolic internment of a cultural phenomenon fostered in a city consecrated to the car.

Yet car service still remains. It is an image that refuses to die. It surfaces periodically in nostalgic re-creations and is seasonally resurrected across small-town America. The cultural importance of the drive-in is tied to the years when it was a populist icon. From the early '20s to the late '50s, the drive-in reflected the eating preferences, the recreational habits, and the architectural stylings of an important sector of twentieth-century American society. Following its journey gives us insight into public tastes and social customs. Though its stature has diminished, the drive-in restaurant remains, nonetheless, one of a handful of artifacts that can measure up to the title of American icon.

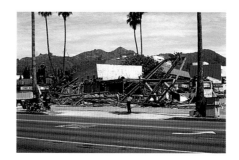

Opposite, top left. Many vintage '30s drive-ins survived several decades unchanged, such as this Scrivner's Drive-In at the corner of Imperial Highway and Western Avenue in Los Angeles. Top right. The future was foreshadowed at Garth's Drive-In in Colorado Springs, Colorado, which used coffee shop imagery for its drive-in service. Middle right. An exaggerated canopy zig-zagged around a central drum in this Texas drive-in, providing one more example of '50s design exuberance. Bottom. Open in 1949 this Bob's Big Boy in Toluca Lake, California, remains an active eatery with limited car service. Insert. Kip's, a Big Boy franchise, entered the '60s minus car service. Above. Emblematic of the drive-in's demise was the 1984 demolition of Los Angeles's last functioning drive-in, Tiny Naylor's, in Hollywood.

EPILOGUE

The demise of the drive-in restaurant at the end of the 1960s gave rise to its mythology. As car hops and curb service were slowly being phased out by fast food outlets, the last generation of drive-in customers began to re-examine this indelible part of their youth. Filmmaker George Lucas recalled his Modesto, California, cruising days in his film *American Graffiti*. Filmed at Mel's Drive-In in San Francisco, it has since become one of the drive-ins most celebrated homages.

Other movies also found drive-in imagery illuminating and in the 1937 film *Hollywood Hotel* a compact drive-in set was featured in one of the musicals scenes. The film version of author James Cain's *Mildred Pierce* had Joan Crawford running a snappy drive-up whose exteriors were shot at a San Fernando Valley drive-in called The Kays, which was located at Laurel Canyon and Magnolia Boulevards. In the 1950s version of *A Star Is Born* Judy Garland works as a car hop before her character hits stardom. Spencer Tracy dined at a drive-in in *Guess Who's Coming to Dinner*, and numerous other feature films and B-movies employed the drive-in as backdrop.

Writers too found the drive-in a great background for their characters. Crime and detective fiction of the '30s and '40s, notably the work of James Cain and Raymond Chandler, used the drive-in as effective set pieces. In Cain's *Mildred Pierce* his main character runs a chicken and waffle stand in Glendale, California, while in another of his books, *The Postman Always Rings Twice*, a roadside restaurant in rural California is the focal location. In Raymond Chandler's *Little Sister* private detective Phillip Marlowe drives through a film noir Los Angeles, into Hollywood and towards the Cahuenga Pass…"I drove on past the gaudy neons and false fronts behind them, the sleazy hamburger joints that look like palaces under the colors, the circular drive-ins as gay as circuses with chipper hard eyed car hops, the brilliant counters, and the sweaty greasy kitchens that would have poisoned a toad."

A similiar journey was taken by Aldous Huxley in his novel *After Many a Summer Dies The Swan*. Arriving by train, his protagonist, Jeremy Posdage, leaves downtown Los Angeles's Union Station and heads towards the ocean. "The car was travelling westwards, and the sunshine, slanting from behind them as they advanced, lit up each building, each sky-sign and billboard,…Eats. Cocktails. Open Nights. Jumbo Malts…The car sped onwards, and here in the middle of a vacant lot was a restaurant in the form of a seated bulldog, the entrance between the paws, the eyes illuminated…Drive-In for nutburgers—Whatever they were. He resolved at the earliest opportunity to have one. A nutburger and a jumbo malt…Classy Eats. Mile High Cones. Jesus Saves. Hamburgers."

While the drive-in was an easily recognized American icon, attempts to translate its success in other parts of the world were less effective. Nonetheless, versions of drive-ins popped up in Great Britain, Japan, Canada, and Mexico. Ultimately the drive-in restaurant succeded best in a culture committed to the car, and it was in the United States that it continued to prosper, remaining a uniquely American experience.

The slow fade of the drive-in restaurant by removal, remodeling, and demolition has eliminated the best examples of this architectural genre. However, the remnants of long-abandoned restaurants still pop up along the roadside and vestiges of the drive-in form can be gleaned while driving urban boulevards. The best place to spot an active drive-in in unaltered form is in small-town America, where some drive-in restaurants have managed to survive. Merle's in Visalia, California, unchanged since the '40s, continues to dispense cherry malts and burgers. The same goes for Beckers Drive-In, the Bear's Den, and Mug 'n' Bun in Indianapolis. An A&W in Modesto, California, still has roller-skating car hops, a phenomenon whose resurgence has more practitioners today than existed during the heyday of the drive-in restaurant. Leon's Custard Stand in Milwaukee, Wisconsin, still features drive-up service at its original '40s location in a building last remodeled in 1955. In Los Angeles, Bob's Big Boy in Toluca Lake has been given landmark status and manages to continue car service on selected days in its 1949 vintage coffee shop/drive-in.

The glory years of the drive-in may have vanished but with a little luck and a lot of imagination it's still possible to experience what was once the birthright of every kid and family with a car. Happy hunting.

Above. Fast food and teenagers signal the end of the drive-in era.

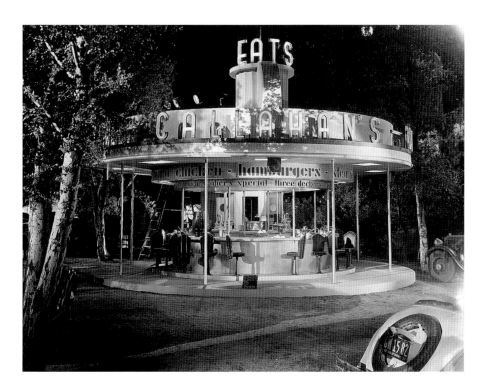

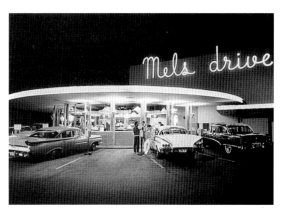

Drive-ins proved to be great visual vehicles for motion pictures. Top. A set from the 1937 film Hollywood Hotel. *Middle right.* Judy Garland takes James Mason's order in A Star Is Born. *Bottom right.* Mel's Drive-In *became the symbol of an idealized youth in* American Graffitti. *Bottom left.* Michelle Lee and Dean Jones are served by Iris Adrian in The Love Bug. *Middle left.* Tom Neal and Ann Savage in Detour.

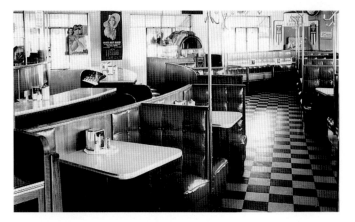

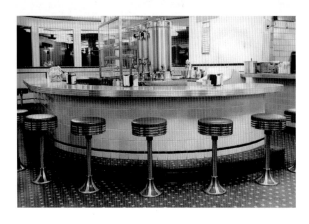

Drive-in interiors came in plain and fancy. Inside seating at drive-ins was usually simple and straightforward. Backless stools discouraged lingering, thus inducing quick turnover.

SELECTED BIBLIOGRAPHY

"A Square Meal." *Restaurant Management*, March 1953

American Heritage History of the 1920's and 1930's. New York: American Heritage Publishing Co., Inc., 1970

"American Roadside." *Fortune*, September 1943

"Air Conditioned Drive-In Service." *American Restaurant*, July 1957

Anderson, Will. *Mid-Atlantic Roadside Delights.* Portland, Maine: Anderson and Sons, 1991

Baeder, John. *Diners.* New York: Harry N. Abrams, Inc., 1978

———. *Gas, Food and Lodging.* New York: Abbeville Publishers, 1982

"The Banana Split Boom." *Food Service Magazine*, June 1958

Bayer, Patricia. *Art Deco Architecture, Design, Decoration and Detail from the Twenties and Thirties.* New York: Harry Abrams, Inc., 1992

Beitkins, Edvins. "Oh Happy Days." *California Living Magazine*, November 20, 1983

"Belles of the Boulevard." *Westways*, March 1940

"Better Drive-In Service." *American Restaurant*, September 1951

"Big Business with a Small Menu." *American Restaurant*, July 1955

"Bloomington Gets Beautiful Theatre-Restaurant." *American Restaurant*, October 1947

"Car Hops Testify Their Tips Run $25 to $60 Weekly." *Los Angeles Times*, April 12, 1941

Carbone, Joe. "Planned for Profit." *American Restaurant Magazine*, January 1953

"Carl's at the Beach." *Pacific Coast Record*, December 1939

"Carl's Viewpark." *Pacific Coast Record*, April 1938

"Carpenter's Catering Catching On." *Pacific Coast Record*, January 1933

Carroll, Rick. "Last of the Old Time Drive-In's." *San Francisco Chronicle*, October 18, 1976

Chazanov, Mathis. "A Burger To Go and a Landmark Drive-In Is Gone." *Los Angeles Times*, March 12, 1984

"Chicken Speciality Hatched from Chance Remark." *American Restaurant*, March 1954

Cirigliani, Linda. *Hoot Mon! The Story of the Tam O' Shanter Inn.* Los Angeles: Lawry's Restaurants, Inc., 1994

"Clowns on Roller Skates-Car Hops with Extra Appeal." *American Restaurant*, September 1954

Cody, Larch. "Are Drive-Ins Being Driven Out?" *Los Angeles Herald Examiner*, California Living, March 4, 1973

"Compact and Compelling." *Pacific Coast Record*, August 1940

"Converting an Abandoned Drive-In Cafe into a Flourishing Enterprise." *Restaurant Management*, March 1945

"Curb Service Dictates New Form." *Architectural Record*, March 1938

Davis, Deering. *Restaurants, Lounges and Bars.* New York: Architectural Book Publishing Co., Inc., 1950

"Designed to Catch the Eye." *American Restaurant*, February 1956

"Designing Modern Drive-Ins." *Restaurant Management*, September 1946

"Dog and Suds." *American Restaurant*, June 1958

"A Drive-In That Features Roof Garden Entertainment." *Restaurant Management*, April 1953

"A Drive-In That Offers Cafeteria-Type Service." *Restaurant Management*, April 1952

Drive-In Management Guidebook. Harbrace Publications, Inc., 1968

Drive-In Operators Handbook. Davidson Publishing Company, 1961

"Drive-In Restaurant Near Jantzen Beach." *Progressive Architecture*, June 1947

"The Drive-In." *Motor Court Management*, August 1948

"The Drive-In Comes to Oklahoma." *American Restaurant*, January 1937

"Drive-In Service Goes Automatic." *American Restaurant*, September 1953

"Drive-In Rowdies Face Crack Down." *Los Angeles Times*, September 4, 1966

Ehle, Henry. "Dollars Roll in as Food Rolls Out." *American Restaurant*, January 1955

"Evolution of a Drive-In." *Drive-In Management*, April 1965

"Eye Catching Roofs Catch More Business." *American Restaurant*, June 1957

Fleming, John. "Halting Hunger on the Highway." *The Magazine of Light*, September 1932

"Foods Made Fast Sell Fast." *American Restaurant*, February 1955

"The Fred Harvey of the Highways." *Pacific Coast Record*, September 1947

"Forum Enters the Drive-In Field." *American Restaurant*, May 1942

"From Root Beer Stand to Millions." *American Restaurant*, May 1948

"From Stand to Stand Out." *Pacific Coast Record*, June 1940

"Future Design Trend for Drive-Ins." *Drive-Inn and Hiway Restaurant Cafe Magazine*, October 1950

Gebhard, David. *Schindler*. Santa Barbara: Peregrine Smith, Inc., 1980

Gebhard, David, and Harriette Von Breton. *Los Angeles in the Thirties, 1931-1941*. Los Angeles: Peregrine Smith Inc., 1975

Hamilton, Andrew. "Dining Out A La Car." *New York Times*, July 27, 1941

Harrigan, Stephen. "Main Street."

Texas Monthly, February 1983

Hess, Alan. *Googie, Fifties Coffee Shop Architecture*. San Francisco: Chronicle Books, 1985

Hines, Thomas S. *Richard Neutra and the Search for Modern Architecture*. New York: Oxford University Press, 1982

Hirshorn, Paul, and Steven Izenour. *White Towers*. Cambridge: The MIT Press, 1979

"Hody Sets the Pace for Take Home." *Food Service*, April 1955

Hoopes, Claudia. "From Root Beer to Millions." *American Restaurant*, May 1948

Horowitz, Joy. "One Restaurant To Go." *Los Angeles Times*, May 28, 1980

Hotels, Motels, Restaurants and Bars. New York: F.W. Dodge Corporation, 1960

"Houston Drive-In Trade." *Life*, February 26, 1940

"How Hody's Trains Car Hops." *Diner Drive-In Magazine*, June 1955

"Installing an Outdoor Dance Floor." *Restaurant Management*, April 1955

Jones, Dwayne with Roni Morales. "Pig Stands." *Society for Commercial Archaeology News Journal*, Winter 1991–92

"Just a Job Isn't Enough."

Restaurant Management, September 1955

Keller, Ulrich. *The Highway as Habitat, A Roy Stryker Documentation, 1943-1955*. Santa Barbara: The Regents of the University of California, 1985

Ketchum, Morris, Jr. *Shops and Stores*. New York: Reinhold Publishing Corporation, 1948

Kordic, Carol. "Decades of Change." *Restaurant Hospitality*, December 1979

Langdon, Philip. *Orange Roofs and Golden Arches, The Architecture of American Chain Restaurants*. New York: Alfred A. Knopf, 1986

Lee, James. "Service a la Car." *Restaurant Man*, September 1930

Liebs, Chester. *Main Street to Miracle Mile, American Roadside Architecture*. Boston: Little, Brown and Company, 1985

"Los Angeles Lowdown." *The Diner*, September 1946

Maier, Jack. "And Over 808,000 Satisfied Customers Later." *American Restaurant*, February 1953

McLellan, Dennis. "Nostalgia in Vintage Cars." *Los Angeles Times*, October 8, 1981

"Misfortune Led Him to Success."

Pacific Coast Record, August 1937

Motor Courts and Drive-Ins. New York: Ahrens Publishing Company

Morken, Cal. "Your Drive-In Heritage." *Drive-In Management*, September 1961

Murrill, Jan. "A Car Hopper Looks at the Stars." *Motion Picture*, August 1935

"New Drive-In a la Hollywood." *Los Angeles Mirror*, July 8, 1949

"New Hat for Los Angeles." *Pacific Coast Record*, August 1941

"The New Plantation." *Pacific Coast Record*, January 1942

"New Roberts Drive-In at Burbank." *Pacific Coast Record*, February 1942

"New Wheeler Drive-In Reflects the Most Modern Food Service Trend." *American Restaurant*, December 1941

Olive, Michael. "Is Everything Allright?" *Restaurant Management*, January 1952

O'Meara, John. "Drive-In Service Do's and Don'ts." *American Restaurant*, July 1956

"One Million Hamburgers." *American Restaurant*, July 1952

Oreb, Nick. "Converting an Abandoned Drive-In Cafe into a Flourishing Enterprise." *Restaurant Management*, March 1945

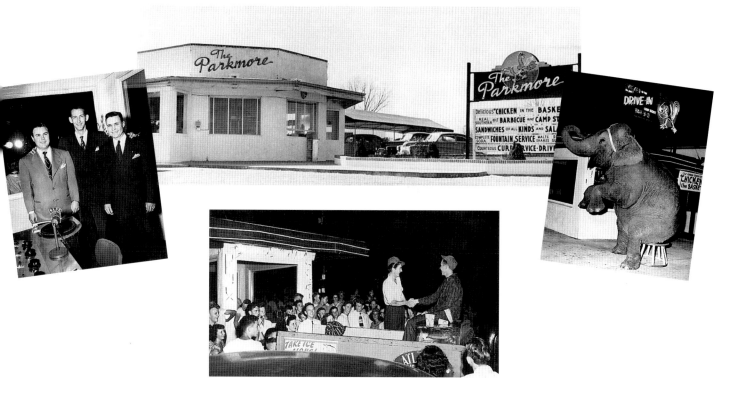

Master promoter Robert Williams, owner of the Parkmore Drive-In in Montgomery, Alabama, jammed his lot with customers who were treated to all sorts of promotions. Free movies were projected from the restaurant's rooftop onto elevated screens, while "Platter Time," a radio program hosted by DJ Leland Childs, was broadcast from a special booth installed in 1947. Trips to Havana, diamond rings, cars, and living room suites could be won in an endless series of contests that had customers sitting on blocks of ice or identifying mystery voices. There was even "Parky," a prize 4-H steer that was bought and displayed at the drive in only to later be "featured" in the restaurant's 20-cent hamburgers!

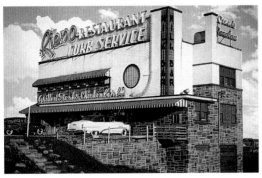

Pollefexen, Jack. "Don't Get Out." *Colliers*, March 19, 1938

Reinhart, Dorothy. "Laughter, Tears, Mark Final Closing of Henry's, Forty One Year Old Glendale Landmark." *The Ledger*, November 22, 1977

Rodd, W.C. "One Building for Two Types of Clientele." *American Restaurant*, August 1948

Seidenbaum, Art. "California's Drive-In Culture Still in High Gear." *Los Angeles Times*, July 25, 1976

Seras, Stephen. *The Automobile in America*. New York: American Heritage Publishing Company, Inc., 1977

"Self Service Success." *American Restaurant*, July 1954

"Selling a Packaged Take Home Meal for Fifty Cents." *American Restaurant*, August 1953

"Selling Take Out Meals in Bulk." *Restaurant Management*, April 1954

"Shrine to the Hamburger." *Popular Mechanics*, January 1949

Silk, Gerald. *Automobile and Culture*. New York: Harry N. Abrams, Inc., 1984

Snibbe, Richard W. *Small Commercial Buildings*. New York: Reinhold Publishing Corporation, 1956

Spalding, Julia. "Curb Service." *Indianapolis Monthly*, July 1991

"Tam O' Shanter." *Pacific Coast Record*, September 1938

"Twelve Shops and $1,000,000 a Year." *American Restaurant*, November 1958

"Two Catchy Items. Thirty Three Busy Drive-Ins." *American Restaurant*, July 1958

"Van de Kamps Drive-In." *Pacific Coast Record*, September 1939

"The Varsity Drive-In." *Restaurant Business*, April 1, 1979

Werner, Harry. "Designing Modern Drive-Ins." *Restaurant Management*, September 1946

Wilson, Guy, Diane H. Pilgrim, and Dickran Tashjian. *The Machine Age in America, 1918-1941*. New York: Harry H. Abrams, Inc., Publishers, 1986

"What Happened When We Barred Riotous Youngsters." *Restaurant Management*, April 1945

"Whatever Happened to the Pig Stands?" *Drive-In Fast Service*, December 1973

Wycoff, Clyde. "A Drive-In That Nets Its Owner a Years Income in Seven Months." *Restaurant Management*, May 1946

"Yaw's Wins Portland's Heart." *American Restaurant*, April 1945

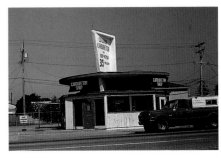

Though not easy to adapt on foreign shores, the drive-in restaurant nonetheless appeared in several countries. Top left. A swinging '60s British drive-up featured high-heeled car hops. Top right. A post-war Japanese drive-in. Middle Right. A wall mural from an Ensenada, Mexico, drive-up. Middle Left. Rieno's Curb Service in Montreal, Canada. Bottom. A few classic drive-in restaurants remain, though their future is uncertain. Pictured here are some of the extant drive-ins scattered across the United States.

INDEX

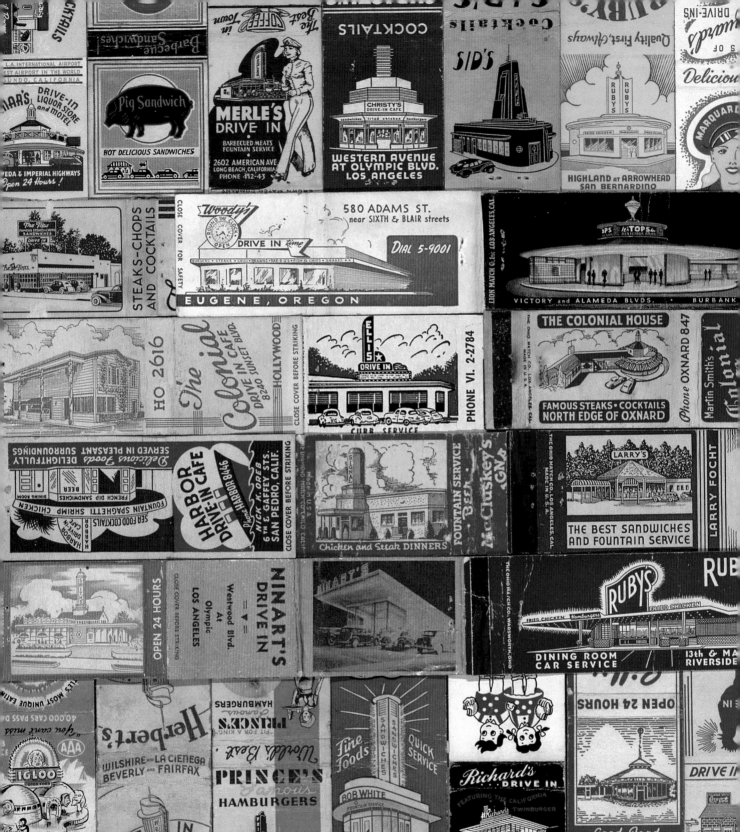